SELECTED WORKS

from the Collection of

THE NATIONAL MUSEUM
OF AFRICAN ART

VOLUME 1

Smithsonian
National Museum of African Art

© 1999 National Museum of African Art, Smithsonian Institution

All rights reserved.

Requests for permission to reproduce material from the handbook should be sent to Publications Department, National Museum of African Art, Smithsonian Institution, Washington, D.C. 20560-0708.

Library of Congress Cataloging-in-Publication Data
National Museum of African Art (U.S.)
 Selected works from the collection of the National Museum of African Art.
 p. cm.
 Includes bibliographical references.
 ISBN 0-9656001-2-2 (softcover : alk. paper)
 1. Art, African—Catalogs. 2. Art—Washington (D.C.)—Catalogs. 3. National Museum of African Art (U.S.)—Catalogs.
 I. Title.
N7380.5 .N38 1999
709'.6'074753—dc 21 99-047142

The text is Lumi silk matt art

∞ The paper used in this publication meets the minimum requirements of the American National Standard for Information Sciences—Permanence of Paper for Printed Library Materials ANSI z39.48-1984.

Cover: Mask, Lele peoples, Democratic Republic of the Congo (cat. no. 92)

Frontispiece: Staff *(oshe Shango),* Yoruba peoples, Nigeria (cat. no. 45)

Back cover: Altar *(asen),* Fon peoples, Ouidah, Republic of Benin (cat. no. 39)

Editor: Suzanne Kotz

Designer: Susan Kelly

Mapmaker: Melanie Milkie

Photographer: Franko Khoury, unless otherwise indicated

Printed and bound by C & C Offset Printing Co., Ltd., Hong Kong

CONTENTS

ACKNOWLEDGMENTS

This volume is the first in a series of publications planned to present the collections of the National Museum of African Art to a wider audience. The museum's holdings of traditional African art are featured in this volume; modern and contemporary African art and the collections of Eliot Elisofon Photographic Archives will be the subjects of subsequent publications. The series was conceived by the museum's chief curator, Philip L. Ravenhill.

The handbook was written by the museum's curatorial staff: Bryna M. Freyer, Dr. Christraud M. Geary, Dr. Andrea Nicolls, Lydia Puccinelli, and Director Roslyn Adele Walker, Ph.D., who, assisted by Dr. Roy Sieber, Associate Director (1983–96) and Research Scholar Emeritus, selected the objects and wrote the entries. Dr. David A. Binkley, appointed Chief Curator in August 1998, provided scholarly review and assistance. Dr. Nicolls organized the photography produced by Franko Khoury, museum photographer. They were ably assisted by Julie Haifley, Head Registrar, and registration staff members Jeffrey Smith and Katherine Sthreshley; Stephen Mellor, Chief Conservator, and Assistant Conservator Dana Moffett; and Keith Conway, who crafted mounts for the works of art. Migs Grove provided editorial assistance, and Assistant Director Patricia Fiske, as project director, kept the publication moving along to completion.

Generous financial contributions by Frieda and Milton Rosenthal enabled the museum to establish its Publications Fund, which has made possible the publication of this volume and those that will follow. The Rosenthals are joined by many individuals, cited in the entries, who have enriched the collection through their donations of important works of art.

Roslyn Adele Walker
DIRECTOR

FOREWORD

The National Museum of African Art began as a private educational institution in 1964. Founded by Warren M. Robbins, a former U.S. Foreign Service officer, it was then known as the Museum of African Art and was located on Capitol Hill in a duplex townhouse that had been the home of Frederick Douglass, the African American abolitionist and statesman, from 1871 to 1877. The setting was appropriate to the museum's unique research and collecting interests in African and African American art, history and culture. During the next several years the museum acquired adjacent properties.

On August 13, 1979, by enactment of Public Law 95-414, the Museum of African Art became part of the Smithsonian Institution, the world's largest museum complex. To reflect both its new status as a national museum and its focus on the traditional visual arts of sub-Saharan Africa, the museum was formally renamed the National Museum of African Art in 1981.

The collection of approximately 7,000 objects required a suitable building, and because there was no space for expansion on Capitol Hill, plans were made to build a new museum on the National Mall. In 1983 Warren Robbins retired to become Founding Director Emeritus. After a national search Sylvia H. Williams, formerly a curator of African art at the Brooklyn Museum, and Dr. Roy Sieber, then Rudy Professor at Indiana University, were appointed Director and Associate Director, respectively.

On September 28, 1987, the National Museum of African Art opened to the public in its new facility on the National Mall. The museum is a major component of a 4.2-acre, largely underground quadrangle complex which also houses the Arthur M. Sackler Gallery of Asian Art , the Smithsonian Associates, the Smithsonian Institution Traveling Exhibition Service and the International Center. Jean Paul Carlhian of the Boston architectural firm of Shepley, Bulfinch, Richardson and Abbot was principal architect for the project.

Five inaugural exhibitions were installed to celebrate the opening of the new and greatly expanded museum. More than 100 works of art—some never before on public view at the museum—represented *The Permanent Collection of the National Museum of African Art.* The museum's largest temporary exhibition space was devoted to a major international loan exhibition, *African Art in the Cycle of Life,* which illustrated art in various stages of the life cycle including birth and coming of age, death, and the afterlife. Three additional installations focusing on African textiles *(Patterns of Life: West African Strip-Weaving Traditions),* utilitarian objects *(Objects of Use)* and Benin metal sculpture *(Royal Benin Art in the Collection of the National Museum of African Art)* completed the opening exhibitions.

The museum's collection today remains at about the same number as in 1979, approximately 7,000 objects. This figure belies the transformation that has occurred to our holdings during the past 20 years. For instance, African American art is no longer well served by a museum dedicated to the visual arts of Africa, so new homes were found for many of these works of art. Nineteenth-century paintings by such artists as Henry Ossawa Tanner, for example, were transferred to the National Museum of American Art. African objects that were neither of exhibition quality nor useful for study purposes were transferred to other museums and conservation laboratories.

With the remaining objects as a foundation, the Williams-Sieber team began an aggressive acquisition program with the intention of creating a world-class art collection worthy of the country's leading collecting, exhibition, research and reference center for the visual arts of Africa. The acquisition of an important Kongo maternity figure in 1983 (cat. no. 78a) established the museum's new standard.

Important works of art also have been transferred from other Smithsonian Institution museums to the National Museum of African Art. For example, a collection of 20 sculptures from

the Benin Kingdom, collected by Joseph H. Hirshhorn and dating from the 16th to 19th century, was transferred from the Hirshhorn Museum and Sculpture Garden to this museum. Further, the collection has been significantly strengthened by generous donations from numerous individuals.

In addition to building and exhibiting the collection of traditional sub-Saharan art, the museum administration and its advisory Commission identified in 1994 the goal of acquiring both modern and contemporary works and art from northern Africa for the permanent collection. This new priority was consistent with the changing state of African art studies. The museum's collections and exhibits now include the ancient and contemporary arts of the entire continent.

In anticipation of this initiative came the museum's first exhibition of modern African art in 1988. *Echoes of the Kalabari: Sculpture by Sokari Douglas Camp,* featured the work of a young Nigerian artist whose kinetic metal sculptures added a new dimension to the museum's galleries. In 1997 the museum inaugurated the Sylvia H. Williams Gallery, the first gallery in any museum devoted exclusively to the exhibition of modern and contemporary African art and named for the former director, who died suddenly in February 1996.

To share our collections with diverse audiences, the museum has carried on an active exhibition program. Three major long-term exhibitions have been installed. *Images of Power and Identity* features masterworks of traditional African art arranged geographically in nine spacious galleries; *Art of the Personal Object* presents beautifully crafted utilitarian objects, and *The Ancient West African City of Benin, A.D. 1300–1897* displays art of the Benin Kingdom. A new gallery devoted to African ceramics has recently opened. Changing exhibitions ensure that the visiting public has access to a wide variety of thematic presentations and new interpretations of African art. The small Point of View Gallery is reserved largely for highly focused explorations of the museum's own collection, and a 5,400-square-foot display space accommodates annually two or three major exhibitions organized by this museum or other national and international institutions. Finally as mentioned earlier, the Sylvia H. Williams Gallery provides a venue for changing exhibitions of modern and contemporary African art. In all, the museum has 20,000 square feet of exhibition space.

The museum has also created a variety of educational programs. Through materials such as videotapes about African art and images of the museum's growing collections, the museum reaches teachers and students around the world. Teacher workshops and curricular materials enable educators to incorporate African art into their classroom programs.

Symposia, lectures and publications present research by national and international scholars of African art, archaeology, history and anthropology. Workshops and demonstrations by African and African American artists engage audiences eager to meet and talk with practicing artists. Films offer contemporary perspectives on African life, art, and cinema. Docent tours, storytelling programs, festivals and workshops for families engage young and old through lively presentations that bring Africa's oral traditions, literature and art to life.

The National Museum of African Art contains a state-of-the-art conservation laboratory whose staff has established and continues to refine conservation procedures unique to the care of African art. The staff has documented the condition of all collection objects, provided appropriate treatment, evaluated the condition of potential acquisitions and maintained professional exhibition standards. The department also serves as a national and international authority on the conservation of African art. The national Museum of African Art Library, a branch of the Smithsonian Institution Libraries and named for Founding Director Emeritus Warren M. Robbins, and the museum's Eliot Elisofon Photographic Archives function as major resource centers in the United States for research and information on the art of Africa. They cover all aspects of pan-continental African visual arts, including sculpture, painting, photography, printmaking, pottery, textiles, crafts, popular culture, architecture and archaeology. Significant supporting collections relate to African ethnography, musicology, perfor-

mance, theater, oral traditions, religion, creative writing and the general history of African countries. In addition to serving the staffs of the museum and other Smithsonian offices, the library and archives attract national and international scholars and are available to the public.

As we enter our second decade on the National Mall, the museum remains committed to presenting African art from throughout the continent. Our growing collections, diverse educational offerings and outstanding resources provide a solid foundation with which to meet the challenges of the next century.

Roslyn Adele Walker
DIRECTOR

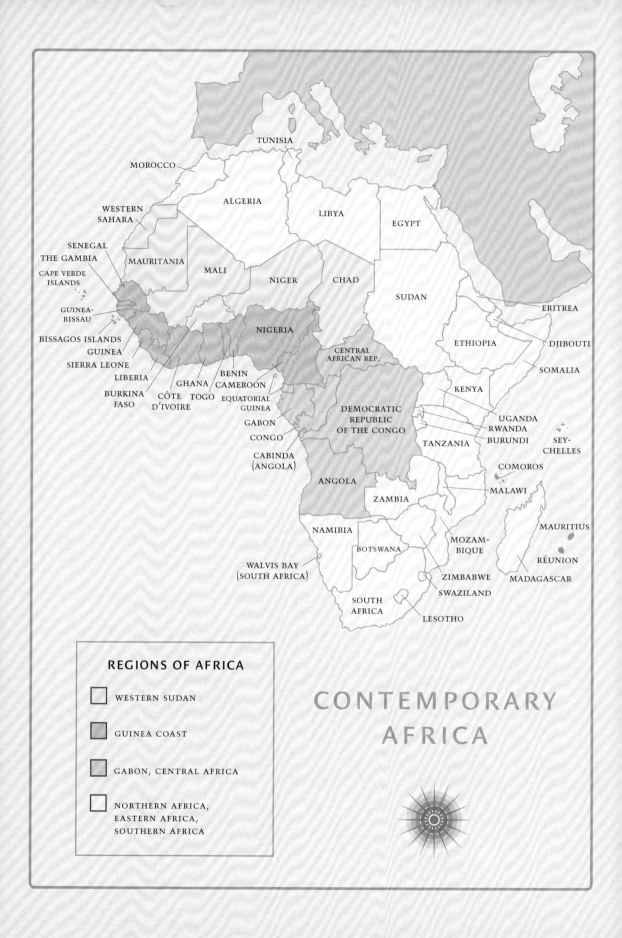

TUNISIA

MOROCCO

WESTERN
SAHARA

ALGERIA

LIBYA

EGYPT

SENEGAL
THE GAMBIA

CAPE VERDE
ISLANDS

MAURITANIA

MALI

NIGER

CHAD

SUDAN

ERITREA

GUINEA-
BISSAU

NIGERIA

CENTRAL
AFRICAN REP.

ETHIOPIA

DJIBOUTI

BISSAGOS ISLANDS

GUINEA

SIERRA LEONE

LIBERIA

BENIN

SOMALIA

GHANA

CAMEROON

KENYA

BURKINA
FASO

CÔTE
D'IVOIRE

TOGO

EQUATORIAL
GUINEA

DEMOCRATIC
REPUBLIC
OF THE CONGO

UGANDA
RWANDA
BURUNDI

GABON

TANZANIA

SEY-
CHELLES

CONGO

CABINDA
(ANGOLA)

COMOROS

ANGOLA

MALAWI

ZAMBIA

MAURITIUS

NAMIBIA

MOZAM-
BIQUE

RÉUNION

WALVIS BAY
(SOUTH AFRICA)

BOTSWANA

ZIMBABWE

MADAGASCAR

SWAZILAND

SOUTH
AFRICA

LESOTHO

REGIONS OF AFRICA

WESTERN SUDAN

GUINEA COAST

GABON, CENTRAL AFRICA

NORTHERN AFRICA,
EASTERN AFRICA,
SOUTHERN AFRICA

CONTEMPORARY
AFRICA

INTRODUCTION TO THE COLLECTION

The arts of Africa, unlike more familiar forms from antiquity, medieval times, the Renaissance, or for that matter, ancient Egypt or China, continue to need interpretation, not necessarily of their aesthetic value to us but for their meaning in the cultures that gave rise to them.

It is the goal of this volume to give these works of art in the collection of the National Museum of African Art the cultural settings and the contextual meanings that will make them more understandable to general viewers unfamiliar with them. Familiarity and understanding breed acceptance, approval and, often, delight. For example, once we ascertain that the meaning of a Hemba ancestor figure (cat. no. 98) lies somewhere between that of a commemorative statue of a war hero and the icon of a saint, or that a bowl by Olowe of Ise (cat. no. 42) originally approximated the prestige status of a Fabergé egg, it may be possible to approach each with a higher comfort level, despite their origins in differing cultures and their reliance on unfamiliar symbols.

However, such parallels are, to a degree, invidious, because the assumption that a medieval icon means to us what it meant to its original viewers is simply not true. A work of art evokes different associations at different times and places. Remove a medieval reliquary containing the relics of a saint from its chapel or a Hongwe reliquary figure (cat. no. 70a) from its basket of ancestral relics and we have—culturally speaking—desanctified both in order to put them in the rarefied and secular setting of a museum. To understand either we must learn something of their original meaning and associations.

The collection of the National Museum of African Art exemplifies the richness of the arts of Africa. Types range from ceramics, textiles and furniture to masks, figures and architectural elements. Although the majority of the works originated in sub-Saharan Africa, a few objects from North Africa and the Sudan are included in this handbook.

All the examples are from a time and cultural frame often subsumed under the term "traditional," a designation that has been challenged because it is often falsely construed to mean precolonial or unchanging or extinct—none of which is true. African art has never been frozen in time, has never reflected an ideal past, and has never existed locked in the so-called ethnographic present.

Because nearly all works of traditional African art were created in perishable materials, they did not long survive the depredations of weather, insects or fire. As a result, each generation had to recreate their arts, usually based on the templates of prior forms and styles. Yet an artist, no matter how dependent on prototypes, still created his or her works of art in an identifiable personal style.

In addition African arts, we may assume, have undergone changes over time affected by the influences—political, military and social—that occurred internally or intruded from the outside. The effect of imports ranging from glass beads to furniture was compounded by foreign religions, literacy, education and commerce as well as wars and the slave trade. Both Arabic and European slaving drastically affected older African forms of domestic slavery.

Perhaps a more important concept is that of "authenticity," a term applied to works usually made by part-time artisans for an essentially local audience and commissioned by and for use among members of that audience. At times, of course, other quite admirable objects might be produced for another audience, for export to other African cultures or, more recently, to Europe as so-called tourist art.

Most African art was created in societies that depended on subsistence agriculture. Each family tended its own farm to produce enough food to last until the next harvest. Thus, with few exceptions, all Africans were full-time farmers and in addition some were part-time specialists: sculptors, weavers, potters, metal workers, musicians or performers.

The aesthetic appreciation of a work of art is quite another matter; the description of its meaning or concerns of tradition or authenticity rarely offer an insight into its quality. The skill with which a well-made work is crafted is easily recognizable. Similarly, a crudely carved figure or an ineptly made mask is quickly discerned. But skill alone does not guarantee aesthetic excellence. A work, however skillfully formed, must also express the deeply shared meaning it held for its original owner and user. As Bryna Freyer notes elsewhere in this book, the best works of African art are a "sophisticated integration of specific, required cult iconography into a coherent work of art."

It must be emphasized, however, that what is perceived, accepted and admired in one place or at one time in a work of art is not necessarily equally accepted or admired at another time and place. In fact, each historical moment has its own set of criteria for what is aesthetically outstanding.

Further, aesthetic appreciation is often clouded if not blocked by nonartistic concerns. For example, many missionaries, both Christian and Moslem, unfortunately could not, and, indeed, still cannot accept African figures and masks as other than heathenish objects adored by natives who lived in spiritual darkness. Colonials saw them, often correctly, as reflective and supportive of modes of governance at odds with those they wished to impose. In either case—missionary or colonial—the works and the beliefs that supported them were outlawed and the objects often publicly destroyed. For the Christian Portuguese it began as early as 1500 upon the conversion of the king of Kongo and his court, when their "idols" were publicly burned.

Aside from political and religious opposition to the beliefs and to the arts that reflected and supported them, there was for the outsiders the unfamiliarity of the forms. European classical canons of beauty were unknown, indeed, never had been known to African artists and their patrons. Styles and forms had developed from cultural needs and expectancies foreign to those of Europe or the Near East.

It is precisely that foreignness, that exoticism, which first attracted collectors and observers in the Age of Discovery. Strange objects were exhibited in curiosity cabinets also called *Wunderkammer,* rooms of wonders. Later the scientific interest of anthropologists was aroused, and the objects were collected and housed in natural history museums. Only in the early 20th century did artists and collectors focus on the objects as art, and since then they have slowly found a place in art museums. The National Museum of African Art is the only museum dedicated solely to the collection, exhibition and study of the ancient and contemporary arts of the entire continent.

Only now are we beginning to understand that the collection history and the pattern of ownership of a work of African art is an important aspect of our knowledge of it. Often that information is one aspect of recovering the recent history of a style. We are becoming aware that such concerns are equivalent to those that have been accepted as significant for the full understanding of works of art from anywhere and anytime.

Ultimately we can accept the view that these marvelous works of art no longer need the cachet of approval or the assumption of "discovery" by Picasso and his peers—cubists or surrealists—to justify our acceptance of them. Rather they have, independently and quite appropriately, earned an honored place in the broadest possible view of world art. They are, in fact, outstanding examples of human creativity that happen to spring from another group of cultures, each with its own history and philosophy, on the great continent of Africa.

Roy Sieber
RESEARCH SCHOLAR EMERITUS

Note to the reader: Unless otherwise indicated, all works date to late 19th/early 20th century.

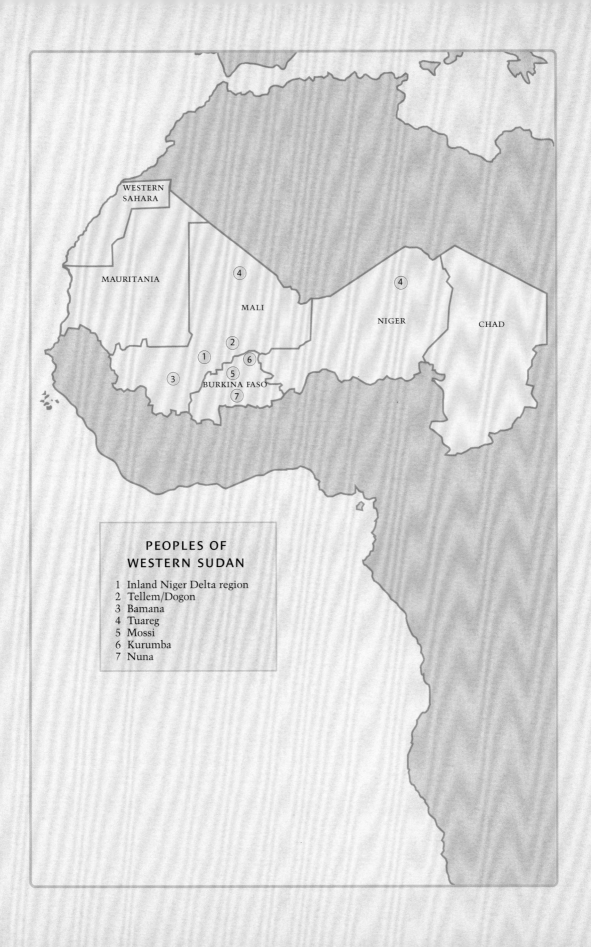

WESTERN
SAHARA

MAURITANIA

MALI

NIGER

CHAD

④

④

②

①

⑥

③

⑤

BURKINA FASO

⑦

PEOPLES OF
WESTERN SUDAN

1 Inland Niger Delta region
2 Tellem/Dogon
3 Bamana
4 Tuareg
5 Mossi
6 Kurumba
7 Nuna

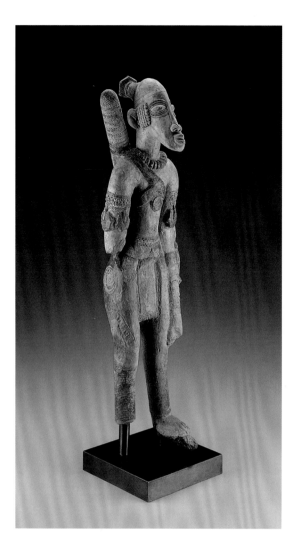

1A. ARCHER FIGURE
Inland Niger Delta region, Mali
Possibly 13th–15th century
Terracotta
H. 61.9 cm (24⅜ in.)
Museum purchase, 86-12-1

These figures, with their rounded, elongated forms and rich apparel, belong to a terracotta sculptural tradition that is no longer extant. Each figure carries on its back a quiver with arrows, and each has a knife in a sheath attached to the left arm. They wear short pants over their legs, which are grooved at the ankles. The archer's headgear is shaped like a hexagonal bead, and hexagonal beads dangle from his upper arm. The rider wears a helmet attached by a chin strap. The headgear of his horse is equally elaborate. Both figures have been broken and restored.

Since the 1940s, low-fired ceramic figures and fragments such as these have been unearthed at various sites throughout the Inland Niger Delta region, an area that once had highly developed urban centers. These works are among the earliest known surviving art forms in sub-Saharan Africa. The makers were from the various peoples in the region (Grunne 1995: 79), but it is not known whether they were men or women. Using a mixture of coarse clay and added grog (crushed pot sherds), the potters modeled the figures by hand. Some were modeled in separate parts and fitted together. Most surviving examples are solid, but a few are hollow and built with clay coils. Surfaces are polished and covered with a red slip (clay wash). These massive works are among the largest known terracotta figures created by sub-Saharan African potters. By the 15th or 16th century, environmental and political events caused the urban centers of the Delta region to be abandoned, and the art tradition did not survive.

Research, including local oral traditions, indicates that all ethnic groups in the Delta region used these figures. The earliest known written reference to them occurs in a letter of 1447. In it, a visiting Italian merchant remarked that the figures were kept in sanctuaries and venerated as representing the deified ancestors of famous founding rulers of the region (Grunne 1987: 97–98). The elaborate dress of the figures suggests ceremonial military attire, and they may represent warriors who were once allies of the Malian emperor Sundjata Keita (c. 1210–c. 1260) (Grunne 1991: 86–87). Based on stylistic comparisons with similar figures, these works can be tentatively dated to between the 13th and 15th centuries.　　　　AN

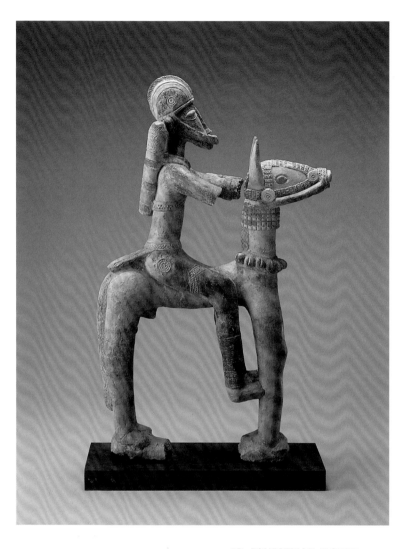

1B. EQUESTRIAN FIGURE
Inland Niger Delta region, Mali
Possibly 13th–15th century
Terracotta
H. 70.5 cm (27¼ in.)
Museum purchase, 86-12-2

PROVENANCE

86-12-1:
Karl Heinz Krieg, Neunkirchen, Germany, 1972–73
(fragments)
Emile M. Deletaille, Brussels, 1972–73 to 1986

86-12-2:
Kassim Sidibe, Mali, 1973–74 (equestrian)
Marie Ange Ciolkowska, Paris, 1973–74 (horse's head)
Karl Heinz Krieg, Neunkirchen, Germany, 1973–74
(fragments)
Emile M. Deletaille, Brussels, 1973–74 to 1986

PUBLICATION HISTORY

Grunne 1980: 76–77, fig. I.10; 84–85, fig. I.14
Cole 1989: 94, fig. 105 (86-12-1)
Grunne 1991: 81, fig. 3; 82, fig. 4

2. HEADREST
Tellem peoples, Mali
11th–14th century
Wood
W. 31.8 cm (12½ in.)
Gift of Saul Bellow, 69-4-1

In the Bandiagara cliffs, above the villages now occupied by the Dogon people, carved wooden headrests have been found in burial caves. The Dogon, who do not now use headrests, attribute them to the Tellem, former inhabitants of the region from the 11th to the 16th centuries. Rogier Bedaux (1988: 43), who has excavated in the burial caves, asserts that headrests "do not occur in Dogon contexts."

Tellem headrests that have been excavated from documented cave sites have elegant silhouettes but minimal decoration. Other undocumented examples, like this one, are adorned with circles, zigzags or other geometric designs. Although unusual, some headrests have animal heads projecting from either end of the curved upper platform. The heads resemble those found on troughlike containers and benches of the contemporary Dogon (Ezra quoted in Dewey 1993: 97). This example is unusual because the platform support is hollow, like the Dogon coffers in the form of a quadruped, and instead of the dessicated grayish appearance of headrests excavated from the caves, this one has a dark brown patina. It is possible that the museum's headrest was originally made for the Tellem but reused by the Dogon.

BMF/RAW

PROVENANCE
Saul Bellow, Chicago, 1969

PUBLICATION HISTORY
National Museum of African Art 1981: fig. 3

3. SEATED FEMALE FIGURE

Dogon peoples, Mali
Wood
H. 40 cm (16 in.)
Gift of Merton Simpson and museum purchase
with funds provided by Joyce Marie Sims and by
the Delta Memorial Endowment Fund, Inc., of
the Milwaukee Alumnae Chapter of Delta Sigma
Theta Sorority, Inc., 97-6-2

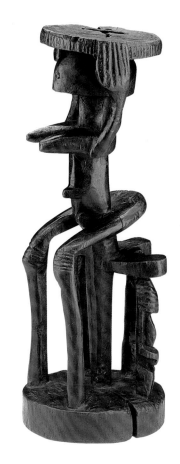

Dogon art is found in the context of religious rituals that center on the veneration of the spirits of three types of ancestors: deceased members of one's lineage or clan; Lebe, one of the eight original ancestors of all mankind; and *binu,* or immortal ancestors, venerated by the whole clan. Figurative sculptures *(dege)* carved from wood and depicting males and females are placed on altars dedicated to these real and mythical ancestral spirits.

Figurative sculptures vary in form and imagery according to the language/dialect group; its location, on either the Bandiagara escarpment or plateau; and the carving style of the individual artist or a workshop. The identities of the ancestral spirits represented by particular figurative sculptures are uncertain because few altars have been described in detail or illustrated (Ezra 1988: 21). Such helpful documentation is not available for this figure.

Dogon artistic conventions prevail in this sculpture, although its creator seems to have interpreted the canon in a highly individualized way. For example, while it is not unusual for the breasts or pectorals to continue the mass of the shoulders, and for the thighs to continue the mass of the buttocks, the sculptor exaggerated these forms. They wrap around the cylindrical torso that extends to the base of the stool. Dogon figures do not always actually sit on the stool but are slightly separated from it; in this figure the separation is exaggerated. According to Leloup, caryatid stools represent "the sky and cannot seat any person, no matter how powerful" (1994: cat. no. 78), and perhaps the artist sought to emphasize this point. The knees bear parallel incised lines rather than protuberances to indicate joints. Dogon oral tradition recounts that the bodies of the first humans had no joints until the first blacksmith descended from the sky and broke his arms and legs on his hammer and anvil. The joints thus formed allowed humans to hammer red hot iron, dig the land and perform other work (Griaule 1965: 44). Following convention, the legs of the figure function as supports for the stool. Caryatids representing the *nommo,* the eight original ancestors, normally appear either paired or alone. In this work, only three of the ancestors are represented, an atypical representation.

It is tempting to describe this sculpture as the work of an eccentric artist who understood the Dogon canon but took liberties, much like the Yoruba artist Olowe of Ise (see cat. nos. 41, 42). Dogon styles range from quasinaturalistic to abstract, however, and one must use caution in forming such an opinion. RAW

PROVENANCE
William Moore, Los Angeles, — to 1984
Merton Simpson, New York, 1985 to 1997

PUBLICATION HISTORY
Robbins and Nooter 1989: 60
Ravenhill 1997: fig. 3

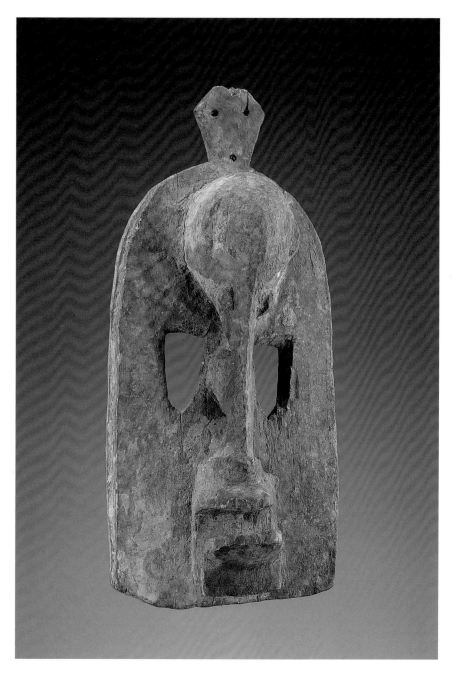

4. MASK OF A HUNTER *(dannana)*

Dogon peoples, Mali
Wood, encrustation
H. 39.7 cm (15⅜ in.)
Gift of Bryce Holcombe, 81-21-1

Perhaps more than any other African peoples, the Dogon have been studied, analyzed and photographed. The documentation begun by turn-of-the-century French colonial administrators was followed in 1931 to 1956 by a series of ethnographic expeditions led by Marcel Griaule and his colleagues. Wider public interest was generated by organizations such as Time-Life, National Geographic and the BBC. Since the 1970s, people have arrived in Dogon country as participants in government-sponsored tourist seasons. Masks and danced performances are the highlight of such visits.

Traditionally Dogon masks are controlled by the Awa society, a group of predominantly male initiates. The society's age-grouped membership functions outside the standard Dogon organizing factors of lineage and village. It conducts the public rites that insure the transition of the dead into the spirit world. A large number of masks are included both for the funerary rites and for the *dama,* the celebration at the end of mourning. The Awa leaders also direct the *sigui,* a celebration held only every 60 years to mark the change in generations (DeMott 1982: 62–63).

While Griaule identified more than 70 different Dogon masks used by the Awa society, they can be grouped into five categories according to medium, whether fiber or wood; subject, whether animal, human or abstract; and character, whether predatory or nonpredatory (DeMott 1982: 90). Based on Griaule's photographs of a mask from Ireli (1938: figs. 143–45), this wood mask is a predatory human, specifically a hunter. Noteworthy traits include the dark encrusted surface, the flat face and the projecting mouth that originally had millet-stalk teeth. The most distinctive feature is its nose, which Griaule (546) described as a "human profile." It resembles the top of an animal head with a long snout or jaw.

Such a mask would be worn by a man more than 20 years old, the senior age-group in the

Awa society (DeMott 1982: 105). His costume would have been an ordinary tunic covered with leaves, combining domesticated and wild materials, and he would have carried a sword, a lance and a leather bag with medicines. In a pantomime rather than a dance, *dannana* aggressively hunts another masquerader, the rabbit, but fails to catch him. The rabbit in this context is the trickster, intelligent and cunning, able to defy man (112). The pairing of hunter and rabbit may refer to the myth recounting how the first hunter mask was created. A skilled hunter killed an antelope, and both the rabbit and the hyena asked for a share. After much discussion and some chasing, the rabbit tells the hunter that the hyena attacked him, whereupon the hunter kills the hyena (Griaule 1938: 547–48). It should be noted that the Dogon consistently describe the hyena in negative terms: as an unprovoked attacker, ugly and smelly, and with a repulsive voice (DeMott 1982: 108). In the myth, the hunter tells his father about killing the antelope and the hyena, and his father dies. The hunter perceives his father's death not as a coincidence but as being caused by the killing of the two animals. This is in keeping with the virtually universal African belief that all illnesses and deaths have more than physical causes. The Dogon myth concludes with the hunter carving masks. Griaule infers that the hunter wanted to protect himself from the spirits of the animals he killed (1938: 550). The other human predatory masks—a foreign warrior, a sorcerer and a mythic ancestor—also have associations with death and disorder.

BMF

PROVENANCE
Bryce Holcombe, New York, before 1981

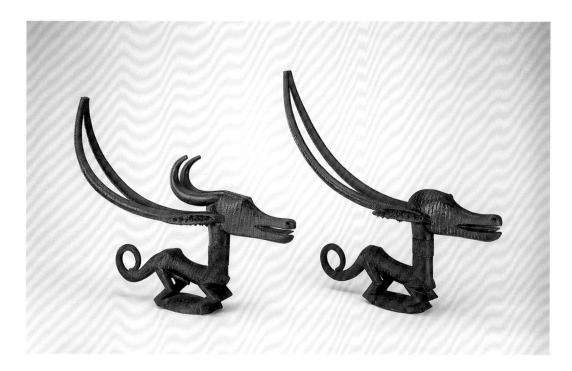

5A. PAIR OF CREST MASKS *(chi wara kun)*
Bamana peoples, Bamako region, Mali
Wood, iron, cotton fiber
L. 53.3 cm (21 in.) each
Gift of Ernst Anspach and museum purchase,
91-8-1.1, .2

Few objects are so generally identified with African art as the Bamana "antelope" crest mask. It is actually a complex object, with tremendous variations in style and technique. These differences are usually attributed to the regional styles set forth by Robert Goldwater (1960), whose work relied on museum-based research and the 1934–35 field data of F. H. Lem. These masks, a pair and a single male, exemplify the range of characteristics exhibited by such objects.

Most African sculptures are carved from one piece of wood, but the horizontal style of antelope mask uses two: one for the head and neck, and one for the body (91-8-1.1, .2). A male and female pair, both have strong silhouettes with spiral tails and sweeping horns. Their surfaces are textured with incised geometric designs. Another style of carving uses a vertical one-piece format that emphasizes the neck and mane (73-7-56). It is distinguished by the deep inside curve of the throat, the dividing of the neck into openwork and triangular elements, the two notched forms articulating the mane, and the curved, unadorned tail. Other traits— the straight vertical horns, bending backward at the tip, covered with spiral incised decoration

on the shaft; the elongated face and nose with parallel lines carved from the forehead band to the mouth; the bands of triangular impressed patterns obscured by a thick patina—are shared with groupings such as the Master of the Flying Mane (Wardwell 1984: 83).

Despite their disparate forms, the masks share the same symbolism. Most African artists use depictions of animals to convey lessons. An appropriate animal is selected according to well-known distinctive physical or behavioral traits. The physical features of different animals are often combined to create mythical creatures whose symbolic powers are greater than ordinary beasts. These masks combine the horns of a large antelope; the body of an aardvark with its big ears, short legs and thick tail; and the textured skin and curling ability of the pangolin —all animals who dig up the earth. This makes them fitting representations of Chi Wara, the supernatural being who the Bamana traditionally believed taught people to farm. Earrings, of red fiber or cowrie shell, reinforce the idea that these are not ordinary animals.

Young men once wore male and female pairs of masks in a dance performance that taught, praised and encouraged good farmers. Ceremonies were held in the fields. Today, because of conversion to Islam and modern changes in employment and school attendance, the masquerade has become more a popular entertainment and less a performance associated with a men's initiation society. Many replicas of the mask can be found for sale in urban markets; it is even copied in other parts of Africa for the export trade. BMF

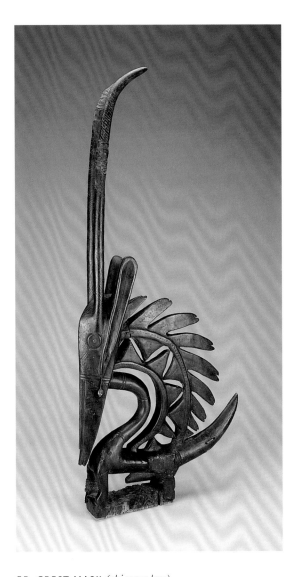

5B. CREST MASK *(chi wara kun)*
Bamana peoples, Kenedougou region, Mali
Wood, metal, fiber, hide, cowrie shells
H. 112.4 cm (44¼ in.)
Bequest of Eliot Elisofon, 73-7-56

PROVENANCE

91-8-1.1, .2:
J. J. Klejman, New York, 1962
Ernst Anspach, New York, 1962 to 1991

73-7-56:
Eliot Elisofon, New York, before 1957 to 1973

PUBLICATION HISTORY

73-7-56:
Goldwater 1960: no. 50
Robbins 1966: fig. 7, 7a
Museum of African Art 1973: 10, no. 19
Zahan 1980: pl. 26, no. IM75
Park 1983: 373

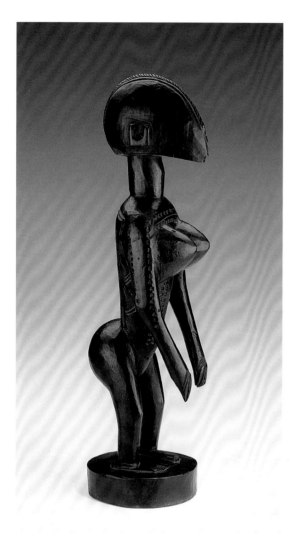

6. FEMALE FIGURE *(jonyeleni* or *nyeleni)*
Southern Bamana peoples, Mali
20th century
Wood
H. 39.4 cm (15½ in.)
Museum purchase, 96-7-2

Jonyeleni (or *nyeleni*, meaning "little orna-
ments") are freestanding sculptures depicting
nubile young women. In creating these figures,
sculptors portray the Bamana ideal of feminine
beauty: a strong neck and straight back, a pair
of prominent breasts, broad shoulders, a long
slender torso and narrow waist, and very large
buttocks. They carve geometric patterns on the
figures' chests, torsos and backs to represent
the scarification that signifies a girl's initiation
into adult society. The figures are rubbed
with oil, clothed and adorned with beads and
other ornaments to resemble Bamana women
dressed for festive occasions (Ezra 1986: 17–21;
McNaughton 1996: 131–37).

Sculpted figures of this type were used in the
context of Jo activities. Jo was a traditional
institution concerned with maintaining social,
spiritual and economic harmony within the
community. Unlike other Bamana institutions,
women as well as men were members. Newly
initiated male youths displayed the *nyeleni*
figures during performances of Jo songs and
dances. Considered *mafilè fèn*, "something to
see," and *masiri*, "decoration," the *nyeleni*
figures made performances or rituals visually
interesting (Ezra 1986: 10).

The precise origin of this figure, whose
style is distinguished by small square ears on
a highly stylized head and distinctive scarifica-
tion on the arms, chest and abdomen, has not
been identified. It represents, however, one of
several carving styles that are associated with
individual carvers or workshops among the
various southern Bamana peoples in the Baule
and Bagoe River valleys where Jo exists. RAW

PROVENANCE
F. H. Lem, Paris, collected in Africa, c. 1934–35
Helena Rubinstein, Paris and New York, c. 1935 to 1966
Private collection, 1966 to 1995
Pace Primitive, New York, 1995 to 1996

PUBLICATION HISTORY
Parke-Bernet Galleries 1966: sale 2429, no. 62, p. 43

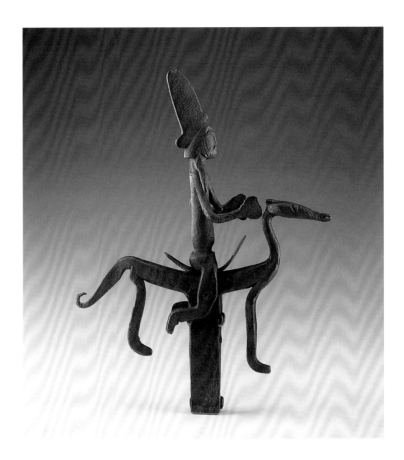

7. STAFF TOP

Bamana peoples, Bougouni region, Mali
Early 19th century
Iron
H. 24.1 cm (9½ in.)
Gift of Joseph H. Hirshhorn in 1966 to the
Smithsonian Institution, 85-19-1

Presenting only the essentials of the form, a
Bamana blacksmith created this minimal image
of a horse and rider, elegant in its stylization
and simplification. In Mali, iron ore has been
smelted and forged since the end of the first
millennium B.C. (McIntosh and McIntosh
1988: 107). Blacksmiths of the region still forge
iron using techniques developed centuries ago.
When heated, iron can be hammered into any
desired shape. It hardens into a permanent form
as it cools. Smiths are regarded as extraordinary
for their ability to transform raw iron into tools,
weapons and ritual objects.

This sculpture was once part of a longer iron
staff. The horse and female rider suggest the
rank and power of the chief and the importance
of his family. The rider wears a hat like those
worn by other important persons: hunters,
ritual specialists and the praise singers or histo-
rians known as *griots.* The portrayal of a female
rider recalls those Mande women who have
acquired power and earned respect through force
of character or ability as a sorcerer and are affili-
ated with hunters' associations (McNaughton
1988: 125). The horse suggests the powerful
cavalry of the Bamana kingdoms. Such staffs
were displayed on special occasions to com-
memorate ancestors or placed near areas sacred
to initiation associations such as Jo (124). It was
probably used as a marker for a chief's burial.

AN

PROVENANCE
J. J. Klejman, New York, 1963
Joseph H. Hirshhorn, Greenwich, Conn., 1963 to 1966
Hirshhorn Museum and Sculpture Garden, Smithsonian
Institution, Washington, D.C., 1966 to 1985
Transferred to the National Museum of African Art,
1985

PUBLICATION HISTORY
Ezra 1986: 9, no. 4
Cole 1989: 48, fig. 53

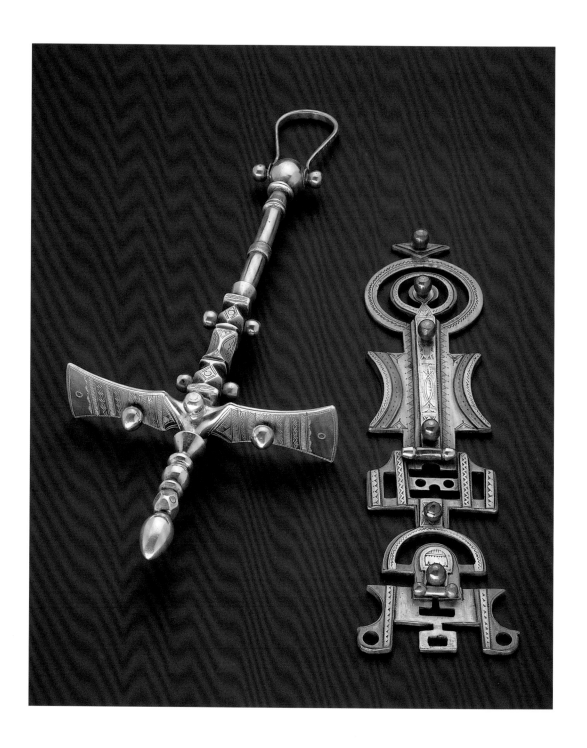

8. *Left:* SUGAR HAMMER *(tafadist)*
Tuareg peoples, probably Algeria
Silver
L. 26.5 cm (10⁷⁄₁₆ in.)
Museum purchase and gift of Mrs. Florence
Selden in memory of Carl L. Selden, 93-6-14

Right: KEY/VEIL WEIGHT *(assrou n'swoul)*
Possibly Tuareg or Moor peoples, regions of West
and North Africa
Brass, copper, silver
L. 20.3 cm (8 in.)
Museum purchase and gift of Mrs. Florence
Selden in memory of Carl L. Selden, 93-6-1.2

The Tuareg are Berber-speaking peoples who originally lived mainly in the western part of the Sahara Desert and the northern parts of the Western Sudan region (Nicolaisen and Nicolaisen 1997: I, 41). Forced by the drought of 1973–74, groups of Tuareg moved to Nigeria, Burkina Faso, Ghana, Togo, Benin, Côte d'Ivoire and Guinea (Nicolaisen 1963: 7; Yakuba in Johnson et al. 1980: 7). Tuareg groups are subdivided into classes of nobles, vassals, freemen and slaves. The Iwellemmeden Kel Ataram or western Iwellemmeden group of Niger and Mali from whom these objects were acquired are counted among the nobility (Nicolaisen 1963: 433–35).

Artists who create objects for all Tuareg groups are known collectively as the *inadan.* Classified as freemen, they travel and live among various Tuareg groups during the year and fashion objects for both ceremonial and daily use. *Inadan* men are blacksmiths, jewelry makers and woodcarvers; the women are leather workers. *Inadan* are both feared and respected for their abilities. Other Tuareg believe that the *inadan* possess a mystical power called *ettama,* which allows them to inflict harm or ward off evil (Casajus 1987: 293–300; Mickelsen 1976: 16; Nicolaisen 1963: 19–21; Rasmussen 1988: 1–4).

This splendid, highly valued key probably once belonged to a noblewoman who prized it as a symbol of status and wealth. She used it to open a storage box in which she kept her possessions, perhaps her dowry. She also attached it to a corner of the veil she wore over her head as a weight to keep the veil in place (Loughran 1995: 18; Göttler 1989: 240–41). The key is composed of a copper-alloy sheet onto which copper and silver sheets were soldered to create a subtle contrast of colors.

The Tuareg used a hammer of special, often ornate form to break up pieces of sugar which they put in their tea. This elaborate example was cast, hammered, engraved and decorated with silver studs. A ring for hanging the hammer is attached to one end. The engraved patterns on the hammer are motifs drawn from the natural world: cross-hatched patterns represent guinea fowl, and the small circle may symbolize the eye of the chameleon. AN

PROVENANCE
Private collection, Europe, acquired in Niger and Mali, 1959–71 to 1993
Reynold C. Kerr, New York, 1993

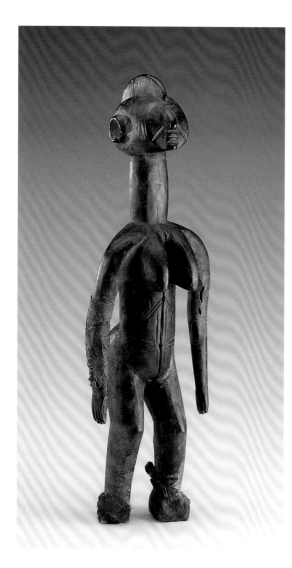

9. FEMALE FIGURE
Mossi peoples, Burkina Faso
Wood, hide, fiber
H. 40.6 cm (16 in.)
Museum purchase, 91-5-1

The attenuated cylindrical neck and torso with yoke-shaped shoulders, long arms, flexed knees, and jutting buttocks and breasts of this sculpture define one Mossi figure style. The small head with minimal features has a female hairstyle, known as *gyonfo*, in which a central ridge runs from the front to the back of the head (Roy 1987: 158).

Figures of this sort were displayed in public at annual sacrifices honoring the ancestors and then stored in the residence of the chief's senior wife (Roy 1987: 162). While on view, the figures were dressed with a cloth wrapper covering the lower portions of their bodies in imitation of Mossi women's traditional dress.

This figure displays considerable wear. Old repairs, indicated by pieces of animal hide covering the partially missing feet and broken right arm, apparently sought to correct damage caused by handling or exposure to natural elements.

The Mossi peoples are mainly farmers who inhabit the central plateau region of Burkina Faso. Mossi society developed in the 15th and 16th centuries when invading horsemen from northern Ghana intermarried with the local population. The descendants of the invaders, known as Nakomsé, assumed political power over the Tengabisi (children of the earth), who as the original inhabitants, continued to exercise control over the land (Roy 1987: 90–91).

The use of sculpture parallels the divisions in Mossi society. Masks are employed exclusively by Tengabisi groups to propitiate and manipulate spirits for the good of the community. Figures, usually female, are reserved exclusively for the ruling elite, the Nakomsé, as symbols of political power (Roy 1982: 52). AN

PROVENANCE
Private collection, before 1968
Jean-Pierre Jernander, Brussels, 1968
Alan Brandt, New York, 1991

PUBLICATION HISTORY
Bastin 1984: 91, fig. 60
Roy 1987: 163, fig. 129

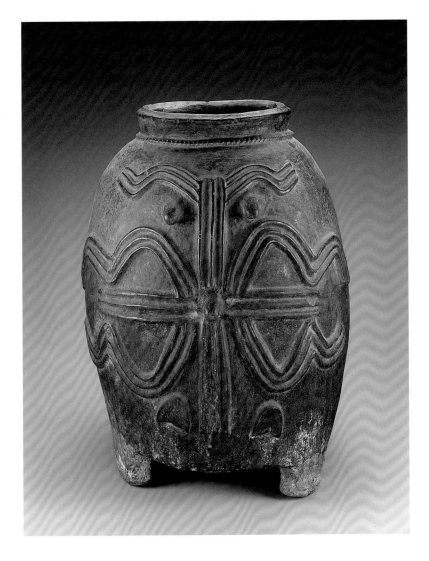

10. VESSEL

Kurumba peoples, Burkina Faso
Terracotta
H. 64.5 cm (25 ⅜ in.)
Gift of Saul Bellow, 81-10-1

The Kurumba live in northern Burkina Faso on the edge of the Sahel, a very dry region. Pottery is made by women, as are most ceramic vessels in Africa south of the Sahara. The wives of Kurumba blacksmiths handbuild the large jars in which women store grain in their kitchens. Women may have five to as many as fifteen jars at one time. The jars, including the one depicted here, are often decorated with applied clay patterns, added to the vessel walls before firing. They represent the scars applied to the abdomen of a married woman who has borne a child and are symbols of human and agricultural fertility (Roy 1987: 57). AN

PROVENANCE

William Wright, New York, purchased Ouagadougou, Burkina Faso, 1978 to 1981
Saul Bellow, Chicago, 1981

PUBLICATION HISTORY

Freyer and Lifschitz 1983: back cover
Roy 1987: 58, fig. 23
Robbins and Nooter 1989: 562, fig. 1552

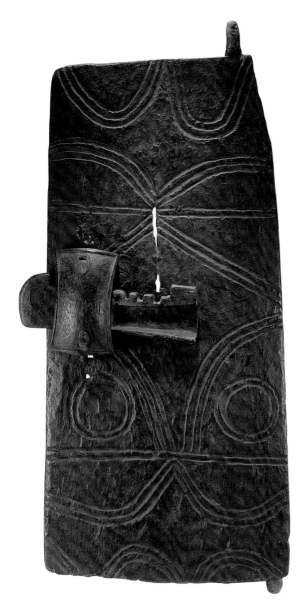

11. DOOR

Possibly Nuna peoples, Burkina Faso
Wood, iron
H. 108.5 cm (42 ¹¹/₁₆ in.)
Museum purchase, 97-14-1

The Nuna are one of the Gurunsi peoples who live in southern Burkina Faso between the Black and Red Volta Rivers. They originally emigrated from northern Ghana to their present location, where they farm, hunt, fish and trade. They live in densely packed villages in which narrow streets and winding alleys separate lineages, and large neighborhoods are composed of several separate clans (Roy 1987: 204–9).

Like other groups in Burkina Faso, the Nuna have highly developed art traditions, including the making of household objects. Nuna artists carve wood doors with locks, such as this example, for their granaries, shrines and homes. The production of these wood doors and locks was once widespread throughout West Africa. Today they are rare, as modern metal hardware and padlocks replace them. Because of its relatively large size, incised geometric designs and well-carved rectangular lock, this door was probably meant for a shrine or a home. Granary doors were much smaller. AN

PROVENANCE

Werner Muensterberger, New York, acquired in Bouaké, Côte d'Ivoire, 1979 or 1980

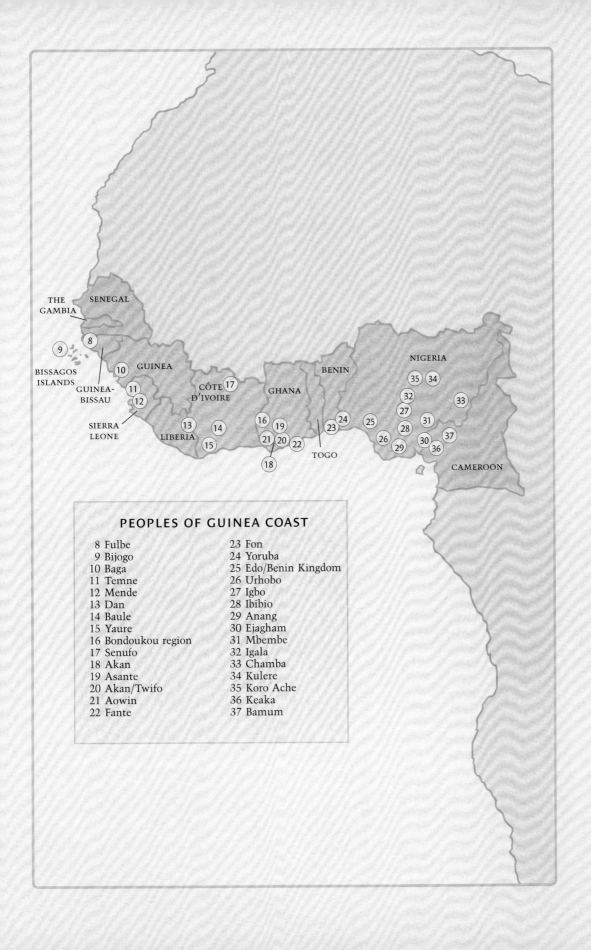

PEOPLES OF GUINEA COAST

8 Fulbe
9 Bijogo
10 Baga
11 Temne
12 Mende
13 Dan
14 Baule
15 Yaure
16 Bondoukou region
17 Senufo
18 Akan
19 Asante
20 Akan/Twifo
21 Aowin
22 Fante
23 Fon
24 Yoruba
25 Edo/Benin Kingdom
26 Urhobo
27 Igbo
28 Ibibio
29 Anang
30 Ejagham
31 Mbembe
32 Igala
33 Chamba
34 Kulere
35 Koro Ache
36 Keaka
37 Bamum

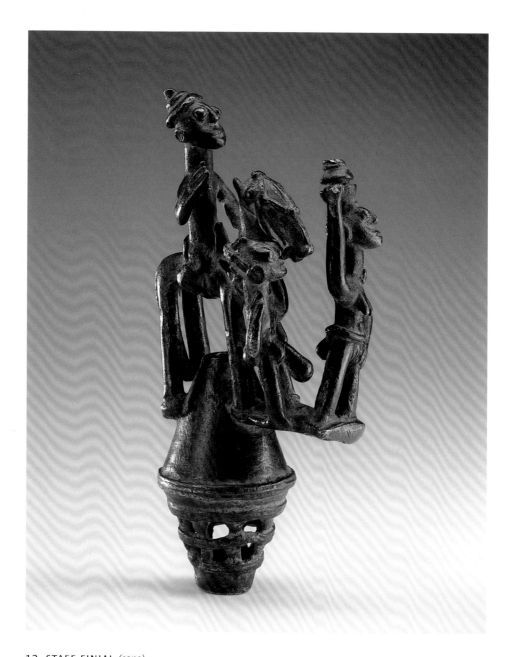

12. STAFF FINIAL *(sono)*

Fulbe, Beafada, Badyaranke or Maninke peoples,
Guinea-Bissau and Guinea
Possibly 17th–19th century
Copper alloy
H. 18.7 cm (7⅜ in.)
Museum purchase, 83-3-12

Iron staffs surmounted by cast brass sculptures have been used as recently as the mid-20th century among a number of peoples in Guinea-Bissau and Guinea. Although their origin and date of manufacture are uncertain, such staffs, called *sono*, may date from the 17th century. Scholars believe the tradition originated with the Mande peoples of the great Mali empire of the 13th to late 16th centuries, offshoots of which migrated into the Guinea-Senegambia region from what is now the country of Mali (Bassani 1979: 47; McNaughton in T. Phillips 1995: 496). While the staffs have historic Islamic leadership links, they also possess non- or pre-Islamic associations. Formed from heat-shaped metals, cast brass atop forged iron, the staffs literally are made of trapped energy, in both local philosophical classifications and universal scientific ones. In some areas, a staff was stuck into a sacred tree to act as a magnet and amplifier of spiritual forces. It could be used in divination before major undertakings such as war (McNaughton in T. Phillips 1995: 497).

The museum's *sono* finial consists of a single horseman and a male attendant preceded by a woman. The figures face forward, moving purposefully as a unit as if toward a predetermined destination. Their progression suggests the journey of a chief's ancestors, those who first took possession of a territory. The woman's sexual attributes call attention to her reproductive and nurturing capacities, as does the food or water container she carries. The depiction of the male attendant, with pronounced genitalia, echoes this theme of sexual potency and implies prowess, thus complementing the woman's social role. He holds the horse's reins with one hand and raises the other in a gesture suggesting greeting or the arrival of a royal presence.

The horse and rider form the thematic center of this sculptural composition. Unlike the other figures, the equestrian wears a cap, drawing attention to his special status as a leader. His right hand, upraised in a gesture paralleling that of the attendant, links him compositionally with the figures before him. His horse is adorned with elements that bespeak special status, including a richly ornamented collar. The horse and rider summarize the attributes of leadership in their central location, elevation and complexity of form, which in turn reflect authority, status and wisdom.

Sono were probably carried by the ruler or a special attendant in processions or special ceremonies; the staff would have been placed before or beside the ruler when seated in state. The ruler would have most often viewed the sculptural group from the rear, symbolically reinforcing the sense that he followed in the footsteps of his ancestors. Subjects standing before the ruler saw him and the *sono* from a perspective that emphasized his ancestral lineage and the rights and powers accruing to it. In sum, the *sono* legitimized, through historic recapitulation, the source of the ruler's power and suggested, symbolically, the strength and continuity of his rule. EL/BMF

PROVENANCE

J. Dierickx, Brussels, before 1979
Michael Oliver, New York, 1983

PUBLICATION HISTORY

Bassani 1979: 46, no. 5
Herbert 1984: 24, fig. 43, cat. no. 79
Robbins and Nooter 1989: 126, no. 195

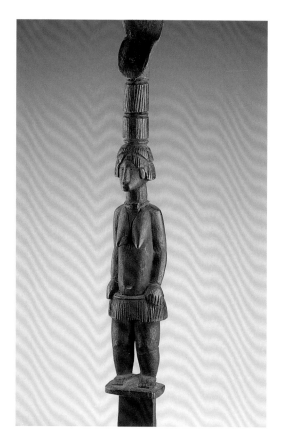

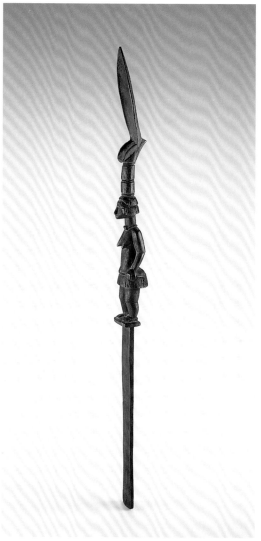

13. SPOON/STIRRER

Bijogo peoples, Bissagos Islands, Guinea-Bissau
Wood
H. 60 cm (23⅜ in.)
Gift of Roy and Sophia Sieber in memory of
Sylvia H. Williams, 96-10-1

The long handle of this spoon/stirrer depicts the full figure of an adult woman wearing a plant fiber skirt. Most spoons carved by Bijogo artists depict only the head and breasts of a woman or a long neck ending at the breasts; the neck itself is usually carved in relief with intricate geometric patterns. Duquette (1979: 34) suggests that the cylindrical form which connects the figure to the spoon represents the large bundles that women (and young boys) carry on their heads.

A spoon such as this is used for serving food during female initiation ceremonies. The carved female figure probably symbolizes the importance of Bijogo women as intermediaries with the spirit world and as procreators of life. The ceremonies, which are carried out over a period of years, initially involve the symbolic possession of a young girl's body by the spirit of a boy who has died before his own initiation was completed. His soul, according to myth, is unable to rest and must wander and suffer. But if he can inhabit the body of a young woman, he can become a powerful and virile being. For her part, the girl becomes a medium and thus fulfills an important religious role for the people. She also has a special relationship to the mother of the deceased boy (Duquette 1979: 32). LP

PROVENANCE

Julius Carlebach, New York, — to 1962
Roy and Sophia Sieber, Bloomington, Ind., 1962 to 1996

PUBLICATION HISTORY

St. Paul Art Center 1963: cat. no. 16
Robbins and Nooter 1989: 138, no. 234
Ravenhill 1997

14. DRUM (a-ndëf)

Sitemu-Baga people, Guinea
Wood, pigment, rawhide
H. 113 cm (44½ in.)
Purchased with funds provided by the
Smithsonian Collections Acquisition Program
and gift of the Annie Laurie Aitken Charitable
Trust, the Frances and Benjamin Benenson
Foundation, David C. Driskell, Evelyn A. J. Hall
Charitable Trust, Mr. and Mrs. Robert Nooter,
Barry and Beverly Pierce, Mr. and Mrs. Edwin
Silver, and Mr. and Mrs. Michael Sonnenreich,
91-1-1

Female power among the Baga is demonstrated
in drums that are carved in the form of a kneel-
ing woman who supports the instrument.
Owned by the women's A-Tëkän organization,
such drums are played by women at annual
initiations, the funerals of association members,
their daughters' weddings, and the reception of
distinguished visitors (Lamp 1996: 122–26).

The beautiful young woman supporting the
drum reflects the female role as "bearer" and of
"bride" in Baga culture. Women carry on their
heads huge clay vessels filled with water and
large baskets of rice. The figure is dressed as a
bride wearing necklaces, armlets and bangles,
crisscrossed cords attached to a chain of metal
bells at her waist, multiple rows of flat waist-
beads, and seed rattles around her ankles. RAW

PROVENANCE

Jacques Boussard, Paris, before 1967 to 1990

PUBLICATION HISTORY

Delange 1967: fig. 28
Musée de l'homme 1967: 78, fig. 79
Hôtel Drouot 1990: front cover, 27, 29, back cover
Lamp 1996: 125, fig. 98

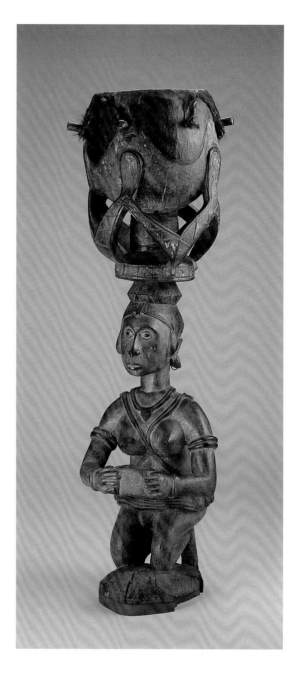

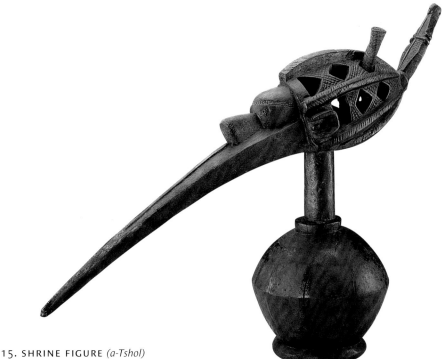

15. SHRINE FIGURE *(a-Tshol)*
Baga peoples, Guinea
Wood, duiker antelope horn, brass tacks
L. 83.3 cm (32¹³/₁₆ in.)
Museum purchase, 93-16-1

The Baga artist who created this sculpture carved the head as a human face with an attenuated birdlike beak on an elongated neck. He pierced the skull with openwork forms into which antelope horns holding medicines might be placed. He carved a projection from the back of the head, inserted brass tacks to represent the pupils of the eyes, and incised elaborate designs into the surface.

Baga art and rituals have been associated with ancestors, various spirits, nature and the cosmos. Inspired by the natural world, Baga artists create complex objects such as this shrine figure known as *a-Tshol*, generally translated as medicine (Lamp 1966: 89). Baga artists do not strictly copy nature, however. The beak of an *a-Tshol* probably echoes that of the long-legged wading birds, possibly pelicans (87), that inhabit the lagoons and marshes where the Baga live. These birds use their beaks as they search for food, an act that may evoke the power of the *a-Tshol* to hunt and punish the enemies of the lineage. Birds, the Baga believe, can also fly between heaven, the world of spirits, and earth, the world of man.

A Baga village traditionally is composed of lineages that are descended from a common ancestor. Each lineage owned an *a-Tshol*, which protected the group from evil. The Baga believed that an enemy with sufficient means can inflict harm. If a person is ill, his or her relatives consult a diviner who locates the cause. At other times, individuals seek help to correct a wrong by approaching the eldest member of their lineage, who addresses the ancestor on their behalf. The ancestor will instruct the *a-Tshol* to punish the culprit.

Tshol are displayed at celebrations for a successful harvest, worn as horizontal headpieces at dances associated with male initiation and appear at funerals. Each *a-Tshol*, the most visible sign of a particular ancestry, incarnates the life of the lineage. When not in use, *Tshol* are kept in shrines sometimes located in the houses of the eldest members of the lineages. The men offer sacrifices to them. As guardians of the lineage, *Tshol* assume a protective role that is reinforced by the presence of horns (reportedly those of a duiker, a type of small antelope) filled with medicines. AN

PROVENANCE
J. J. Klejman, New York
John A. Friede, New York, 1966 to 1977
Donald Morris Gallery, Detroit and New York,
1977 to 1993

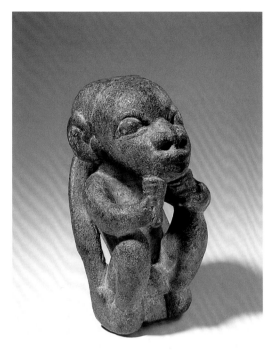

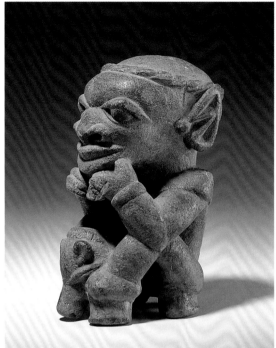

16A. SQUATTING MALE FIGURE WITH CHAIR
(nomoli)

Nomoli style, Sierra Leone and Guinea
Steatite
H. 16.2 cm (6⅜ in.)
Museum purchase, 85-1-2

16B. MALE FIGURE ON QUADRUPED *(nomoli)*

Nomoli style, Sierra Leone and Guinea
Steatite
H. 19 cm (7½ in.)
Museum purchase, 85-1-3

The squatting figure leaning against a tripod chair has a large head with a jutting jaw, bulbous eyes, a broad nose with large nostrils and large C-shaped ears positioned flat against the head (85-1-2). The hands of the figure grasp the two plaits of a beard protruding from either side of the chin, and the figure's legs are pulled up so that his knees touch his arms. At the very top of the head is a deep cavity.

The second figure, similar in style, wears a bracelet and headdress (85-1-3). The latter is a twisted band similar to examples worn by Temne chiefs at their installations (Lamp 1983: 227). The figure rides either an elephant or a leopard. Because neither animal was ridden in West Africa (Lamp 1983: 227; Curnow 1983: II, fig. 31), the relationship between the figure and the animal is probably symbolic. The elephant is a metaphor for the king's strength based on the support of a broad constituency, and the leopard represents the ruler's unbridled power to administer justice, to seize what is naturally his and to protect his people (Lamp 1983: 227; Curnow 1983: II, fig. 31).

Called *nomoli* in Mende, these figures are two among many similar examples that have been found throughout southeastern Sierra Leone and neighboring Guinea (Lamp 1983: 219). Recent scholarship has identified the

makers of the figures as the Sapi, whose present-day linguistic descendants are the Baga, Temne and Bullom (220). Stylistically they are similar to Sapi Portuguese ivory carvings dated to the 15th and 16th centuries. The Sapi tradition of carving stone figures probably dates at least to the 15th century. While no longer made, such figures have been found in the ground and are reused in a variety of ritual contexts by peoples in the area such as the Mende, Bullom and Kono.

The original purpose of such figures is the subject of ongoing debate, but the attributes of other examples and the customs of local inhabitants have caused scholars to speculate that the figures were commemorative, representing the regenerative force of an identifiable, honored ancestor or a recently deceased prominent person (Lamp 1983: 235, 237). For example, the beard on the first figure matches descriptions of beards among present-day inhabitants of the area, and beards often are associated with elderly men who are heads of lineages (224).

A beard distinguishes those in authority and signals that the individual is in control. The tripod chair on which the first figure leans is also significant. Temne and Bullom peoples buried important men seated in chairs (Curnow 1983: 135). AN

PROVENANCE
85-1-2:
Alpha Tiam, Monrovia, Liberia
Emile M. Deletaille, Brussels, before 1974 to 1985

85-1-3:
René Guyot, Monrovia, Liberia, before 1982
Mrs. René Guyot, 1982
Emile M. Deletaille, Brussels, 1982 to 1985

PUBLICATION HISTORY
85-1-2:
Bodrogi 1982: I, no. 24

85-1-3:
Tagliaferri and Hammacher 1974: pls. 9–10
Lamp 1983: 221, fig. 5
Arnoldi and Kreamer 1995: fig. 1.4

17. FEMALE FIGURE

Temne peoples, Sierra Leone
Wood, glass beads, plastic beads
H. 73 cm (28 ¾ in.)
Museum purchase, 94-6-1

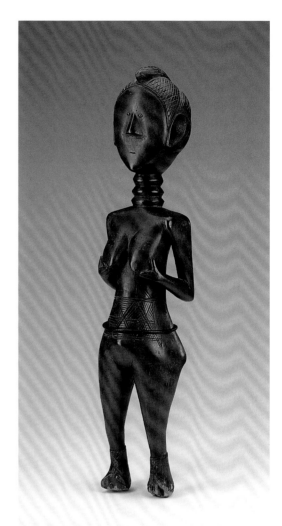

This female figure appears to be by a sculptor whose work is also represented by a figure in the Natal Museum in Pietermaritzburg, South Africa, and two figures in the British Museum, London; all three have early collection dates—1884, 1900 and 1911 (Trowell and Nevermann 1968: 107). Six more figures in this style are found in public and private collections in Europe and America (Gillon 1979: 57; Vogel 1986: 37; Robbins and Nooter 1989: 148). Their early collection histories suggest that the figures were in use in Africa around the turn of the 20th century.

The Temne figures in the British Museum, the Natal Museum and a private collection in California share with this one a very similar interpretation of the female body. Their relative proportions and volumes are alike: heads are emphatically large, necks are long and heavily ringed, breasts are pronounced, backs have expansive curves, buttocks are similarly undercut, and legs taper from large, full thighs to relatively small feet.

On each figure, the ear is interpreted as a rimmed concavity having an inverted teardrop form. The face, sharply delineated by the hairline and the front edge of the ears, is carved as a smooth, rounded form with a triangular nose jutting sharply from its surface. Eyes are formed by either inset glass beads or the red and black seeds of *Abrus precatorius.* The mouth is minimally depicted as a simple inset line. The coiffures, although different in style, reveal a similar attention to detailed tresses and elaborate crests.

The figures may have been used within the women's medicine society called Ang-bon, whose members combined herbal preparations with spiritual aid to cure illnesses (Frederick Lamp 1998: personal communication). Ang-bon figures (or Yassi along the Temne/Mende border to the east), like the Bondo/Sande helmet masks that appear at the female coming-of-age ceremony, reflect local aesthetic notions. For example, the rings on the neck of the figure represent the horizontal creases on Temne women who are considered to be beautiful and healthy. The composed facial features and closed mouth may signify poise and self-control. The abdominal scarification may denote the status of an initiated woman. In its totality, the figure embodies cultural ideas of female beauty and character. PLR/RAW

PROVENANCE

René Guyot, Monrovia, Liberia, c. 1969
Mrs. René Guyot, — to 1986
Private collection, 1986 to 1994
Anthony Slayter-Ralph, Santa Barbara, 1994

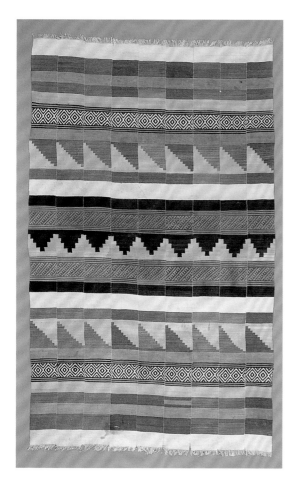

18. TEXTILE (kpokpo)

Mende peoples, Liberia and Sierra Leone
Cotton, indigo dye, kola nut dye
207 × 125.7 cm (81½ × 49½ in.)
National Museum of African Art, National
Museum of Natural History, purchased with
funds provided by the Smithsonian Collections
Acquisition Program, 1983–85, EJ10408

This cloth is a fine example of West African narrow-strip weaving. Nine identically patterned strips, each about five inches wide, are joined to form bands of pattern across the width of the fabric. The textile was woven with two different techniques, a plain weave with twill patterns and a tapestry weave. Both the overall design and the combination of weaves indicate the diffusion of North African weaving traditions to Sierra Leone. This particular type of weft-dominated cloth, known as *kpokpo,* is intended for display as an architectural space divider, furniture covering or as a door.

Narrow-strip weaving is done by men on looms with horizontal beds. In Sierra Leone the primary weaving parts—the treadle, the heddles and the beater—are suspended from a tripod composed of poles. The warp, or lengthwise threads, are fixed to poles stuck in the ground to maintain proper tension. Both the weaver and the tripod move along the threads as the cloth is woven. Unlike cloth woven by women on vertical looms, the narrow strips can be almost any length. The strips are cut to a fixed length and sewn together to create a larger cloth. Because the design is carried by the weft, or crosswise threads, it can be of any desired width.

LP

PROVENANCE
Mr. Stott-Cooper, acquired in Yengema, Sierra Leone, 1930s
Venice and Alastair Lamb, England, c. 1970

PUBLICATION HISTORY
Lamb and Lamb 1975: 35
Lamb and Lamb 1984: 112
Gilfoy 1987: 57

19. MASK *(sowei)*
Mende peoples, Sierra Leone
Wood
H. 36 cm (14 3/16 in.)
Gift of Estera Votaw in memory of Albert Votaw,
98-4-1

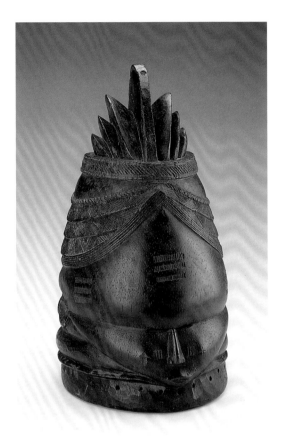

Sowei masks are danced by members of the
Sande women's society in Sierra Leone. All
Mende girls join this society at puberty. *Sowei*
appears in public during the time when young
girls are initiated into adulthood. It may also
emerge at the crowning of a paramount chief or
during the funeral ceremonies of a paramount
chief.

 Sowei masks share specific stylistic features.
Carved in the form of a helmet, they depict a
female head with an elaborate hairstyle and a
ringed neck. All *sowei* are stained black. This
mask exhibits all these elements and in addi-
tion has cicatrization marks on the forehead,
cheeks and temples. Its hairstyle, one popular
at the turn of the 20th century, is divided into
seven graduated ridges, running from front to
back, with the highest rising at the center of
the head.

 An important part of the ritual of Sande
masquerading is the custom of giving personal
names to *sowei* to describe the personality or
dancing style of its performer (R. Phillips 1995:
97). Few names refer to the visual appearance
of the mask. By the 1970s, a large number of
the masks in use by the Sande society were not
commissioned works but had been purchased
from itinerant carvers (114). The practice had
begun decades ago, but was particularly preva-
lent in the 1970s. Mende carvers, by their own
admission, studied and copied images seen in
old masks. This was probably the case with this
mask, which was collected in Liberia in 1968.

LP

PROVENANCE
Albert Votaw, collected in Liberia, 1968

PUBLICATION HISTORY
Museum of African Art 1973: 18
Robbins and Nooter 1989: 151, fig. 269

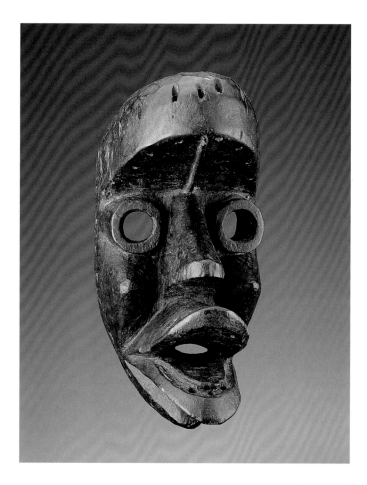

20A. MASK

Dan peoples, northeast Liberia, Guinea and
Côte d'Ivoire
Wood
H. 34.4 cm (13⁹⁄₁₆ in.)
Museum purchase, 97-20-1

20B. MASK

Dan peoples, northeast Liberia, Guinea and
Côte d'Ivoire
Wood, pigment, metal
H. 33 cm (13 in.)
Museum purchase, 85-15-1

The Dan call masks *gle* or *ga* and believe them
to be manifestations of wild forest spirits. These
spirits *(du)* have no form, but when they wish
to use their powers to support mankind, they
manifest themselves in magical objects, large
ritual spoons or masks. Spirits select an indi-
vidual to impersonate them by appearing in his
or her dreams. Only men, however, are selected
to don masks that represent spirits. The spirit
informs the man of the required type of mask,
its name, accoutrements, musical accompani-
ment and dance steps (Fischer 1996: 486–90).

Dan masks range in design from naturalistic
to highly stylized. They represent male and
female humans, male animals or a mixture of
human and animal features. Masks appear in
contexts related to social control, political and
judicial matters, peacemaking, education,
competition and entertainment.

The prominent cantilevered forehead, angu-
lar projecting cheeks, tubular eyes and large
open mouth that once held teeth are attributes

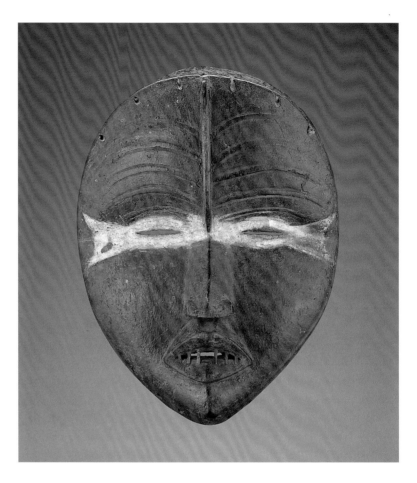

of a fearsome male spirit (97-20-1) (classified *bugle* in Fischer and Himmelheber 1984: 65, fig. 71; *zog* in Harley 1950, pl. XXXV, fig. b). The mask accompanied warriors into battle or supported them by creating a frightening atmosphere in an adversary's village. A feather headdress and a big beard were originally attached to the mask, which was worn with a heavy raffia skirt.

Other masks are associated with boys' coming-of-age ceremonies. Some masquerades instruct; some entertain; and some, possibly the context for the larger mask (97-20-1), solicit food for the initiates.

The Dan commissioned artists to carve masks but not often. Successful old masks were preferred and were employed as long as possible. The identity and contexts of use changed over time. Accordingly, an entertainment mask could become a renowned court justice mask.

RAW

PROVENANCE

97-20-1:
Charles Ratton, Paris
Alfred Scheinberg, New York
Private collection, New York
Donald Morris Gallery, New York

85-15-1:
Rudolph Fuszek, collected in Liberia, 1928
Neprajzi Museum, Budapest, — to 1972
Emile M. Deletaille, Brussels, 1972 to 1985

PUBLICATION HISTORY

97-20-1:
Jacob 1976: 18

85-15-1:
Bodrogi 1982: I, no. 245

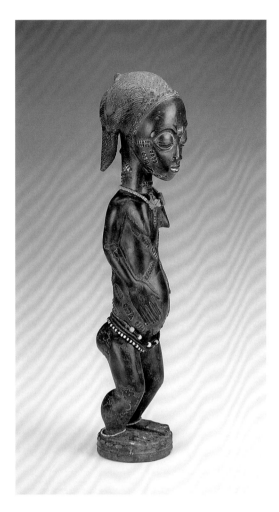

21. FEMALE FIGURE
Baule peoples, Côte d'Ivoire
20th century
Wood, glass beads, gold beads, fiber, white
pigment, encrustation
H. 48.9 cm (19¼ in.)
Museum purchase, 85-15-2

A Baule person would have recognized this figure as a *waka sran*, a "person in wood" (Vogel 1997: 295). For the Baule, every successful sculpted figure necessarily conveys a sense of individuality, as in the approbation *o fa sran!* —"it resembles a person!" Whether carved to represent one's otherworld mate—the "otherworld woman" *(blolo bla)* of a man, or the "otherworld man" *(blolo bian)* of a woman—or a bush-spirit familiar, the sculpted Baule figure is a stand-in interlocutor for an unseen spirit.

A Baule man probably commissioned this female figure as a portrayal of his otherworld woman, following the instructions of a diviner and his revelation that the particular problem the man faced stemmed from the jealousy of his neglected mate in the otherworld. To picture her identity and also to ultimately please her, the sculptor set out to carve a person of beauty as perceived by Baule notions of attractiveness. She is depicted with serenity and composure: her flexed legs, her hands at rest on her abdomen, her downward gaze—all impart a sense of a person who is still, quiet and potentially responsive. Her beauty is revealed in her ample calves, her rounded buttocks, the swelling curve of her abdomen, the fullness and potential of her pelvic circle (accentuated by hip beads), her high breasts, her long elegant neck, and the symmetry and perfection of her facial features. Beauty, for the Baule, is also seen in the depiction of scarification—the raised keloids which give the body a culturally imposed, tactile texture that speaks to her individuality while also evoking that betwixt-and-between status of youthfulness when, free from childhood yet not constrained with the responsibilities of adult status, one explores and enjoys physical maturity.

This figure also bears witness to its former owner. It was he who added the hip beads which would have supported a miniature loincloth. He adorned her with beaded anklets and a necklace embellished with two gold jewels and a piece of precious coral. Her lustrous surface is due to the frequency with which he held her and addressed her on the mornings after the nights set apart for the dream visits from his otherworld mate. The figure concretized his waking dreams and made possible his daytime reveries (Ravenhill 1996). PLR

PROVENANCE
Samir Borro, Côte d'Ivoire, 1974
Emile M. Deletaille, Brussels, 1974 to 1985

PUBLICATION HISTORY
Nebout 1975: 16
Société générale de banque 1977: 40, fig. 11
Ravenhill 1993: fig. 1
Ravenhill 1996: cover, fig. 1

22. LOOM HEDDLE PULLEY

Baule peoples, Côte d'Ivoire
20th century
Wood, iron, fiber
H. 22.5 cm (8⅞ in.)
Purchased with funds provided by the
Smithsonian Collections Acquisition Program,
96-7-1

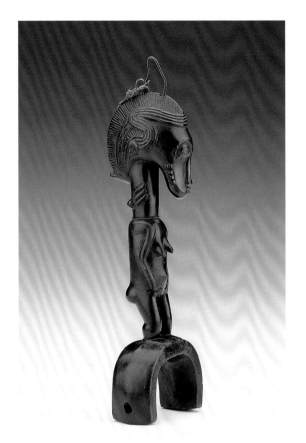

The female figure on this pulley, a *waka sran,*
or "person in wood," is carved with all the
attributes of feminine beauty that accord to
Baule ideals. Even as a miniature, the figure
displays an elaborate coiffure, facial and neck
scarification, hands at rest on the lower abdo-
men, and gracefully rendered buttocks, legs
and calves. Particular attention is given to the
head, for the figure evokes notions of personal-
ity and individuality. The figure originally had
a raffia thread wrapped around the waist and
threaded through the holes behind the hands
(Parke-Bernet Galleries 1966: lot 36). The thread
probably supported a miniature loincloth which
would have conveyed the proper sense of female
social modesty.

The pulley, from which the double heddles
of the men's horizontal loom are suspended, has
provided Baule sculptors with the opportunity
of creating aesthetic tours de force. They most
often depict either human heads or faces or
helmet masks. Pulleys with full figures are
comparatively rare. PLR/RAW

PROVENANCE

Helena Rubinstein, Paris and New York, — to 1966
Private collection, 1966 to 1996
Pace Primitive, New York, 1996

PUBLICATION HISTORY

Parke-Bernet Galleries 1966: lot 36

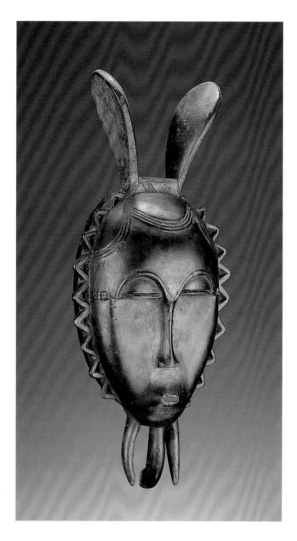

23. MASK
Baule peoples, Côte d'Ivoire
20th century
Wood
H. 36 cm (14 3/16 in.)
Museum purchase, 96-6-3

This mask can be attributed to a Baule artist by the treatment of the face. The eyes with their sharply curved brows are offset by a strong horizontal line that is complemented by scarification on the temple. Subtle asymmetries occur in the surrounding rickrack openwork (Philip Ravenhill 1996: personal communication). Such openwork around the face is considered a distinguishing mark of Yaure masks; it also appears in both Baule and Guro mask forms.

Baule masks creatively blend anthropomorphic and zoomorphic features. The central element is modeled on the human face, but zoomorphic projections are often depicted on the crown of the head and from the chin. Here the elephant's ears project from the top of the head, and its trunk and tusks extend from the chin.

Among the Baule, the elephant is invoked in royal regalia to affirm an immutable "natural" order of power. In masking, to the contrary, elephant imagery is a metaphor for change. In this context another aspect of power is evoked: the power to transform as well as the ability to respond to change (Ravenhill 1992: 126). RAW

PROVENANCE
Ernst Anspach, New York, — to 1996

24. MASKETTE

Baule peoples, Côte d'Ivoire
Gold alloy
H. 8.5 cm (3⅛ in.)
Bequest of Mrs. Robert Woods Bliss, 69-20-1

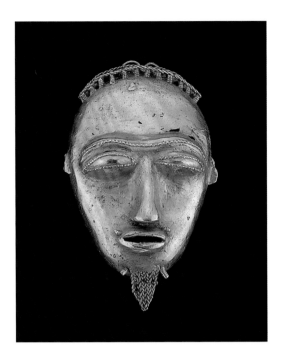

This maskette is a superb example of the skill of a Baule goldsmith. The artist began by artfully modeling beeswax into the likeness of a male Baule elder with a plaited beard. The wax, soft enough to form but hard enough not to be distorted when covered with clay, took the convex shape of the face with its subtle lines and curves. To fashion the hair, the artist made threads by rolling the wax with a paddle on a flat board. He then wrapped the threads into spirals or braided them together before pressing them onto the face. The finished form was first covered in a fine clay slip, then coarser layers were added until the wax finally was embedded within a large lump of dried clay. When the clay was heated, the wax melted and ran out. The "lost wax" left a perfect mold, ready to receive molten gold alloy.

The intended use of the maskette is uncertain. Garrard (1989: 92–94) states that gold pendant heads were popular as hair adornments in the Baule region during the 19th century. Although no longer items of personal adornment, gold ornaments are still used at times to embellish the sculpted coiffure of a Baule face mask. Although attributed to the Baule, this maskette and other forms of jewelry made by Baule smiths could have circulated in the coastal region of Côte d'Ivoire, where gold jewelry was a prized possession of rich families and public exhibitions of acquired gold served to increase one's status. PLR

PROVENANCE
Mrs. Robert Woods Bliss, Washington, D.C., before 1966 to 1969

PUBLICATION HISTORY
Robbins 1966: 91, fig. 85
Smithsonian Institution 1996: 106

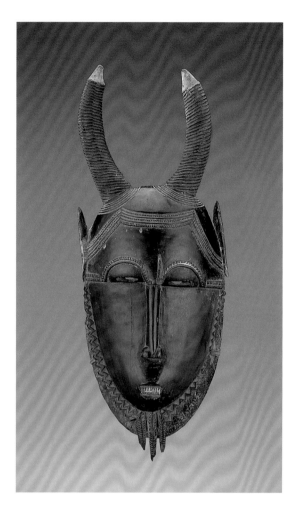

25. MASK

Possibly Yaure peoples, central Côte d'Ivoire
20th century
Wood, pigments
H. 37.5 cm (14¾ in.)
Museum purchase, 91-21-1

The Yaure (also Yohure) are geographically and
linguistically situated between the Baule, an
Akan language group to the east, and the Guro
and Gban (Gagu), southern Mande–speaking
peoples to the west. Depending upon their
proximity to these neighbors, the inhabitants
of Yaure villages are either entirely Baule or
Mande speaking. The style of their masks
reflects artistic borrowings and influences in
the region (Boyer 1993: I, 246). For example,
the characteristic rickrack beard and scalloped
hairline that appear on Baule masks are also
found on masks from both the Baule and Guro.

Masks are the emblems of *yu*, spirit powers,
that have human and animal features. The
human face of this mask is surmounted by
a pair of antelope horns. It was worn in a
celebratory communal theater that was seen
by both men and women. RAW

PROVENANCE

André Blandin, Abidjan, Côte d'Ivoire, 1962–75 to 1991
Lucien Van de Velde, Antwerp, 1991

PUBLICATION HISTORY

[Blandin] 1976: fig. 67

26. FEMALE FIGURE
Bondoukou region, Côte d'Ivoire
20th century
Wood, pigment
H. 42.6 cm (16¹³⁄₁₆ in.)
Gift of Evelyn A. J. Hall and John A. Friede,
85-8-5

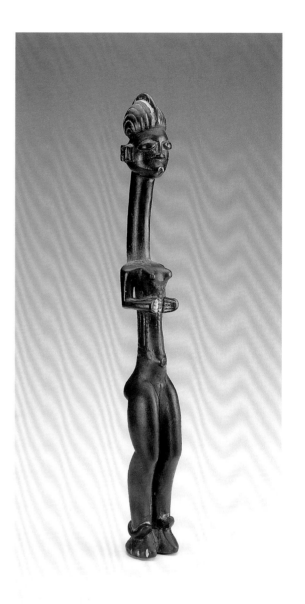

A study in contrasts, this figure opposes naturalism with stylization. The naturalistically rendered head rests on an exceptionally long neck that almost equals the length of the torso. Buttocks, thighs and legs, however, display natural forms and proportions. The wedge-shaped feet are adorned with elliptical anklets. The hands, like the feet, are rudimentary.

The origin of this figure and the context in which it was used are not known. It probably comes from the Bondoukou region near the border of Côte d'Ivoire and Ghana where the Mande, Voltaic and Akan peoples live in an artistic melting pot (Garrard in T. Phillips 1995: cat. no. 5.112; Fagg 1968: fig. 91; *Arman* 1996: fig. 96). Because these people interact closely, it is difficult to attribute art from the region to a specific group. This figure reveals the merging and overlapping of the carving styles of the Western Sudan and the Guinea Coast which is typical of this area. PLR/RAW

PROVENANCE
Henri Kamer, before 1968
John A. Friede, New York, 1968 to 1994

PUBLICATION HISTORY
Robbins and Nooter 1989: fig. 141
Garrard in T. Phillips 1995: cat. no. 5.112

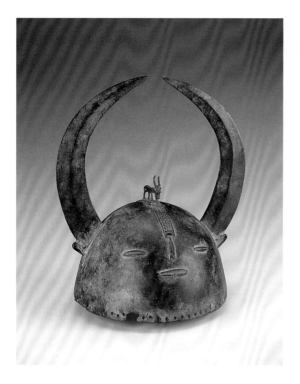

27. HELMET
Possibly Senufo peoples, northern Côte d'Ivoire
Copper alloy
H. 24.8 cm (9 ¾ in.)
Museum purchase, 91-16-1

This cast copper-alloy helmet raises interesting questions for African art history. In the past certain formal resemblances to Senufo helmet masks carved in wood have led to a Senufo attribution. The helmet has to be situated, however, within a larger historical context. On formal grounds, the most compelling comparative works of art are in fact Qajar metal helmets from 18th- and 19th-century Persia. Such an intriguing parallel raises the issue how this helmet might be related to helmets and armor of the Islamic world. Although this connection might seem far-fetched, it must be pointed out that chain mail from Egypt and Persia was still in use at royal courts in northern Nigeria (Bivar 1964: 9, 13). Given how many types of Islamic armor have been found there, it is surprising that no helmets have been seen.

The formal similarities between this helmet and the Qajar helmet type are many: both have the overall shape of a shallow inverted bowl,

vertical horns, a central decorative projection between the horns, narrow oval eyes, a rim pierced with many holes, and plume holders —two of which are found on the back of the museum's helmet. In the Qajar case, the holes in the rim were used to suspend chain mail. It is intriguing to speculate that the loop above the nose on the museum's helmet is a remnant of a similar loop found on Qajar helmets which held a metal nose guard in position to protect the face of the warrior who wore the helmet.

The Reverend Knops (1980: 64), who worked among the Senufo in the 1920s and 1930s, refers to metal combat helmets used during warriors' dances. This helmet shows some affinity to metal face masks in northern Côte d'Ivoire, for which Timothy Garrard (1979: 41) has argued a Mande (Dyula) origin and a date of manufacture between 1770 and 1890. The Mande link and the existence of metal masks in the great trading city of Kong make plausible a connection to patterns of long-distance trade and cultural borrowings that have already been demonstrated by research on the Islamic origins of Akan *kuduo*, or cast brass ritual vessels (Glaze 1981: 36; Sieber 1967; Silverman 1982: 15), and thus the larger connections between the West African savanna, the Sahel region, northeastern Africa and the world of Islam. PLR

PROVENANCE
Lucien Van de Velde, Antwerp, 1967 to 1991

PUBLICATION HISTORY
Jacob 1974: 66
Société générale de banque 1974: 24

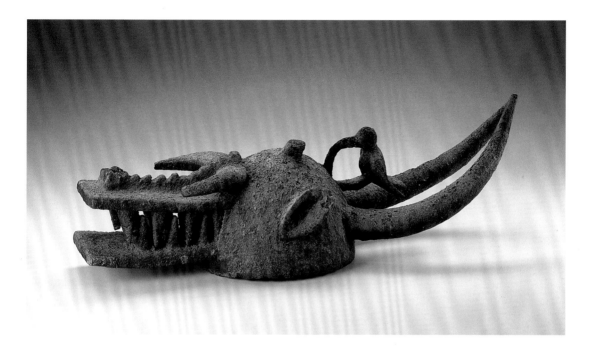

28. MASK

Senufo peoples, Burkina Faso, Côte d'Ivoire
and Mali
Wood, encrustation
W. 59.1 cm (23¼ in.)
Bequest of Samuel Rubin, 79-16-17

Senufo horizontal masks are generally composites of carved animal parts—jaws, teeth, ears and horns. Most frequently seen are the muzzle of the crocodile, the tusks of the warthog and the long horns of the antelope or buffalo, as well as smaller representations of chameleons, birds and snakes. These combinations, often of mythic significance, are intended to impress and terrify. The masks are so powerful that contact with their dancers is believed hazardous and, for women, possibly fatal. They are used in rituals connected with agriculture, initiations and funerals.

This mask is heavily encrusted with clay and other substances, a feature atypical of Senufo masks but resembling the patina found on some masks of the neighboring Bamana of Mali. It does not show signs of wear, however, and may be the double of a mask made for use by a secret society. Richter (1979: 70) reports that in the Poro men's society, a second mask is often commissioned to serve as a replacement for the ritually consecrated one in the event of mishap or theft. The doubles are usually not danced.

The task of deciding which identification is most likely is complicated by the lack of clarity in the literature regarding the origins, nomenclature, influences and characteristics of Senufo masks. The term "Senufo" is applied to nearly one million people, residing in three countries, who do not share a common cultural identity. The area has been the site of trading and migrations for hundreds of years. Furthermore, the use of style characteristics to identify the origin of a work of art often fails to account for variations in expression that may satisfy the creators or their patrons. Therefore we can say with assurance only that this mask is in a Senufo style and hope that further study will reveal more precise information. LP

PROVENANCE

Samuel Rubin, New York, — to 1979

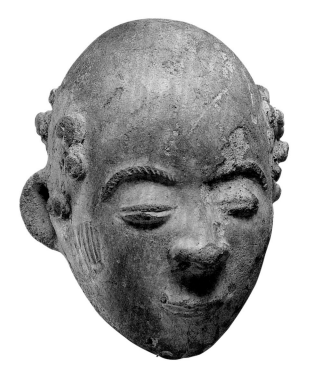

29. COMMEMORATIVE HEAD
Akan peoples, Twifo style, Ghana
Late 17th–early 18th century
Terracotta
H. 22 cm (8 11/16 in.)
Museum purchase, 86-12-4

This terracotta head commemorated a deceased member of a royal family who lived in what is now south central Ghana. Such sculptures, viewed as substitutes for the deceased, were installed at formal funerals, which took place days or months after the actual burial. Although regarded as portraits, they offer only a stylized resemblance to the departed, with some specific aspects such as hairstyle, a beard or pierced ears (Cole and Ross 1977: 125).

Stylistically similar pieces have been found in archaeological contexts at Hemang in southern Ghana, a site that was occupied from before 1690 to about 1730. The broad forehead, the semicircular eyebrows, the closed eyes whose form parallels a small mouth with upper and lower lips of equal size, and the naturalistic nose with open nostrils are characteristic of the Twifo style. The head bears scarification marks at the outer corners of the eyes.

When a royal personage died, a potter would be commissioned by the family to make a commemorative portrait along with sculptures representing family members, associates and servants. The potter would also be asked to make cooking pots and jars. This group of ceramic objects, produced for a special purpose and used only once, probably was assembled within the village where the funeral services were held. The female head or queen mother of another clan would prepare food in the pots. Then the figures, the food and the hearth would be moved to an area called the "place of pots," a spot outside the village reserved for funerary objects. The male head of the clan would taste the food, and the funeral party would return to the village, leaving the food, pots and portraits behind. Research suggests that such funerary practices, in which portrait figures played an important part, existed as early as the 17th century and lasted well into the 20th (Bellis 1982: 30–34). LP

PROVENANCE
Samir Borro, Côte d'Ivoire, — to 1974
Emile M. Deletaille, Brussels, 1974 to 1986

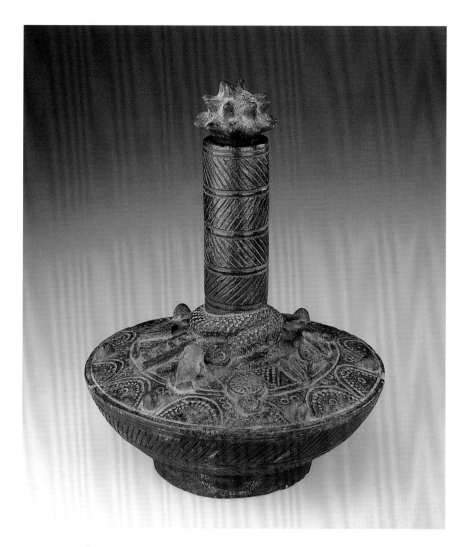

30. VESSEL *(abusua kuruwa)*
Asante peoples, Ghana
20th century
Terracotta
H. 25.4 cm (10 in.)
Gift of Emil Arnold, 69-35-36 A, B

Among the Asante, hand-formed vessels called
abusua kuruwa, meaning "family pot" or "clan
pot," are kept in shrines and special rooms,
where the royal ancestral stools are preserved,
as well as in community cemeteries. The ves-
sels contained the nail and hair clippings of
close relatives of the deceased, water or other
offerings (Rattray 1927: 164–65; Cole and Ross
1977: 119–20).

A prestigious version of an *abusua kuruwa*
is an *abebudie,* or proverb pot, which is elabo-
rately decorated with representational motifs.
An example of the type shown here has a long
neck and multilobed stopper. Motifs modeled
on the vessel visualize proverbs relating to
death. The snake encircling the neck, for ex-
ample, refers to the saying "the rainbow of
death [a python] encircles everyman's neck"
(Sarpong 1974: 21), that is, death is inevitable.
Other motifs include an *oware* gameboard and
an axe the deceased can use on the 40-day jour-
ney to the afterlife (see cat. no. 51). A cacao
pod and an imported pocket watch may indicate
the deceased was a successful farmer. RAW

PROVENANCE
Emil Arnold, New York, — to 1969

PUBLICATION HISTORY
Stössel 1984: 107, fig. 77
Robbins and Nooter 1989: 562

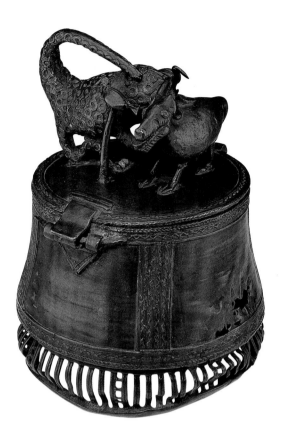

31. CONTAINER (kuduo)

Akan peoples, Ghana
Copper alloy
H. 18.7 cm (7⅜ in.)
Museum purchase, 97-9-1

This container, called *kuduo* in the Twi language, was cast by the lost-wax technique (see cat. no. 24). It is composed of three integrated parts: a pedestal base with open grillwork, a cylindrical body and a hinged lid. The lid is surmounted by a leopard attacking an antelope and two birds that face in opposite directions. The leopard with prey and birds in this stance are associated with royalty and with Akan proverbs. The Twi expression "after the leopard has had its fill, the birds can eat" refers to the power and respect given to a ruler.

Silverman (1983: 183) has persuasively argued that the *kuduo* form derived from containers originally manufactured in Mamluk Egypt in the 14th and 15th centuries. Muslim Dyula traders, who came from the north to exchange goods for gold, brought with them vessels to be used for ritual washings required by Islam. By the 19th century, possibly earlier, the Akan were casting copper alloy containers in a variety of forms. The simplest were open bowls. The more elaborate ones, the *kuduo,* had hinged lids decorated with figural groups.

The British anthropologist Robert Rattray, who investigated Asante life in Ghana in the 1920s, was the first to record the word *kuduo,* and he discussed the context in which these containers functioned in Akan society (1923: 312–15). The vessels, said to have been owned by Asante kings and chiefs as well as by men and women of senior status, held gold dust and precious beads. They were used in religious rites and also revered as shrines, in which sacred objects or sacrificial foods were kept, and placed before the stools of ancestral rulers. According to Rattray, when the owner died, his *kuduo* was buried with him, with gold dust and beads remaining inside. LP

PROVENANCE
Fieret collection, Bordeaux
Hélène and Philippe Leloup, Paris, — to 1997

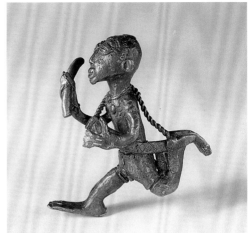

32A. FIGURATIVE WEIGHT *(abrammuo):* PORCUPINE

Akan peoples, Ghana and Côte d'Ivoire
Copper alloy
L. 7.8 cm (3 ¹/₁₆ in.)
Gift of Philip L. Ravenhill in memory of
Sylvia H. Williams, 96-42-3

32B. FIGURATIVE WEIGHT *(abrammuo):* RUNNING MAN

Akan peoples, Ghana and Côte d'Ivoire
Copper alloy
L. 8.8 cm (3 ⁷/₁₆ in.)
Gift of Ernst Anspach, 90-5-1

Although often identified with the Asante, the most numerous and best known of the Akan peoples, weights for measuring gold dust were made and used throughout Ghana and Côte d'Ivoire. For more than five centuries, from about 1400 to 1900, Akan smiths cast weights of immense diversity. Their small size made them portable and easy to trade. Each weight was cast individually in the lost-wax method (see cat. no. 24). What resulted was a unique piece, but one that had to be a specific weight to function. The shape or figure of a weight did not correspond to a set unit of measure: a porcupine in one set could equal an antelope in another, or a geometric form in a third. For important transactions, gold dust was placed on one side of a small, handheld balance scale, a weight on the other. Each party to the dealing verified the amount of gold dust using his or her own weights.

Visually, weights fall into two distinct categories: geometric and figurative. Stylistically they are divided into early (c. 1400–1700) and late (c. 1700–1900) periods. Most early weights are geometric with notched or indented edges, incised surfaces, punch marks and inset copper plugs. Rare early-period figurative weights are relatively simple, with any decoration being large in scale and undetailed (Garrard in T. Phillips 1995: 442–43; Garrard 1980: 294–308). Although geometric weights were made in the late period, figurative weights increased in both number and variety. Generally late-period

figurative weights have added details and textures beyond the basic form that would identify the subject. Both objects selected from the museum's collection are late-period figurative weights.

Some figurative weights evoke well-known Akan proverbs, and more than one proverb may apply. This is perhaps particularly true of animal weights. The weight depicting a porcupine *(kotoko)* relates to a proverb of the Anyi of Côte d'Ivoire in which the porcupine displays greater responsibility than his dependent relative, the hedgehog (Niangoran-Bouah 1987: 202–3). The porcupine is cast in the role of the senior, powerful character because of its quills. Its many quills were also taken as a symbol of the Asante kingdom and its large, well-equipped army, as demonstrated in the sayings "*Asante kotoko* kill thousands and thousands more will come," an expression relating to the size and courage of the army (McLeod 1981: 10), or "who dares to attack the porcupine which has so many spikes" (Menzel 1968: 198, no. 772). Other images of military power depicted in weights included shields, swords, guns, cartridge belts, trumpets with human jaw bones and warriors themselves on foot or horseback (McLeod 1981: 127).

The male figure is unusual because of his running pose. Although weights show some activities, most figures are frozen onto a rectangular base. The blade of the sword in the man's hand appears shortened by wear or perhaps was corrected to achieve the required weight. The style of the scabbard, leather with circular attachments and streamers, is more northern Islamic or Mande than southern Akan (as is the amulet around the neck). Given the context just described for the porcupine, it is tempting to read the man's rapid pace as a retreat from the large Asante army. The figure may be entirely symbolic, however, in the same manner as images of a mounted warrior, who, while shown in weights and other objects, was not a part of the armies in the forested south. The running man with a northern sword might also be a representation of non-Akan military prowess that has been adopted into the service of Akan power symbolism.

Most weights, however, are not commissioned to make a point or tell a story. They are not usually sent as messages, with the exception of an occasion on which an Asante king once dispatched a large weight in the form of a porcupine to indicate the size of a fine owed by a guilty individual (McLeod 1987: 295). Weights may act as display pieces implying wealth in both the size of individual weights and the number owned. This is reinforced by the presence of pseudoweights, objects that do not meet weight requirements but are appealing in appearance (such as tax seals and bits of European metalwork such as drawer pulls). BMF

PROVENANCE

96-42-3:
Philip L. Ravenhill, collected in Côte d'Ivoire, 1976–82 to 1996

90-5-1:
Jay C. Leff, Uniontown, Pa., before 1959
Merton Simpson, New York, 1971
Ernst Anspach, New York, 1971 to 1990

PUBLICATION HISTORY

96-42-3:
Geary and Nicolls 1992: 14

90-5-1:
Carnegie Institute 1959: 45, no. 265
Carnegie Institute 1969: no. 126

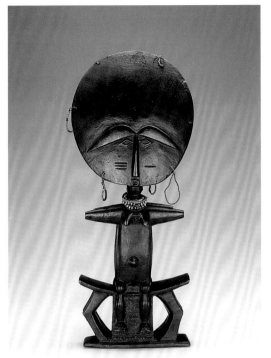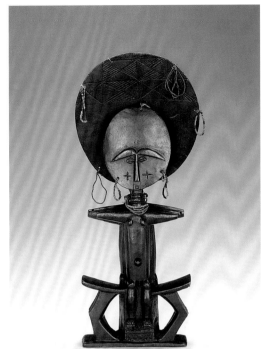

33. SEATED DOUBLE FIGURE *(akua-ba)*
Asante peoples, Ghana
Wood, glass beads, fiber, metal
H. 37.5 cm (14¾ in.)
Acquisition grant from the James Smithson
Society and museum purchase, 87-4-1

Asante *akua-ba* figures are typologically of two
kinds: those with cylindrical bodies with arms
thrust out horizontally, and those with more
naturalistic bodies. Both types display large,
circular, thin, flat heads.

This *akua-ba* figure, carved from a single
block of wood, is consistent with the second
type. It is rare because it is a double image. Its
two figures, one large and one small, sit back to
back on a rectangular stool. This unusual form
is known only in a few examples. Both figures
are female, as are most *akua-ba* (Cole and Ross
1977: 107).

The oversized head of the larger figure is the
dominant feature. It is flat, discoid and tilted
slightly back on a ringed neck. The back of the
head has incised lines arranged in symmetrical
decorative patterns of varying complexity that
may represent a hairstyle. The facial features
are delicately carved with raised arched eye-
brows, which meet at the bridge of the nose.

The eyes are diamond-shaped. The body and
features of the smaller figure are similar.

Akua-ba with a single figure are carved for
women and girls, who care for them and often
carry the figures on their backs inside their
wrappers. It is believed that the figure ensures
fertility and, if the woman is pregnant, the
health and beauty of an unborn child (Cole
and Ross 1977: 104). In the matrilineal Asante
society, descent is reckoned principally from
mothers to children. It is therefore crucial
that women bear females, who will continue
their line. AN

PROVENANCE
M. René Lavigne, Geneva, 1950s
Mme. Alfonseca-Bursztejn (Mme. René Lavigne),
Geneva, 1981 to 1987

PUBLICATION HISTORY
Musée des Beaux-Arts–La Chaux-de-Fonds 1971: fig. 202
Lehuard 1973: 7, figs. 3–4
Musée d'ethnographie 1973: 28–29, figs. 20–21
Cole and Ross 1977: 108, fig. 217
Smithsonian Institution 1996: 163

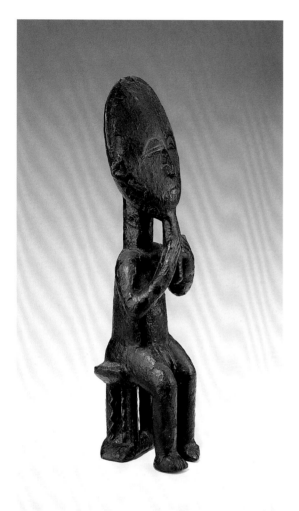

34. SEATED MALE FIGURE
Akan peoples, Ghana or Côte d'Ivoire
Wood, encrustation
H. 35.6 cm (14 in.)
Purchased with funds from the Annie Laurie
Aitken Endowment, 96-6-2

This rare, visually compelling seated figure
raises significant questions about stylistic
boundaries in African art. It frustrates attempts
to neatly delimit the artistic styles of Ghana
and Côte d'Ivoire. The beard and seated pose
are widely recognized African emblems of
elderhood and status. Several neighboring Akan
peoples create terracotta funerary sculptures
with relatively flattened heads with high fore-
heads. This form is also like that of an Asante
akua-ba, the well-known figure that promotes
the birth of a healthy, beautiful child (see cat.
no. 33). The holes along the top edge of the head
are found on some *akua-ma* as attachment
points for beads. The gesture of hands holding
the beard, however, is a gesture more typical for
Baule wood figures (Cole and Ross 1977: 113).
The thickly encrusted surface suggests that the
figure was placed in a shrine dedicated to a deity
and that the object was used for some time,
although it probably dates to the 20th century.

BMF

PROVENANCE
J. J. Klejman, New York, 1966
Ernst Anspach, New York, 1966 to 1996

PUBLICATION HISTORY
Museum of Primitive Art 1967: 23
Preston 1969: 34, no. 44
Cole and Ross 1977: 113, 116, fig. 241

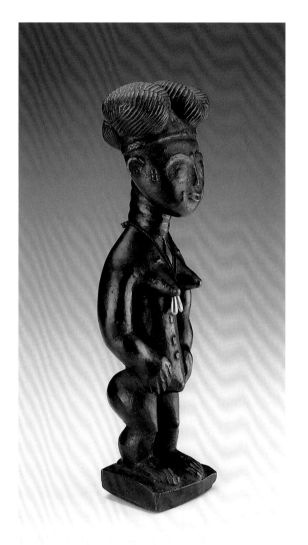

35. FEMALE FIGURE

Aowin peoples, Ghana
Wood, gold alloy, fiber, pigment
H. 38 cm (14¹⁵/₁₆ in.)
Gift of Ernst Anspach, 96-38-1

This female figure was acquired before 1926 in
what was then the western Gold Coast by Lieu-
tenant Commander Scofield of the British Royal
Navy (Ernst Anspach 1997: personal communi-
cation). Its general characteristics are typical
of figural sculpture from this region of West
Africa. The figure is similar to the museum's
Baule figure (cat. no. 21). Both display a confi-
dent standing pose with the hands firmly set
on the abdomen. Both figures are adorned with
elaborate, detailed coiffures, scarification pat-
terns on the face and torso, and necklaces with
gold pendants. While this figure has been desig-
nated as Aowin, it may have been created by
a carver from another area or imported to the
Aowin region (Cole and Ross 1977: 113).

The precise function of this figure is un-
known. Like figural sculpture produced by the
Baule, it may have formed part of a shrine con-
text where it functioned to focus and control
spirit forces. BMF

PROVENANCE

Lieutenant Commander Scofield, Ghana, 1926
J. J. Klejman, New York, 1964
Ernst Anspach, New York, 1964 to 1996

PUBLICATION HISTORY

Museum of Primitive Art 1967: 30
Cole and Ross 1977: fig. 235
Anderson and Kreamer 1989: 85, pl. 7

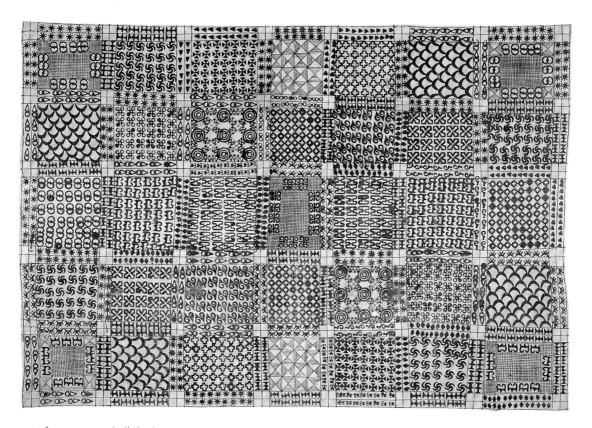

36. WRAPPER *(adinkra)*
Asante peoples, Ghana
c. 1896
Imported cotton cloth, black pigment
210.8 × 302.3 cm (83¹⁄₁₆ × 119⅛ in.)
Museum purchase, 83-3-8

Historically Asante royalty wore *adinkra,* large wrappers with stamped patterns, only during periods of mourning. Though still worn in times of grief, *adinkra* cloths recently have become increasingly fashionable at social festivities and nonfuneral functions (Mato 1987: vi).

The artist produced the pattern on this *adinkra* by first drawing the border and cross lines with a tool resembling a comb, creating a grid of rectangular fields. In each rectangle and along the borders of the grid, the artist stamped a single symbol or group of symbols associated with royalty, leadership and government. Stamps were made of dried calabash, cut and shaped to produce the desired symbol.

The central block of this *adinkra* contains a double curve representing a ram's horn and symbolizing leadership and royalty. Other symbols associated with royalty are three concentric circles, signifying the eternal nature of Asante kingship; eagle's talons, representing the coiffure of the queen's attendant; and the double *dono* drum played during royal processions. Government and leadership are represented by two versions of the two-storied house or the king's castle, two versions of a chain alluding to prisoners of war and slavery, and an executioner's knife, a symbol of justice.

More than 150 distinct design symbols used in *adinkra* cloths have been identified, although with recent innovations, there may be as many as 300. The earliest wrappers utilized only nine stamped symbols (Cole and Ross 1977: 45); some of these are still in use today. Nearly every symbol is a close visual expression of its name.

The term *adinkra* means "to employ or make use of" or "a message." It also connotes separation or leave taking (Mato 1987: 107). This cloth was worn by Asantehene Agyeman Prempeh I on the day the British deposed him in January 1896. Prempeh had successfully resisted British demands to relinquish Asante sovereignty for several years, but his alliance with Samory Touré, a dynamic Muslim warrior who had conquered large regions of Ghana, Côte d'Ivoire, Liberia and Sierra Leone, led to punitive action by the British. Prempeh and his followers were arrested and exiled for 28 years, first to Sierra Leone and then to the Seychelles. Prempeh returned to Ghana in 1924 and ruled as chief of the capital city of Kumasi until his death in 1931. Throughout this period, the Asante peoples recognized him as their Asantehene (sovereign). LP

PROVENANCE

Asantehene Agyeman Prempeh I, 1896
W. Nicholson, Englishman of Bradford and Lagos, acquired wrapper from Prempeh (while Prempeh was in captivity in Sierra Leone), 1897
James Freeman, Kyoto, 1983

PUBLICATION HISTORY

Fortune 1997

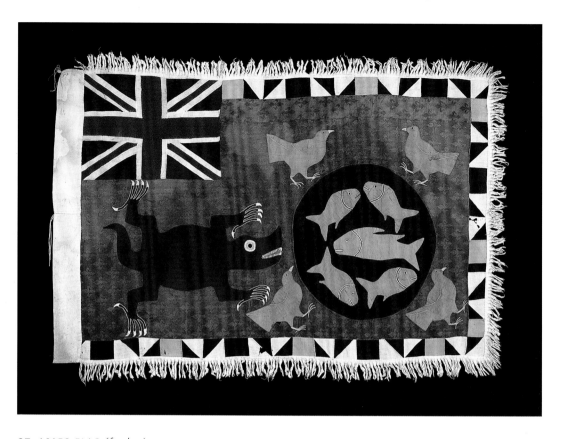

37. ASAFO FLAG *(frankaa)*
Artist: Kweku Kakanu (born c. 1910)
Fante peoples, Ghana
c. 1935
Commercial cotton cloth
108 × 152.4 cm (42½ × 60¹/₁₆ in.)
Museum purchase, 88-10-1

This colorful flag *(frankaa)* is a wonderful example of one of the most exciting areas of Fante art. It is the emblem of a Fante Asafo company. One of the most influential of all Akan institutions, Asafo is a military organization that may have existed in some form as early as the late 1400s (Ross 1979: 3; Datta and Porter 1971: 288, 293). Asafo companies play an important role in the political process by balancing the power of paramount chiefs. Asafo members also take part in ceremonies when a new chief is installed.

Asafo is most highly developed among the Fante. A Fante town may have from 2 to 14 companies. Each company has its own name, number, regalia and shrine. A company is led by a senior commander, captains of subdivisions and various other officials, including linguists, flag bearers, priests and priestesses. This flag belonged to an Asafo company in Mankesim,
capital of Fanteland (Doran Ross 1992: personal communication).

The flag is made from commercially produced trade cloth with a fleur-de-lis background design. Its appliqué figures were copied from paper patterns; each figure is two-sided. The British Union Jack in the upper left indicates that the flag was made before Ghanaian independence in 1957. Asafo flags after this date display the Ghanaian flag.

The crocodile represents the Asafo company that owned the flag. The round pond may evoke water deities associated with ponds, streams and rivers for whom the Asafo company acts as protector. An alternative interpretation focuses on the fish in the pond. They may represent rival companies and allude to the Fante proverb "Fish grow fat for the benefit of the crocodile." The meaning of the birds is unknown. AN

PROVENANCE
Damon Brandt, New York, 1988

PUBLICATION HISTORY
Fiberarts 1990: 27
Geary and Nicolls 1992: front cover

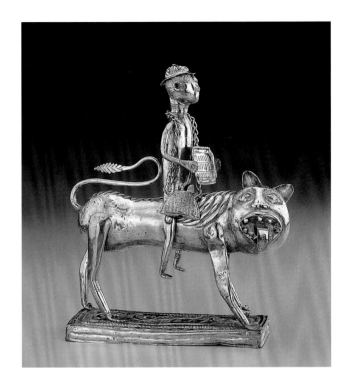

38. MALE FIGURE ASTRIDE A LION

Fon peoples, Porto Novo, Benin
c. 1913–17
Silver
H. 19 cm (7½ in.)
Museum purchase, 95-9-1

The Fon peoples of the former Kingdom of
Dahomey (modern Republic of Benin) built
an empire controlled by an absolute monarch.
They developed rich oral and visual art tradi-
tions, with major art objects commissioned by
royalty. European travelers have cited the fash-
ioning of prestige works in metal by Fon crafts-
men since the 18th century (Bay 1987: 12).

This silver figure of a man riding a lion is an
elegant example of Fon metalwork and displays
conventions associated with the finest Fon art.
The threatening lion with its outstretched
tongue, curled tail and turned head is similar to
depictions on Fon altars *(asen),* bas reliefs and
appliqué banners (Mercier and Lombard 1959:
figs. 12, 17; Bay 1985: 44, cat. no. 30; Herskovits
1938: II, pl. 83a). The elongated forms and ani-
mated, naturalistic poses of the figures are char-
acteristic of Fon work. The use of sheet, rather
than cast, metal follows older Fon conventions
(Visonà 1978: 46–47).

The figure represents Oudji, "king" of Porto
Novo, who reigned from 1913 to 1929 and was a
grandson of King Toffa (reigned 1874–1908).
In fact, Oudji was called a paramount chief
because the French colonial administration
had abolished the traditional title of king after
Toffa's death (Akindélé 1953: 5; Brasseur-
Marion and Brasseur 1953: 30). Oudji holds a
plate engraved with his own name and that of
Charles Noufflard, French governor of Dahomey
from c. 1912–13 to c. 1917–19 (Decalo 1995:
257; Blandin 1988: 283). The figure was almost
certainly commissioned by Oudji himself as a
gift to Noufflard. Oudji's power to rule is ex-
pressed metaphorically by his mount, the king
of the beasts the lion. In Dahomean art, the
lion is also the personal symbol of King Glele
(reigned 1858–89). According to historical rec-
ords, Oudji's grandfather, King Toffa, in part
owed his rise to power to Glele (Decalo 1995:
347). As king, Oudji controlled his kingdom's
wealth, represented by the purse hanging at
his side. AN

PROVENANCE

Charles Noufflard, c. 1913–17 to 1966
Hélène and Philippe Leloup, New York, — to 1995

PUBLICATION HISTORY

Hôtel Drouot 1966: pl. II, no. 60
Blandin 1988: 283
Cole 1989: 154, fig. 182

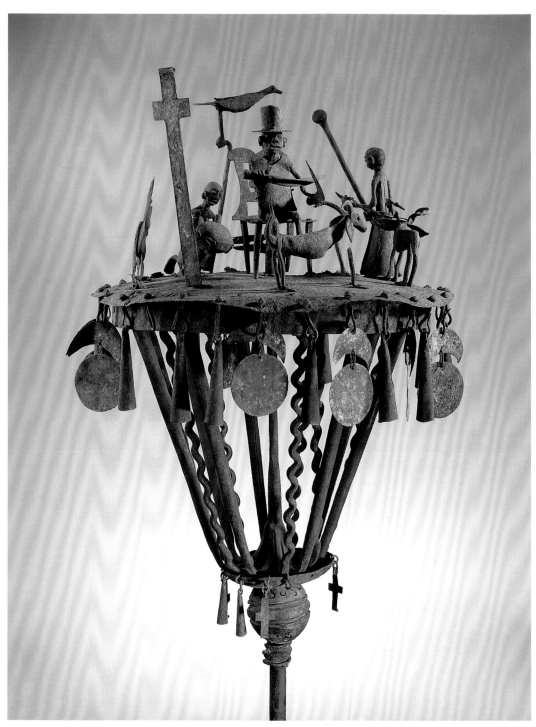

Detail

39. ALTAR *(asen)*
Fon peoples, Ouidah, Republic of Benin
Iron, wood, paint traces
H. 113 cm (44½ in.)
Gift of Monique and Jean Paul Barbier-Mueller,
93-2-2

Fon artists create altars or memorial sculptures known as *asen*. In the coastal city of Ouidah, craftsmen developed a distinctive local style. Their works feature forged and cut-out iron figures riveted to a large iron disk set atop a cone of alternating serpentine and cylindrical iron support rods. Ouidah *asen* tend to be larger and more complex in design and iconography than the brass and sheet metal ones from other Fon centers. This is often attributed to the rich and turbulent history of Ouidah as a place where inland and coastal African cultures interacted with European and Afro-Brazilian ones.

Each *asen* bears imagery that refers to a particular ancestor's occupation, religious beliefs and family heritage. The representational choices are analogous to an inscription on a tombstone (Bay 1985: 11) or a newspaper obituary caption—"beloved husband and father" or "longtime area resident" or "noted author." *Asen* are more difficult to interpret, however, since the individual details refer to proverbs and personal names, often using puns. The Fon themselves say that the only people who can fully read the symbols of an *asen* are its maker and the donor who commissioned it (9).

The central figure refers to the deceased; his attire and seated pose suggest high status and authority. His swords could refer to his occupation or to a particular affinity with the god of iron, Gun. The other human figures would be his family, those who commissioned the *asen*.

The animals that appear on *asen* may refer to sacrifices, family lineage or proverbs. The goats shown following the man with a staff represent an offering. A flat cutout of a bull on this *asen*

(but not visible in this photograph) may connect the family with King Gezo of Dahomey who reigned from 1818 to 1858 (Suzanne Blier 1994: personal communication). His emblem was a bull, and Gezo's ascension to the throne was particularly linked to events and individuals from Ouidah. The bird perched on a millet stalk probably refers to the proverb "If only one bird remains, he will find a field of millet and eat," meaning that even if an individual is survived by only one child, he or she will honor the parent and presumably pay for a suitable *asen* (Bay 1985: 21).

While many Fon are Christian today, the cross on the *asen* is usually intended as a symbol of Mawu, the female half of the creator couple. Rather than having a following of worshipers, she is commonly invoked in solicitations rather like the English-language expression "such and such will happen, God willing."

Although the name of the individual commemorated is now lost, a general sense of his identity and his value to his family and community can be felt. Similarly the name of the professional artist commissioned to create this work is not known, but his consummate skill can be recognized in this complex and impressive *asen*. BMF

PROVENANCE
Private collection, France, before 1975
Jean Paul Barbier and Monique Barbier-Mueller, Geneva, 1975 to 1993

PUBLICATION HISTORY
Freyer 1993

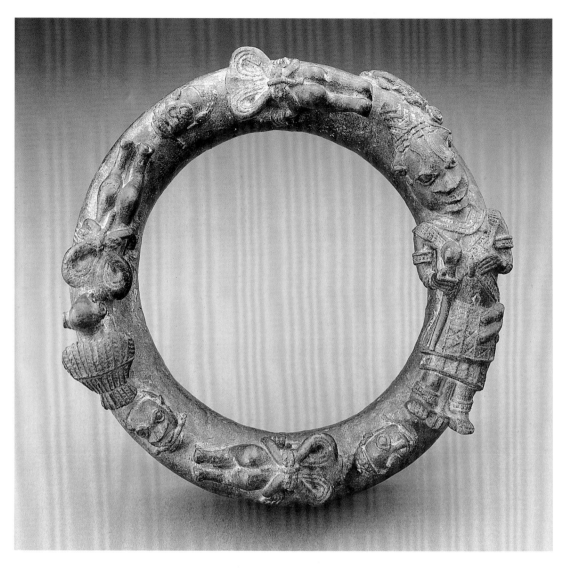

40. RING

Yoruba peoples, possibly Ijebu region, Nigeria
15th–19th century
Copper alloy
Diam. 19 cm (7½ in.)
Museum purchase, 89-17-1

This ring, cast by the lost-wax process (see cat. no. 24) and weighing nearly eight pounds, is embellished with images in relief. Most prominent is a human figure dressed in full regalia and with opposed crescent-form scarification on the forehead. Three nude human bodies, bound at the elbows and lying on their stomachs, are depicted with their severed and rope-gagged heads turned in opposition to the bodies. A bird modeled in full relief pecks at the neck of the body placed directly opposite the major figure. On the outer side of the ring (but not visible in the photograph) are a tortoise and a pair of looped pins joined by a cord. This imagery is repeated with variations on the other rings in the corpus of 10 known examples.

The figures can be identified and interpreted by reference to Yoruba oral traditions, religious beliefs and kingship rituals. The decapitated bodies are sacrificial victims. In the distant past, the Yoruba practiced human sacrifice on occasions of great importance to the entire community such as festivals honoring Ogun, the god of iron, or rites connected with the crowning of a new king. The victims were gagged to prevent them from cursing the priests who executed them. The bird is a vulture, which in Yoruba cosmology is a messenger of the gods charged with carrying sacrifices to them. Thus the presence of vultures on the ring indicates that the sacrifice was acceptable to the god (Awolalu 1979: 168; Idowu 1962: 51, 119).

The prominent figure represents an individual of elevated status as indicated by the elaborate regalia: a conical crown or headdress with raised V-shaped motifs; the necklaces, crossed baldrics, armlets and bangles; a scepter or staff carried in the right hand; and the two-tiered wrapper made of textured material. The scarification on the figure's forehead is like that found only in connection with the Oshugbo association of the Ijebu-Yoruba kingdom (now a town in southwestern Nigeria). The pattern is seen on male and female association members and on Oshugbo paraphernalia. That the figure may relate to the Oshugbo association seems to be supported by the looped pins on the outer edge of the ring which resemble Oshugbo ritual objects. The figure's gender is ambiguous; the protrusions at either side of the crossed baldrics may represent feminine breasts or masculine pectorals.

Under what conditions could the imagery of human sacrifice, death (represented by a tortoise), the Oshugbo society, and royalty or high status appear in the same composition? Susan Vogel (1983: 350) has suggested that the iconography of the rings symbolizes the successful transfer of rule in satellite Yoruba kingdoms. Following a new king's installation, a cast metal ring would have been sent to the paramount Yoruba king, the Oni, at the ancient capital of Ile-Ife, as proof that the prescribed rituals, including human sacrifice, had been accomplished.

Frank Willett (in T. Phillips 1995: 428) has observed that the headdress on the prominent figure is unlike those used in depictions of Ife royalty from the Classical period (14th to 15th century), suggesting that the ring may date from a later period or that it was not made at Ile-Ife. The figure wearing the headdress may represent a newly crowned *oba* or queen, or a female representative of the Oshugbo society, each of whom played an important role in Yoruba kingship rituals.

Cast copper-alloy rings with high relief decoration reportedly were found in an undocumented excavation at Ile-Ife, Nigeria (Vogel 1983: 350). When the rings were cast is not known; however, their greenish patination suggests they may have been buried.

It is possible that the ring in the museum's collection was made to commemorate the installation of a king in a satellite Yoruba kingdom. Alternatively, it may have been part of a satellite kingdom's treasury or belonged to the Oshugbo society. RAW

PROVENANCE

K. John Hewett, London, c. 1970 to 1975
F. Rolin & Co., New York, 1975 to 1983
Steve Kossak, New York, 1983 to 1986
Entwistle, London, 1986

PUBLICATION HISTORY

Rolin 1977: 30
Lehuard 1992: 25–26
Vogel 1983: 334, fig. 4
Willett in T. Phillips 1995: 428

41. PALACE DOOR (ilekun aafin)

Artist: Olowe of Ise (c. 1875–c. 1938)
Yoruba peoples, Nigeria
c. 1904–10
Wood, traces of pigment
H. 221.3 cm (87³⁄₁₆ in.)
Gift of Dr. and Mrs. Robert Kuhn, 88-13-1

Olowe of Ise is considered by many art historians and art collectors to be the most important Yoruba artist of the 20th century. Active in the first quarter of the century, he designed and carved architectural sculptures for several palaces in the Ekiti region of Yorubaland. His work first became known in Europe when an elaborately carved and painted door and lintel ensemble he had created for the palace of the Ogoga (king) of Ikere was displayed at the 1924 British Empire Exhibition in London. Considered by experts in the British Museum to be "the finest piece of West African carving that has ever reached England" the door and its lintel were acquired for that museum's collection in exchange for a British-made throne (Lawrence 1924: 1214; Fagg 1969: 55).

Olowe's innovative approach to carving the palace doors stands apart from Yoruba low relief work, which typically is flat and even. Olowe, however, carved in exceedingly high and uneven relief. The figures on this panel, the right side of a door, project in profile from the background by as much as 10 centimeters (approximately 4 inches), and the upper bodies of some figures are carved completely in the round. Instead of using static, frontal poses, Olowe turned the heads of the figures in opposition to their bodies to face the viewer. He crossed their legs to suggest walking or dancing motions.

The panel shown here commemorates an actual event. At the end of the 19th century the Arinjale (king) of Ise received the first British traveling commissioners for the Ondo Province (Allison 1952: 100–15). The left side of the door (in a private collection) depicts Major W. R. Reeve-Tucker, the first traveling commissioner, and Captain W. G. Ambrose, his successor, and their entourage of African porters, soldiers, prisoners and British missionaries.

This right panel depicts the Yoruba king and his entourage. The Arinjale, who is mounted on a horse and wears a conical crown surmounted by a bird, is seen in the second register. He is accompanied by a court messenger and a musician. Royal wives and children, guards, priests and others from the palace appear in successive registers. The decapitated female figure in the lowest register is a human sacrifice, an act committed on the rarest occasions to insure the survival of the community. Originally three vultures pecked at the female's eyes, abdomen and feet; now only the feet of the birds remain. The faces carved on two columns along the length of the door may represent war captives or royal ancestors.

Olowe carved the palace door from *iroko*, an iron-hard wood highly valued in his time and still used in modern building construction and furniture making. No photograph of Olowe has been located, but his *oriki*, or chanted attributes, claims that he was handsome and so strong that he could carve *iroko* wood "as though it were as soft as a calabash" (Pemberton in Drewal and Pemberton with Abiodun 1989: 206)

RAW

PROVENANCE
Dr. and Mrs. Robert H. Kuhn, Los Angeles, c. 1972 to 1988

PUBLICATION HISTORY
Walker 1994: 90–106
Walker 1998: 17, fig. 3; 42–45, cat. no. 4

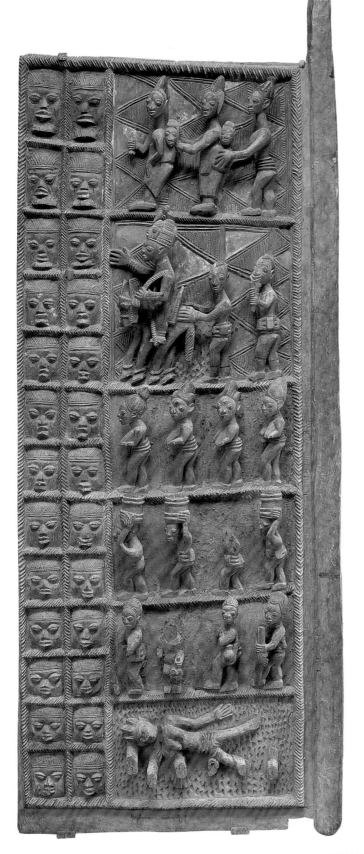

Detail

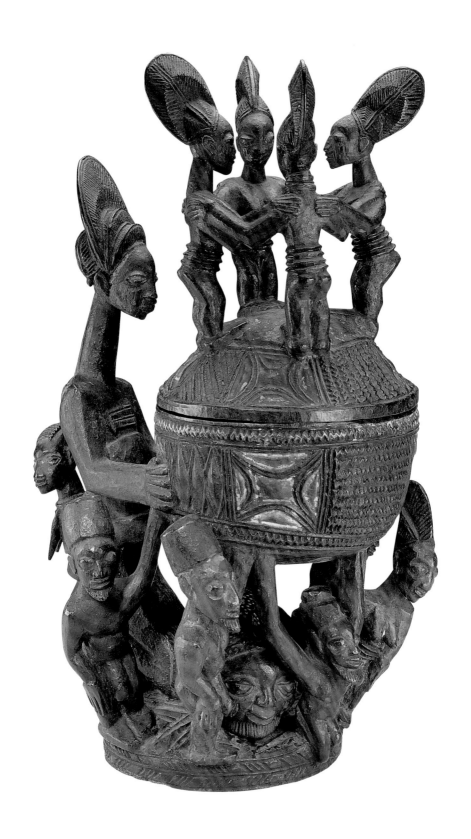

42. BOWL WITH FIGURES

Artist: Olowe of Ise (c. 1875–c. 1938)
Yoruba peoples, Nigeria
c. 1925
Wood, pigments
H. 63.7 cm (25⅛ in.)
Bequest of William A. McCarty-Cooper, 95-10-1

Olowe of Ise was born about 1875 in Efon-Alaiye, a town in eastern Yorubaland that was once a kingdom and one of the most important centers of Yoruba carving. Olowe moved to Ise at a young age to serve the Arinjale (king) as a court messenger (Allison 1944: 49). The details of his early life and training in sculpture are not known. His descendants claim he was self-taught, but it is likely that he learned the Yoruba canon and perfected his carving skills during an apprenticeship (Olowe family 1995: personal communication). Eventually he became a master artist at the Arinjale's palace, and as his fame grew, other Yoruba kings and wealthy families commissioned him to carve architectural sculptures, masks, drums and other objects for their palaces.

Olowe probably carved this lidded bowl with figures for a king or other person of high social status or for a shrine. Among the Yoruba such elaborately carved and decorated bowls were prestige objects used to offer kola nuts to guests or to deities during religious worship.

That Olowe was an innovative and virtuosic, even daring, artist is demonstrated in this sculpture. The image of four dancing girls on the lid, for example, is the first such representation in Yoruba art. Olowe's choice of dancers raises questions about his inspiration. Had he seen a picture of the Three Graces of ancient Greece or, as reproduced in *Notre colonie: Le Congo Belge* (1909: 55), a photograph of grass-skirted females similarly posed in a circle? Olowe also depicted nude males, one of whom is kneeling, on this bowl. Such renderings are exceptional and challenge the Yoruba canon. Finally, except for the lid, the entire sculpture—including the bearded head shown on the base—was carved from a single piece of wood. While the head can be moved within the "cage" formed by the male and female figures, it cannot be removed.

The bowl is believed to be a later version of a bowl in the Walt Disney–Tishman African Art Collection which was collected at the turn of the century (Fagg in Vogel 1981: 104–6). Although similar in design and decoration, this later work is a more dynamic sculpture. RAW

PROVENANCE

Leon Underwood, collected in Nigeria, 1944
Sidney Burney, London, 1946
William Moore, Los Angeles, 1946 to 1984
William McCarty-Cooper (and estate), Los Angeles, 1985 to 1995

PUBLICATION HISTORY

Wingert 1948: 38
Wingert 1950: pl. 36
Sieber and Walker 1987: cat. no. 56
Drewal and Pemberton with Abiodun 1989: fig. 242
Walker 1998: cat. no. 28

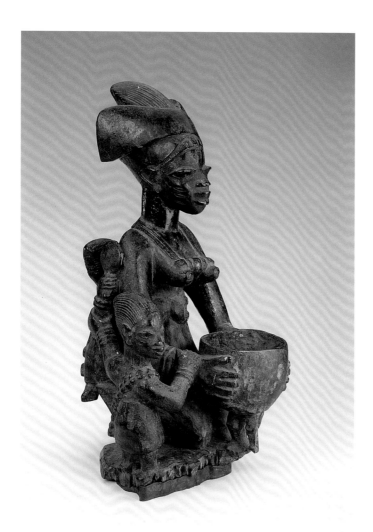

43. FEMALE FIGURE WITH CHILDREN

Yoruba peoples, Oyo region, Nigeria
20th century
Wood, pigment
H. 38.5 cm (15¼ in.)
Museum purchase, 85-1-11

Yoruba figurative sculptures for shrines dedicated to various deities often depict female devotees accompanied by children and holding bowls for kola nuts or other offerings. This particular example, according to an inscription on a 1948 field photograph by Kenneth Murray, was a gift to Orisha Oko, an *orisha* (deity) associated with fertility throughout Yorubaland but particularly in the Oyo region (Nigerian National Museum, photographic archives, 11.18.3.11.19.4).

The sculpture is attributed to an unknown artist in Irawo, an ancient village near the town of Oyo. Originally two children flanked the kneeling mother, who carries an infant on her back. The bowl probably had a lid carved in the form of the upper body of a fowl. In this work the artist created the image of a fecund woman who is testimony to the god's power to bestow fertility and insure successful childbirth. RAW

PROVENANCE

Samir Borro, Côte d'Ivoire, — to 1973
Emile M. Deletaille, Brussels, 1973 to 1985

PUBLICATION HISTORY

Lehuard 1977a: 20
Société générale de banque 1977: fig. 25
Bodrogi 1982: I, pl. XII
Cole 1989: 91, fig. 102
Kerchache, Paudrat and Stéphan 1993: 393, fig. 428

44. DIVINATION CUP *(agere Ifa)*

Yoruba peoples, Ekiti/Igbomina area, Nigeria
20th century
Wood, pigment
H. 27.3 cm (10¾ in.)
Gift of Dr. and Mrs. Robert Kuhn, 92-10-1

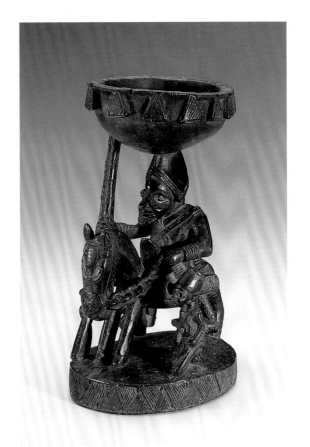

Yoruba sculptors carved several of the implements that diviner-priests *(babalawo)* used in the Ifa divination ritual to consult Orunmila, the god of wisdom. The Yoruba sought Orunmila's help to understand the cause of misfortune or to secure blessings and advice on significant undertakings. Ifa divination implements include a wooden or ivory tapper *(iroke Ifa)* with which to signal the deity; a wooden or, rarely, ivory container *(agere Ifa)* for the 16 sacred palm nuts that are manipulated during the ritual; and a wooden board or tray *(opon Ifa)* on which the diviner makes the mark(s) of an *odu,* the corpus of verses that prescribe the action necessary to assure success (Bascom 1969a; 1969b: 70–71, 80).

Although Ifa divination is a system of religious practice, the iconography of its sculpture is not limited to religious themes. This cup, for example, is supported on the head of an armed warrior *(jagunjagun),* a beneficiary of Orunmila's wisdom. The warrior rides astride a caparisoned horse, a symbol of power and military might. The drummer kneeling at his side, now missing his right arm, once beat a pressure drum *(dundun)* while chanting the warrior's praises. RAW

PROVENANCE

J. J. Klejman, New York, — to c. 1974
Private collection, c. 1974 to 1980
Dr. and Mrs. Robert H. Kuhn, Los Angeles, 1980 to 1992

PUBLICATION HISTORY

Sotheby's 1980: sale 4471Y, lot 168
Fagg 1982: pl. 6

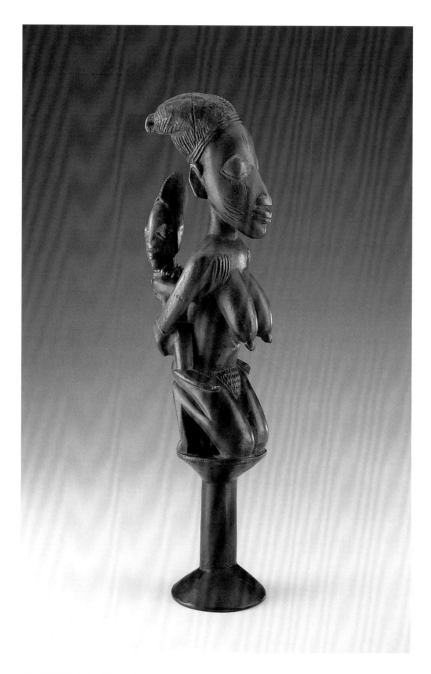

45. STAFF *(oshe Shango)*
Yoruba peoples, Nigeria
Wood, indigo, glass beads
H. 41.9 cm (16½ in.)
Purchased with funds provided by the
Smithsonian Collections Acquisition Program,
88-1-1

This staff was carried in ceremonies and dances to honor Shango, the Yoruba *orisha* (god) of thunder and a deified legendary king of Oyo-Ile (Old Oyo). The woman with child is an archetypal Yoruba theme that is considered particularly suitable for Shango-related imagery. Her nudity and kneeling pose suggest humility before a deity in a ritual setting. Following Yoruba artistic convention, she is portrayed as a physically mature but youthful woman, capable of bearing children and counterbalancing the hot-tempered virility of Shango. Children, like the one carried on her back, are considered to be blessings given from the god in return for devotion.

The master artist who carved this particular staff achieved a subtle and sophisticated integration of specific required cult iconography into a coherent work of art. Most figural *oshe Shango* consist of three sections—a handle, a female figure and a superstructure depicting two stone axes. Of nonfigural staffs, many have only a shaft and the axes, which represent the thunderbolts hurled by the god to punish wrongdoers who have aroused his anger. Carrying goods on the head is commonplace in Africa, and priestesses literally bear images of the deity on their heads. To avoid the compositional awkwardness of the usual axe blade superstructure, the innovative carver of this staff replaced it with a distinctive hairstyle that refers to Shango. Spiritual power is thought by the Yoruba to almost literally spring from the head (M. Drewal 1977: 43; 1986: 61). The woman's shaved hairline emphasizes the head as a channel for the god's possession and allows for the insertion of medicines, magical substances associated with Shango. The swelling forehead is suggestive of spiritual possession or a trance state (1977: 44; 1986: 67). The two hornlike plaits recall the double axes as well as the ram, who is specifically associated with the aggressive male nature

of Shango. The sound of two rams fighting, the impact of their horns, corresponds to the thunder of the god. A final cult reference is provided not by the sculptor but by the staff's owner, who added the red and white beads that are Shango's colors.

This staff has often been acclaimed as a masterpiece by an artist whose work gives definition to Yoruba art while expanding its boundaries. It has been suggested that it was carved at the turn of the century by a member of the Igbuke Family Workshop of Oyo (Jeffrey and Deborah Hammer 1988: personal communication), but little more is known about the artist's life and work. He has employed classical Yoruba proportions that emphasize the head and the eyes, and the stylization of details such as ears and toes within a naturalistically rounded body fits Yoruba stylistic canons. Balancing smooth forms and surface detail, warm wood and indigo pigment, the artist controlled volume and space to make an exceptional sculpture. BMF

PROVENANCE
Leon Underwood, collected in Ogbomosho, Nigeria, 1944
René d'Harnoncourt, New York, before 1947 to 1968
Private collection, United States
Entwistle, London, 1988

PUBLICATION HISTORY
Underwood 1947: pl. 19a, b
Wingert 1950: pl. 34
Brooklyn Museum 1954: pl. 109
Trowell 1954: pl. 18A
Elisofon and Fagg 1958: pl. 143
Fagg 1963: pl. 87
Leiris and Delange 1968: no. 82
Willet 1985: pl. 211
Drewal and Pemberton with Abiodun 1989: fig. 162
Smithsonian Institution 1996: 90

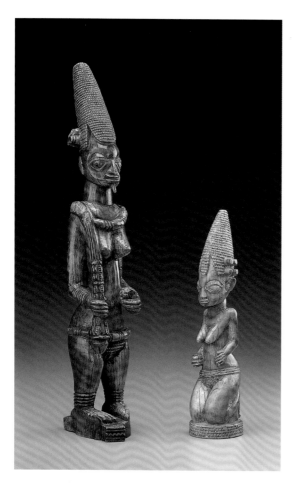

kingdom situated between the Edo kingdom at Benin City and the Yoruba capital at Ile-Ife, may have been the center of Yoruba ivory carving. Owo artists, primarily employed by their Olowo (king) but free to have other patrons, may have exported ivory carvings to other Yoruba towns, such as Oyo, and to Europe, and they may have worked as itinerant artists in such towns as Benin, where they tailored their designs to local taste (Abiodun in Drewal and Pemberton with Abiodun 1989: 104; Eyo 1996: personal communication).

Both of these female figures wear bridal waist beads. The standing figure holds a flywhisk decorated with cowrie shells and wears a lip plug and jewelry signifying high status. She may also have held a separately carved fan that is now lost. Stylistic traits from the Oyo and Owo regions can be seen in both figures: cone-shaped hairstyles with cylindrical projections, the prominent bulging eyes, thick necks, triangular breasts and softly rounded bodies.

The function of full ivory figures depicting men or women is not known. They may be related to *olori ikin,* the miniature ivory heads that Ifa diviners used in the divination ritual (Drewal 1992: 195). RAW

46. FEMALE FIGURE

Yoruba peoples, Oyo or Owo region, Nigeria
Mid-19th century
Ivory, black stone
H. 30.2 cm (11⅞ in.)
Acquisition grant from the James Smithson
Society and museum purchase, 85-9-1

KNEELING FEMALE FIGURE

Yoruba peoples, Oyo or Owo region, Nigeria
Ivory
H. 18 cm (7¹⁄₁₆ in.)
Gift of Robert and Nancy Nooter in memory of
Sylvia H. Williams, 96-41-1

The earliest extant examples of ivory carving from Nigeria, designated "Afro-Portuguese," were produced between the 15th and 17th centuries (Curnow 1983; Bassani and Fagg 1988). Current research suggests that Owo, a Yoruba

PROVENANCE

85-9-1:
[Art dealer], New York, — to 1975
Morris Pinto, France, c. 1975 to 1983
Prince Sadruddin Aga Khan, 1983
Entwistle, London, 1983
Robert Loder, England, 1983 to 1985
Entwistle, London, 1985

96-41-1:
Georges Rodrigues, New York, — to 1970
Robert and Nancy Nooter, Washington, D.C., 1970 to 1996

PUBLICATION HISTORY

85-9-1:
Sotheby's 1983: fig. 21
African Arts 1987: 31

96-41-1:
Gillon 1979: pl. 14
Melikian 1983: 131
Drewal 1992: fig. 9–13
Ravenhill 1997: fig. 4

47. MASK *(oloju foforo)*
Attributed to Bamgboshe of Osi-Ilorin
(died c. 1920)
Yoruba peoples (northern Ekiti), Nigeria
Wood, pigment
H. 97 cm (38 in.)
Museum purchase, 94-12-1

The name of this mask, *oloju foforo*, means
"the owner of the deep-set eyes," a reference to
the cut holes through which the wearer sees.
The form is unique to Osi-Ilorin, one of a dozen
villages populated by the Opin Yoruba clan in
the northeast region of Yorubaland. Honoring
Baba Osi, or "father of Osi," the mask used to
appear at an annual festival called Ijesu (Carroll
1967: 79, 163). This type of mask also came
forth during Epa festivals that exalted ancestors
and cultural heroes in other villages within the
cluster of Opin towns (Pemberton 1989: 189)
and may be, as William B. Fagg has suggested,
a two-dimensional version of the Epa mask
(1963: fig. 81; Carroll in Vogel 1981: 120, fig. 65).

Two female figures kneel on the superstruc-
ture of the mask. They represent a priestess of
Oshun, a river goddess who enables conception,
and an attendant, who holds a lidded bowl. The
priestess holds strings of cowrie shells in her
left hand. Cowrie shells *(Cypraea moneta)*,
which were imported from the Maldive Islands
in the Indian Ocean and exchanged as currency,
symbolized wealth, and devotees of Oshun used
them in divination. Because of their similar
dimensions and flanking positions, the atten-
dant and strings of cowries create a symmetrical
composition.

The mask was originally painted with black
pigment on the hair, eyes and the bar on which
the figures kneel. White was applied to the
cowries and the blackened bar. The composi-
tion of the pigments on this mask have not yet
been analyzed. Traditionally, however, colors
were made from natural sources: indigo, ochers,
eggshells, broken crockery, excreta of birds or
snakes and ash from corncobs. Reckitt's blue,
an imported laundry whitener, became a con-
ventional substitute for indigo. A coat of milky
latex from a cactus made the mask waterproof
(Carroll 1967: 84).

Comparison with other sculptures suggests
this mask was carved by Bamgboshe, a major
sculptor in the village of Osi-Ilorin who died
about 1920. RAW

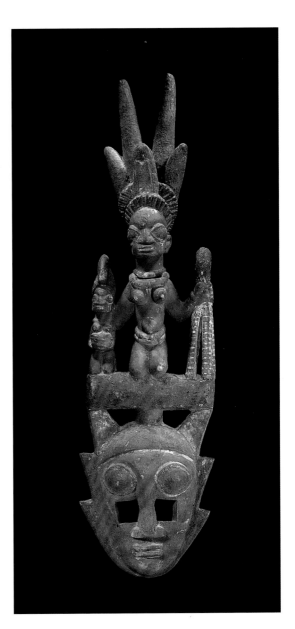

PROVENANCE
Pace Primitive, New York, — to 1982
Deborah and Jeffrey Hammer, Thousand Oaks, Calif.,
1982 to 1994

PUBLICATION HISTORY
Fagg 1982: pl. 59
Drewal and Pemberton with Abiodun 1989: fig. 218

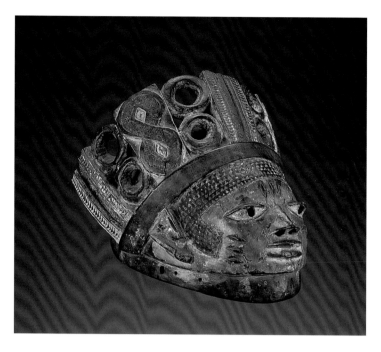

48. MASK *(gelede)*
Attributed to the Anago Master
Yoruba peoples, Republic of Benin
19th century
Wood, pigment
D. 27.5 cm (10¾₆ in.)
Museum purchase, 97-11-1

Gelede is a masquerade to honor and placate
the "mothers," incarnate forces of thwarted
fertility and spiritual power who are less diplo-
matically referred to as witches. Although men,
appearing in pairs, dance these masks, many
gelede masks depict women. Some are satiric
or genre characters such as the prostitute or the
Islamic northerner. Others have elaborate super-
structures with figures of devotees, animals,
exaggerated head ties (a woman's head covering)
or even palm trees. The headdress on this mask
is apparently unique; it most probably refers
to a particular deity or the deity's devotee. Al-
though the sections rising from the head have
some stylistic affinities with the relief carving
of divination boards, a reference to Ifa, the god
of fate and order, is unlikely. Similarities can
also be found with the designs on the textile
panels of some *gelede* mask costumes.

Gelede masks are worn like caps and tilted
at a 45-degree angle on the forehead. The sculp-
tor takes this angle into account when carving
the mask.

This mask is one of four identified as being
by the same individual, an unidentified artist
from a far western Yoruba group, the Anago of
Benin (Drewal in Fagg 1982: 56, 110). The attri-
bution is now formalized as the Anago Master.
The distinctive arrangement and size of the
features are consistent with characteristics of
this master, as are the flat-topped, rectangular
ear, the profile of the eyelids and the precise
triangular chip carving.

This beautiful mask is masterfully carved
and retains much of its traditional polychrome
decoration. Exemplifying a particular work-
shop and artist, the mask is distinctly local but
also clearly Yoruba in a panregional sense. It
offers possibilities for iconographic research and
references to other Yoruba deities and related
object types. BMF

PROVENANCE
Pace Primitive, New York, 1982
Private collection, United States
Entwistle, London, 1997

PUBLICATION HISTORY
Fagg 1982: pl. 29

49. CROWN (ade)

Yoruba peoples, Ijebu region, Nigeria
c. 1930
Glass beads, fiber, cotton, iron
H. 76 cm (30 in.)
Gift of Milton F. and Frieda Rosenthal, 94-1-1

A beaded cone-shaped crown with a long fringe of beads that covers the wearer's face is the most important symbol of Yoruba kingship (Beier 1982: 24; Fagg 1980b: 40, 50, 76). Beaded crowns signify that the king-wearer can trace his ancestry to Odudua, the mythical founder of the 16 original Yoruba kingdoms.

This crown, formed by starched cotton placed over a basketry structure, is decorated with beaded faces, birds and geometric patterns. The faces represent local kings, past and present. The gathering of birds refers both to rituals that make the king semidivine and to the concealed forces that enable him to control and mediate the human and supernatural realms. Interlace patterns called *salubata* are associated with royalty or leadership. Their meaning is debatable, although the pattern may depict intertwining snakes, symbols of continuity. The veil protects the king's subjects from the supernatural powers radiating from his face (Thompson 1970: 10).

According to the crown makers of Efon-Alaiye, the earliest crowns were decorated with beads of one color. No examples survive of the first crowns, made with blue *segi* (Aggrey beads). The next crowns were decorated with red coral beads, which the Portuguese introduced in the late 15th century. Such crowns are rare. Crowns are now decorated with brilliantly colored glass beads, which have been imported from Europe probably since the mid-17th century.

A Yoruba king might have several different beaded crowns and caps to wear for particular occasions. Like human beings, each ritual crown has its own *oriki* (chanted attributes or oral history). RAW

PROVENANCE

Milton F. and Frieda Rosenthal, Westchester, New York, c. 1989 to 1994

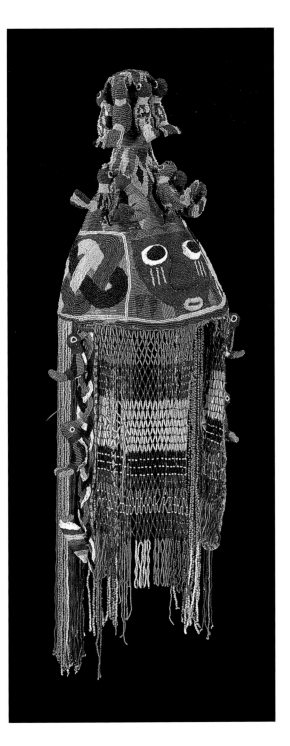

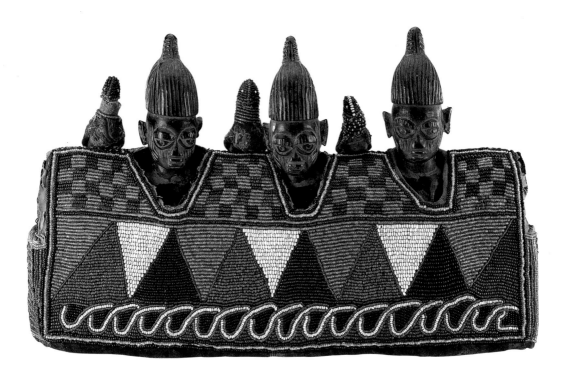

50. STANDING FEMALE FIGURES (ere ibeji)
IN A BEADED GARMENT (ewu)

Yoruba peoples, northern Oyo region, Nigeria
20th century
Wood, glass beads, metal, pigment, cloth, fiber
Figures: H. *(l. to r.)* (A) 26.7 cm (10³/₁₆ in.),
(B) 26.8 cm (10¼ in.), (C) 27.3 cm (10½ in.)
Vest: (D) L. 46 cm (18¼ in.)
Museum purchase, 92-3-1 A–D

The incidence of twin births is extraordinarily high among the Yoruba peoples, but so is infant mortality (Houlberg 1973: 13). *Ere ibeji* are Yoruba memorials to twins who have died. In 1830, the British explorer Richard Lander encountered mothers carrying carved wooden figures, which he understood were little memorials (Lander 1832: I, 120, 124–25). The *ere ibeji* shown here represent deceased female triplets or siblings from two sets of twins in one family, a relationship indicated by their identical facial markings.

Twins are believed to be the children of Shango, the god of thunder and lightning. They are also thought to possess supernatural powers and share the same soul. A memorial figure serves as a receptacle for half of the shared soul (Houlberg 1973; Thompson 1971; Mobolade 1971).

Although representing deceased infants or children, *ere ibeji* depict them as adults in the prime of life. Each figure is dressed and adorned according to the gender, social status and religious affiliation of the twin for which it stands. These *ere ibeji* wear an elaborately beaded vest, a sign of royal status. The decoration is symbolic. The birds on the shoulders, for example, indicate the protection of Oshun, a river goddess, while the color-filled zigzags refer to Shango's thunderbolts. The interlace patterns, called *salubata,* are associated with royalty or leadership. The pattern may also depict intertwining snakes, symbols of continuity.

The mother of a departed twin carries an *ere ibeji* tucked in her wrapper and treats it as a live infant in the belief that to deny twins—Shango's children—such honors is to court their wrath. Thus, to forestall grave misfortune, the sculptures are bathed, rubbed with oil, clothed and adorned. They are kept in the family's twin altar or in a calabash container with paraphernalia used in Shango worship. RAW

PROVENANCE
Georges Rodrigues, New York, — to 1971
Ernst Anspach, New York, 1971 to 1992

PUBLICATION HISTORY
University of Pennsylvania 1974: 78

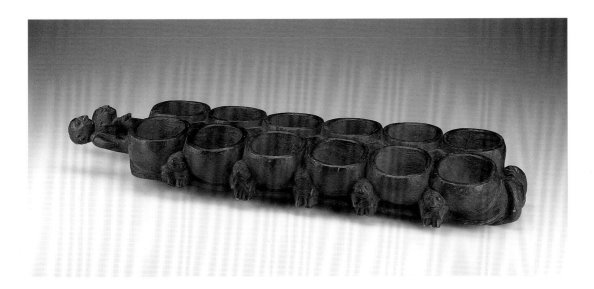

51. GAMEBOARD *(opon ayo)*
Yoruba peoples, Nigeria
20th century, before 1938
Wood
L. 65.5 cm (25 in.)
Gift of Monique and Jean Paul Barbier-Mueller,
93-2-1

This gameboard is for playing *ayoayo*, the Yoruba version of *mankala* (also *mancala*), the generic term for an ancient family of "count and capture" games. Played by two people or, rarely, two teams, *ayoayo* uses undifferentiated pieces and a board with cuplike depressions evenly distributed in two, three or four parallel rows. The goal is for a player to capture a majority of the pieces or at least to immobilize his or her opponent. The successful player depends on strategy more than luck to win (Townshend 1986; Voogt 1997).

Mankala is or has been played in parts of Africa, Asia and the Americas. African captives brought the game to the Americas during the era of the Atlantic slave trade. Because of its wide distribution and the presence of two-, three-, and four-row gameboards on the continent, Stewart Culin (1896: 507–9) called *mankala* Africa's "national" game. It has thousands of vernacular names (Murray 1952: 249–57). The Yoruba *ayoayo* (meaning "real *ayo*," a men's term used to distinguish their game from those played by women and children) is played on 2-row,

12-hole board *(opon ayo)*, the type that predominates in West Africa. Hard, grayish green, inedible seeds act as the game pieces (Odeleye 1977: 12–16.

Gameboards range from holes scooped out of the ground or formed in exposed tree roots to wooden gameboards carved by professional artists. This elaborately decorated example is supported by 10 male figures and decorated with a male and female couple at one end and a pair of snakes at the other. Finely crafted boards like this were emblems of elevated political or social status and sometimes were given as prestigious gifts to important visitors (Walker 1990: 142–299. RAW

PROVENANCE
Josef Müller, Solothurn, Switzerland, — to 1977
Jean Paul Barbier and Monique Barbier-Mueller, Geneva, 1977 to 1993

PUBLICATION HISTORY
Basden 1966: xxx

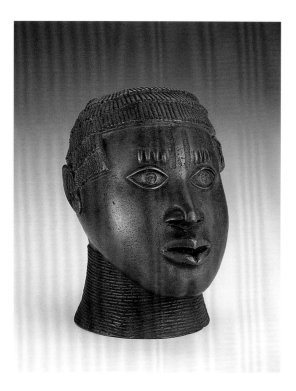

52. MALE HEAD
Edo peoples, Benin Kingdom, Nigeria
Late 15th–early 16th century
Copper alloy, iron inlay
H. 22.2 cm (8¾ in.)
Purchased with funds provided by the
Smithsonian Collections Acquisition Program,
1982, 82-5-2

The rulers of the ancient Benin Kingdom exercised a monopoly over the use of copper alloy, and the majority of sculptures made of it once were displayed within the palace—atop altars, attached to piers or as regalia. Coral beads were a similar royal prerogative, worn as crown jewels and allocated to others in the court. This representation of a male head with beads totally covering the neck would seem to have a royal association, but the tight-fitting collar differs from the looser style shown on images of Benin kings. The substitution of an elaborate but unadorned hairstyle for a beaded crown also separates this individual from Benin royals.

This style of head is probably a trophy head representing a powerful defeated enemy. A foreigner is suggested by the four raised scars over each eye, which are generally explained as denoting someone who is not Edo; most depictions of Edo men show three scars over each eye. This identification is in keeping with present oral tradition maintained by a chief of the Benin casters' guild, who avows that his guild cast trophy heads of the most stubborn defeated enemies (Ben-Amos 1995: 26). Iron inlay in the eyes and forehead signifies strength of character, just as the English cliché "steely eyes" denotes determination or a "furrowed brow" signifies deep thought. The depiction of a worthy, yet beaten, enemy reinforces belief in the awesome magical and military powers of the Benin king. He triumphs where ordinary beings would fail.

This piece displays the caster's technical skill in the lost-wax method as shown by its uniform thickness, the clear detailing of the hair and beads, and a general absence of casting flaws such as cracks, holes or flanges. The maker not only was adept in modeling the original form but ably constructed a mold over it that yielded a sculpture that did not require filing or post-casting repairs. This is particularly remarkable because of the high copper content of the head (tested at 94.4 percent). Copper lends itself to hammering in its pure form, but to pour and mold it easily requires alloying it with other metals. BMF

PROVENANCE
Augustus Lane-Fox Pitt-Rivers, Farnharm, Dorset,
before 1900
Pitt-Rivers estate, 1900
Private collection, New York, before 1982

PUBLICATION HISTORY
Pitt-Rivers [1900] 1976: 31, pl. 15, figs. 88–89
Park 1983: 395
Freyer 1987: 21, cat. no. 1
Robbins and Nooter 1989: no. 552
Levenson 1991: 177–78, no. 60
Arnoldi and Kreamer 1995: fig. 1.3

53. PLAQUE: ARCHERS

Edo peoples, Benin Kingdom, Nigeria
Mid-16th–17th century
Copper alloy
H. 34.3 cm (13½ in.)
Gift of Joseph H. Hirshhorn to the Smithsonian
Institution in 1966, 85-19-6

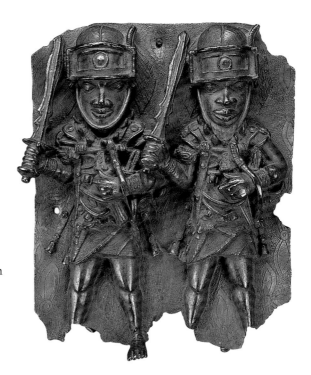

According to local court histories and the
accounts of early-17th-century Dutch travelers,
the *oba* or king of Benin covered the piers of
his palace courtyard with hundreds of plaques
such as this. As a sheer display of wealth and
power, this act would rival covering the White
House with gold from Fort Knox. But more than
excess, it reveals aspects of artistic technique,
local history and a society in which art was
essential. Today, some 900 plaques survive in
public and private collections, but there is no
documentation to indicate how they once were
arranged. After 1700, travelers' accounts do not
mention the plaques, and an 1897 British mili-
tary forces found them in a palace storehouse.
A few plaques show narrative scenes, such as
battles and hunts; some depict symbolic ani-
mals; most, like this example, have one, two
or more male figures in court regalia.

Benin art served as both a sign of status and
a record of court life. The *oba*, nobles, officials
and attendants were depicted on various objects,
including plaques. Costumes and regalia indi-
cated their relative position in the court hierar-
chy. The warriors on this plaque carry swords
and short bows and wear headdresses made
from imported horsetail. According to early
accounts, horsetail headdresses symbolized
military authority and were worn by war chiefs
(Dapper cited in Ryder 1969: 40.) Fanning out
in low relief behind the heads, the horsetail is
sculpted in a manner similar to Benin depic-
tions of European hair or the fins and tails of
the mudfish, a symbolically significant animal.
Both Europeans and the mudfish are associated
with Olokun, the god of the waters and bringer
of wealth.

Benin art emphasizes patterns and texture;
empty space is avoided. A background pattern
of quatrefoil "river leaves" is typical of most
Benin plaques. Symbolically the background
design is another reference to Olokun, who is
linked with the *oba* and wealth, and to the

oba's monopoly on foreign trade (Ben-Amos
1995: 40–41). Artistically the loose, freehand
quality of the linear foliate motif contrasts with
the formal pose, frontality and high relief of
the figures. The well-defined musculature of the
legs on this plaque is unusual and may be the
style of a particular artist.

This recurring emphasis on wealth and
foreign trade leads back to the most basic and
blatant of symbols, the metal itself. The most
obvious effect of Benin's overseas trade with
Europe was a dramatic increase in the availabil-
ity of copper and brass. European ingots and
imported metal trade goods provided the raw
material that was transformed into royal Benin
art by metal casters who worked solely for
the *oba*. BMF

PROVENANCE

Augustus Lane-Fox Pitt-Rivers, Farnham, Dorset,
before 1900
Pitt-Rivers estate, 1900
Aaron Furman Gallery, New York, 1959
Joseph H. Hirshhorn, Greenwich, Conn., 1959 to 1966
Hirshhorn Museum and Sculpture Garden, Smithsonian
Institution, Washington, D.C., 1966 to 1985

PUBLICATION HISTORY

Pitt-Rivers [1900] 1976: pl. 22, fig. 130
Museum of African Art 1973: 29, no. 193
Freyer 1987: no. 13

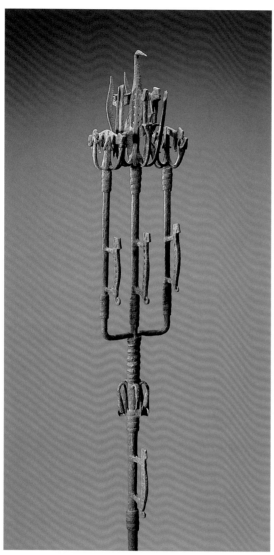

Detail

54. MEDICINE STAFF *(osun ematon)*
Edo peoples, Benin Kingdom, Nigeria
18th–19th century
Iron
H. 168.8 cm (66½ in.)
Museum purchase and gift of Dr. Werner
Muensterberger, 96-29-1

As with copper-alloy production, the smithing
of iron in the Benin Kingdom predated European
contact. Benin trade with Europe, however, not
only increased the amount of metal available
but provided it in more convenient iron bars.
This greatly expedited production by eliminat-
ing labor-intensive ore smelting. The English in
the 1580s included iron bars in their cargos.

Dutch traders in the 1630s standardized the
iron bar, and by 1644 they were prominent in
lists of trade goods (Ryder 1969: 98).

Monumental all-iron staffs such as this may
or may not have been associated with palace
shrines: those staffs combining iron and copper
alloy have definite royal associations. Both
types feature images of birds, chameleons and
tools made of iron. The staffs and their iconog-
raphy express the power of the Osun specialist,
a healer, diviner and fighter of witches. The
staff is thought of as strong, hot and dangerous.
Its praise name is *osun nigiogio,* "*osun* burning
up with heat," but it gives the herbal specialist
the power to escape danger (Ben-Amos 1995:
74). The iron that forms the staff and its repre-
sentations of tools and weapons are links to
the god Ogun, the patron of warriors, hunters
and craftsmen, all of whom use iron. The bird
surmounting the staff is the gray heron of witch-
craft and destruction. It rides a chameleon, a
pose which indicates its high status. The cha-
meleon symbolizes the transformative capabili-
ties of the witch and witch hunter.

Osun, as the god of forest leaves and herbs,
is closely linked with war. The medicines asso-
ciated with the deity and his staff offer not just
spiritual protection but promise safety from
physical harm as well. Oral tradition tells of
smaller Osun staffs carried into battle and
used to hold the heads of slain enemies (Neva-
domsky 1986: 43). An 1897 photograph shows
copper-alloy trophy heads on an iron staff
(Luschan 1919 [1968]: 348, fig. 515, reprinted
in Freyer 1987: fig. 6). The heads are similar to
the example in the museum's collection (see
cat. no. 52).

Some staffs and staff fragments have just a
single cluster of birds and tools, but three seems
to be the preferred number. Staffs vary in the
thickness of their diameters and in their forms,
whether with curving or sharply angled arms
(like this example). The overall size of the staff
and the complex forging of its multiple ele-
ments testify to the ability of the artist. BMF

PROVENANCE
Arthur Speyer, Berlin, before 1960s
Werner Muensterberger, New York, 1960s to 1996

55. VESSEL WITH CHAMELEONS

Lower Niger Bronze Industry style, Nigeria
c. 1668–1773 (by thermoluminescence dating)
Copper alloy
H. 22.9 cm (9 in.)
Museum purchase, 85-16-1

This unique vessel arrived in England shortly after a punitive expedition by the British against the Benin Kingdom in 1897 (Sotheby's 1954: 9). The lack of surface decoration, the shape of the vessel and the style of the chameleons are not typical of Benin art. Although a number of unique objects emanated from the Benin court, this vessel may have been cast elsewhere or by a non-Benin artist. The technical expertise required for such a complex lost-wax casting would seem to demand the skills found in a major metalworking center. Until a more exact identification can be made, this vessel is labeled "Lower Niger Bronze Industry," a term suggested by William Fagg (1963: 40) as a temporary grouping for such atypical Nigerian archaeological works.

The eight animals on the neck of the vessel provide some information. Their four legs and curled tails, but no spots and no ears, rule out identification as leopards and suggest chameleons. The use of the chameleon in art can be documented from the western Sudan to central

Africa. The lizard's ability to change color and separately rotate its eyes, as well as its slow quavering walk, are distinctive traits. In nature the chameleon's tail curls down, not up as here, but representations of spirals are important in the cosmologies of many African peoples. The spiral often refers to concepts of time and the ancestors (Roberts 1995: 51–52).

Although the Edo peoples of the Benin Kingdom credit the chameleon with magical powers, it is not a common motif in their art except on iron staffs (see cat. no. 54). It symbolizes the transformative power of the diviner/healer, and its ability to change to meet any situation makes it a symbol of wisdom. The chameleon's slow gait is compared to that of an old man— one with the wisdom of age. But because the chameleon is also the spy in the magical night and is capable of such quick adaptation, it is also the nickname given to tricky and unscrupulous persons (Ben-Amos 1976: 250).

To look for clues to the significance of the chameleon and this vessel, one could turn to the nearby Ijebu-Yoruba peoples, who make lidded wood boxes in the form of single chameleons. The chameleon *(agemo)* symbolizes the Ijebu reputation for powerful curses and medicines. The lizard's ability to transform its appearance is compared to the Ijebu peoples' history of surviving or defeating powerful enemies (Drewal in Drewal and Pemberton with Abiodun 1989: 122). The dominant cult among the Ijebu takes the name *Agemo,* and certain *Agemo* priests wear brass crowns that resemble royal beaded crowns. Although illustrated examples of these crowns do not feature chameleons, they do have the frontal faces and finial birds of Yoruba royal crowns. The grouping of the chameleons on this vessel resembles the vertical placement of birds on some Yoruba beaded crowns (including one in the museum's own collection, see cat. no. 49). *Agemo* is a term synonymous with extraordinary leadership, and one of the followers of Oduduwa, the god who created the Yoruba kingdoms, adopted the name *Agemo* (Thompson 1972: 238). Therefore, while the origin, function and meaning of this vessel are yet to be determined, its rarity, technical artistry and intriguing symbolic references make it a treasure. BMF

PROVENANCE

Mr. A. A. Cowan, 1897 to 1954
K. John Hewett, London, after 1954
Werner Muensterberger, before 1978 to 1985

PUBLICATION HISTORY

Sotheby's 1954: no. 81

56. FEMALE FIGURE *(edjo)*

Urhobo peoples, Nigeria
Wood, pigment, kaolin
H. 106.5 cm (41¹⁵⁄₁₆ in.)
Museum purchase, 97-17-1

The Urhobo are an Edo-speaking people who live north of the western fringe of the Niger River delta and are grouped into autonomous villages and village groups called clans, each with a common ancestor (Foss 1976a: 15, 17).

The Urhobo have two distinct sculptural traditions of nearly life-size wooden figures, one representing spirits and the other, actual or mythic ancestors. To identify Urhobo figures as either spirits or ancestors can be difficult unless the context is known; however, Perkins Foss's written descriptions and in situ photographs (Foss 1976a, 1976b) of Urhobo figures suggest that this figure represents a spirit.

The Urhobo believe that singular and collective spiritual forces exist in nature: in water, trees, plants, land or air. These spirits, known as *edjo,* are pervasive, and their powers encompass all of Urhobo life. A single community may have several different kinds of *edjo,* although one may be recognized as the spirit of the town. Wood carvings are the physical manifestations of these spirits. A single shrine building *(oguan redjo)* may contain a dozen carved *edjo* figures presided over by an elaborate hierarchy of titled priests and priestesses, the spiritual leaders of the *edjo* cult (Foss 1976b: 12, 13, fig. 1).

This figure was probably part of an *edjo* sculptural ensemble known as a family. A female figure such as this might be described as the "wife" of a large male *edjo* figure. Sometimes a wife is shown nursing a child (Bastin 1984: 209, fig. 198; Société générale de banque 1977: opposite 10, fig. 33). This figure, and others similar to it, is depicted standing and facing frontally with arms held rigidly at its sides; the feet are slightly apart and planted firmly on the base. The face displays vertical keloids on the swelling forehead, the nose is angular, the jaw jutting and displaying an open mouth with two rows of bared teeth. The chest swells, and two well-formed, triangular-shaped breasts are positioned to emphasize the symmetry of the body. Like figures from eastern Nigeria, this one has a herniated navel, a sign of beauty. Stomach, chest and shoulders are decorated with diamond-shaped scarification. The figure is depicted wearing an elaborate hat or coiffure. The carved necklace and bracelets are probably meant to represent ivory, a sign of wealth and high status. The white chalk *(orhe)* that appears on the eyelids may be a sign of purity and otherworldliness. AN

PROVENANCE

Lucien Van de Velde, Antwerp, acquired in Abidjan, Côte d'Ivoire, 1965 to 1997

57. MALE FIGURE *(alusi)*
Igbo peoples, Nri/Awka region, Nigeria
Wood, pigment
H. 161 cm (63⅜ in.)
Museum purchase, 97-17-2

The Igbo are the largest ethnic group in south-eastern Nigeria. Their artists carve numerous masks for public performances and figures for shrines. Among the figures they create are tutelary deities *(alusi)* who are the founders of communities or spirits associated with the earth, rivers or a nearby market. This figure is most likely a tutelary deity whose precise meaning has been lost. Such figures are often situated in permanent compounds or in single buildings on the edges of public commons (Bastin 1984: 203, photo 190). They are the center of weekly and yearly activities. Figural groups are conceived as families. It is probable that this figure was the male member of such a family, which would have consisted of a husband, wife, children, messengers and other helpers (Cole and Aniakor 1984: 89, 98, pl. 18).

This well-made figure was probably carved in the central Nri/Awka region, a focal point for the creation of major Igbo sculpture, for it perfectly fits the Igbo canon for figures from this area. It is frontal, symmetrical and stands with legs slightly apart. The arms are cut free from the sides, and the hands, which are minimally delineated, extend outward with palms up. This gesture is meant to show open-handedness or generosity on the part of the deities as well as their willingness to receive sacrifices and other presents (Cole and Aniakor 1984: 92). The elongated neck supports a head that is normally proportioned and not oversized, as is so often the case in African sculpture. The stylized face displays the scarification marks *(ichi)* of a titled person at the temples and forehead (Jones 1984: 37, photo 5). This figure is red, probably the result of having been rubbed with camwood, much as the Igbo do to beautify themselves. The scarification marks on the stomach and chest are known as *mbubu*. Around the legs are carved spirals, which may represent anklets. The figures were often clothed when in use (98, pl. 18). AN

PROVENANCE
Lucien Van de Velde, Antwerp, 1989 to 1997

PUBLICATION HISTORY
Hôtel Drouot 1989: 94, no. 90

58. MASK

Ibibio peoples, Nigeria
Wood, fiber, encrustation
H. 29.5 cm (11⅝ in.)
Purchased with funds provided by the
Smithsonian Collections Acquisition Program,
97-8-1

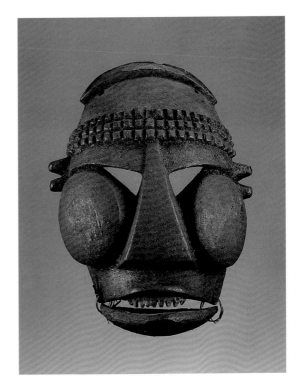

Despite its relatively small size, this mask has
a dominant presence. By emphasizing the lines,
curves and volumes of the facial features, the
artist directs the viewer's attention to the
mask's outstanding three-dimensionality: the
prominent round cheeks, a nose shaped like a
truncated pyramid and two small triangular
eyes. For added dramatic effect, a series of deep
cross-cut incisions were placed across the fore-
head. The hinged jaw, a distinctive feature of
many Ibibio masks, reveals a row of teeth and
completes the picture of awe the mask inspires.
The surface is heavily encrusted.

The mask may have been worn during Ekpo
ceremonies. Ekpo is the Ibibio men's ancestral
spirit association. There were two kinds of Ekpo
masks—"beautiful" and "fierce." The former
were said to be colored white, while the latter,
such as this example, were stained and polished
black. Raffia costumes dyed black were worn
with the mask. Ekpo characters, especially
the fierce ones, were meant to inspire fear and
respect. AN

PROVENANCE

Mariette Henau, Antwerp, 1974
Alan Brandt, New York, 1997

PUBLICATION HISTORY

Bastin 1984: 210, fig. 201
Kerchache, Paudrat and Stéphan 1993: 403, fig. 474

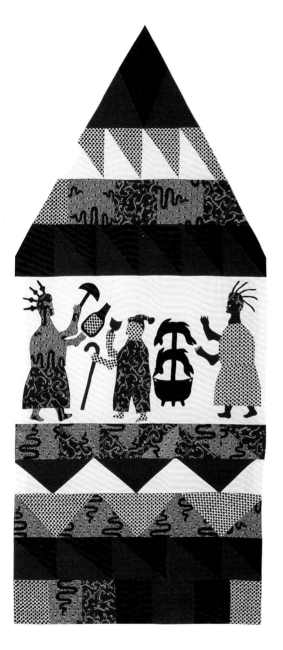

59. FUNERARY SHRINE CLOTH

Artist: Okon Akpan Abuje (born c. 1900)
Afaha clan, Anang peoples, Ikot Obong village,
Ikot Ekpene Local Government Area, Akwa
Ibom State, Nigeria
Late 1970s
Commercial cotton cloth, cotton thread
344.8 × 153 cm (135¾ × 60¼ in.)
Museum purchase, 84-6-9

This large colorful funerary cloth is the work
of the master Anang shrine-cloth maker, Okon
Akpan Abuje. Using the traditional Anang tech-
niques of appliqué and patchwork, he created
the complex designs of the cloth, which is
machine stitched except along the sides. In the
center is the deceased elder wearing a long shirt,
trousers and the woolen hat *(iyat* or *uyat)* of
the Ebie-owo, an institution to which all Anang
men who wished to be warriors aspired. In one
hand he carries a cane and in the other a drink-
ing vessel. The female figure to the left, prob-
ably his eldest daughter, pours a locally distilled
liquor into the vessel. Her coiffure indicates
that she has completed the *mbobo* rite of pas-
sage, marking the assumption of full woman-
hood. She carries an umbrella, a woman's status
symbol. The woman on the right is depicted
with the coiffure of a widow in mourning. She
stands next to an iron cooking pot with two
dried fish for the funeral feast.

The dominant colors of the cloth—red, black
and white—have particular meanings. Red, the
color of blood, is meant to inspire men to acts
of valor. Black is associated with life and the
ancestral spirits. White symbolizes the spirit
world and death. Until recent years, Anang
artists created these cloths for prominent dis-
play at funerals. Each was the featured element
of a shrine, called *nwomo,* erected to commem-
orate a deceased member of the Ebie-owo.

AN

PROVENANCE
Keith Nicklin and Jill Salmons, England, commissioned
in Nigeria, late 1970s

PUBLICATION HISTORY
Nicolls 1991

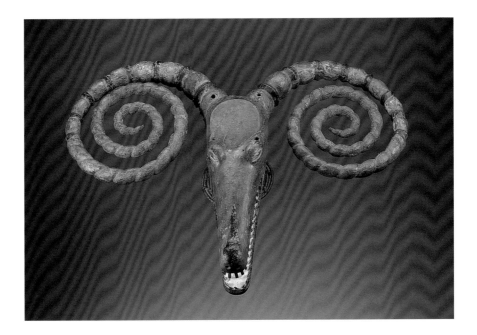

60. MASK

Ejagham peoples, Cross River region,
southeastern Nigeria and western Cameroon
Wood, antelope skin, palm fiber, bamboo,
metal, pigment
W. 86 cm (33⅞ in.)
Museum purchase, 88-11-1

Sculptors from several groups living in south-eastern Nigeria, east of the Cross River and across the border in western Cameroon, produce a distinctive type of mask carved from wood and covered with antelope skin. The tradition probably originated among the Ejagham peoples. Most of the masks portray the human head, often janus or multifaced, with a high degree of naturalism.

Although depictions of animals are rare, this example features a long, tapering crocodile head with spiral structures said to represent a woman's coiffure rather than horns (Eyo in Vogel 1981: 167). A hole in the forehead, now covered with skin, may have held a wooden crown or a third spiral that jutted from the forehead. When in use, the mask, attached to a woven basketry cap, sits on the masquerader's head; his face and body are covered with netting or fabric.

P. Amaury Talbot, a British administrative officer, was the first European to observe the crocodile mask in use at Oban, Nigeria, before 1909. He described it in relation to the *bassinjom*, an antiwitchcraft association:

The image was robed in a long gown of dark blue cloth daubed with mud from the river bed. . . . On its head it bore a crocodile mask carved in wood, perhaps a representation of Nimm herself. (1912: 45)

Talbot noted, that according to Ekoi/Ejagham mythology, Nimm was a deity worshiped by women and dreaded by men. Her guardian spirit lived in the "sacred lake" and was manifested in crocodile form.

Keith Nicklin, who conducted fieldwork among several Cross River groups, suggests a stylistic classification of skin-covered masks into the lower, middle and upper Cross River areas. He reports that though there is little variation in the *bassinjom* masks throughout the Cross River region, "crocodile cap" masks in the lower Cross River can be more realistic, their surfaces covered with skin and bearing representations of horns or crowns (Nicklin and Salmons 1984: 35). LP

PROVENANCE
Maurice Nicaud, Paris, before 1972
Alan Brandt, New York, — to 1988

PUBLICATION HISTORY
Leuzinger 1972: 223

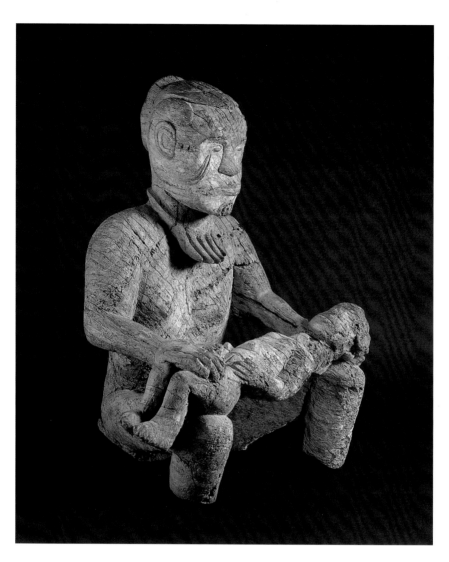

**61. FRAGMENT: FIGURE OF
WOMAN AND CHILD**

Mbembe peoples, Nigeria
Wood, seeds, pigment
H. 68 cm (26¹³⁄₁₆ in.)
Museum purchase, 85-1-12

Male and female figures, fragments of slit gongs
created during the 19th and early 20th centuries
by artists of the Mbembe, are among the most
powerful and enigmatic wood carvings from
the Middle Cross River region in southeastern
Nigeria. Large in scale and weathered, with sur-
faces resembling rugged landscapes, these sculp-
tures seem to possess a primordial quality. The
museum's fragment of a female figure holding a
child is among the best-preserved examples.

The female figure has a solid torso and heavy
limbs and assumes an upright, serene pose, all
features that resemble other Mbembe sculptures
(Kamer 1974; Nicklin in T. Phillips 1995). She
supports the child comfortably on her bent
knees, cradling the head with her left hand and

protectively placing her right hand on its thighs. Although the features of the child can no longer be discerned, there are indications of an elaborate painted coiffure. The child's navel, a reference to a person's beginning, protrudes from the belly like that of the mother figure. A prominent herniated navel was considered a sign of beauty among peoples of the Cross River and the adjacent regions in Cameroon.

The elegant face, coiffure and adornment of the female figure are features no longer discernible in other less well preserved Mbembe sculptures. The delicate oval face has a narrow nose and thin, slightly pointed lips. Inset black seeds highlight the eyes and recall the practice of artists among other Cross River peoples to emphasize eyes with metal and other inlays. The Cross River peoples elaborated and perfected their bodies through scarification and painting in an intricate, now almost forgotten language of patterns and two-dimensional designs. In keeping with this aesthetic, scarification in the form of raised lines and dots embellishes the cheeks, temples, forehead and chin of the figure. Bearing traces of red and dark pigment, the hairdo with distinct curves on both sides of the head is reminiscent of the finely shaved coiffures of men and women in the region in the 19th and early 20th centuries. The woman must be of high rank, because her necklace has five leopard's teeth, an adornment reserved for leaders.

Sculptures such as this originally were finials on one or both ends of monumental slit gongs that ranged in size from 10 to 16 feet (2.5 to 4 meters). Carved from the same log as the slit gong, the sculptures have a horizontal wood grain, a rare occurrence in African sculpture depicting the human form. Usually the grain runs parallel to the axis of the body. This different configuration challenged the artist to anticipate and carefully integrate the radiating patterns of the core of the trunk into a sculpture's design and surface modeling.

Although slit gongs with figurative finials had a wide distribution, ranging from Igbo country to the Cameroon Grassfields (Geary 1989), Mbembe slit gongs possessed a unique design.

The figurative finials either faced outward, connected by their backs to the ends of the slit gong, or they were almost entirely separated from the body of the gong and freestanding, in some instances facing inward toward the body of the gong. While standing or seated male figures holding a severed head in one hand alluded to warfare, the female figures suggested prosperity, fecundity and the important role women assume in Cross River societies. In some instances, gongs had a male figure on one end and a female on the other, an image that depicts the important and complimentary roles of men and women in Mbembe society.

Slit gongs belonged to the village or to particular men's associations. They were placed out in the open, which explains their weathered surfaces (Harris 1965: 1984), where their purpose was to call the community together in case of emergencies such as military attacks, conflagration, deaths or other important events.

Only a few complete slit gongs left southeastern Nigeria at the beginning of the 20th century. Two are now in the Museum für Völkerkunde in Berlin (Krieger 1969: 86–87). One of these gongs, a well-preserved piece, is painted. This may have been a common practice and would serve to explain the traces of pigment on the museum's sculpture. During the Biafran War (1967–70), a period of destruction and upheaval in southeastern Nigeria, many figurative finials were removed from slit gongs and exported to Europe and the United States. Nevertheless, several complete gongs remain in the region and are now protected by Nigerian antiquities laws (Nicklin 1981).

CMG

PROVENANCE
Lucien Van de Velde, Antwerp, before 1973
Emile M. Deletaille, Brussels, 1973
Walter Vanden Avenne, Oostrozebeke, Belgium, 1973
Emile M. Deletaille, Brussels, 1983

PUBLICATION HISTORY
Arts d'Afrique noire 1977: 20
Société générale de banque 1977: 54, pl. 35

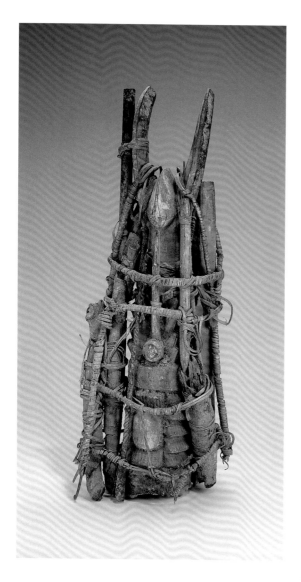

62. SHRINE FIGURE *(okega)*
Igala peoples, Nigeria
Wood, fiber, iron, kaolin, pigment
H. 62.2 cm (24½ in.)
Gift of Orrel Belle Holcombe in memory of Bryce
Holcombe, 87-6-1

This figure represents a type of Igala shrine figure, or *okega,* found in the Ibaji district of Nigeria (Boston 1977: 87). The cylindrical body is surmounted by a stylized head with horns that curve up and back. The head is flat on both sides, reducing the face to a small area. Facial features are minimal. The body is covered with a cage of various materials that almost obscures the form. The artist carved the bottom half of the figure as a series of tiers marked by deep, vertical incisions. The figure smokes a pipe, as is often the case for such *okega.*

Individual Igala own this type of *okega* and keep them in the ancestor shrine of the extended family to which the person belongs. As with the Igala's southern neighbors, the Igbo, rituals involving *okega* (called *ikenga* by the Igbo) center around personal success and social achievement. Advancement occurs through title taking, which is based on wealth and on promotion through a series of grades based on the individual's ability to pay entrance fees (Boston 1977: 89). AN

PROVENANCE
Pace Primitive, New York, 1987

PUBLICATION HISTORY
Cole 1989: 27, fig. 24

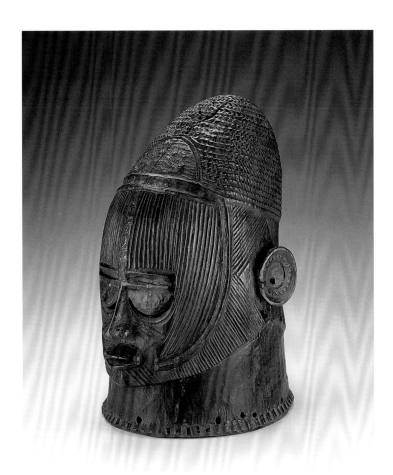

63. MASK *(odumado)*
Igala peoples, Nigeria
Wood, pigment
H. 34.4 cm (13⁹⁄₁₆ in.)
Museum purchase, 97-18-1

The Igala inhabit the left bank of the Niger
River, south of its confluence with the Benue
in Central Nigeria. They have had historical
connections with their neighbors the Igbo and
the Idoma, and also with the Jukun, the Yoruba
and Edo peoples of the Benin Kingdom.

Because the Igala are situated near the con-
fluence of two of West Africa's most important
waterways, the Niger and Benue Rivers, their
art, culture and history have interacted with not
only their immediate neighbors, the Igbo and
Idoma, but with more distant peoples such as
the Jukun, the Yoruba and the Edo peoples of
the Benin Kingdom (Neyt 1985: 33; Sargent in
Kasfir 1988: 19; Kerchache, Paudrat and Stéphan
1993: 542). Consequently, the Igala population
consists of ethnically diverse clans that retain
their own historical origins. Within the Igala
state, however, the population speaks the same
language and exhibits similar cultural traits.

Over time, the western Igala have developed
a highly evolved artistic complex of masks and

masquerades to represent the spiritual relationship between living members of the community and the ancestors. The masks are an expression of the cult of the ancestors and a physical representation of both collective and individual ancestor figures. They also reflect the cultural, ethnic and political reality of the diverse Igala state (Sargent in Kasfir 1988: 17).

Among the most important masking complexes of the Igala are the so-called central public masquerades known as *Egwu-Ata.* While ostensibly under the direct control of the ruling house, each mask exists in an individual clan or group that keeps, cares for and performs it. Each masquerade exhibits certain physical characteristics that identify the group and its relationship to the larger community. Together these masks signify the state or nation (Sargent in Kasfir 1988: 20–22).

This fine helmet mask is close in type to one of the *Egwu-Ata* masks known as *odumado* (Neyt 1985: 41, II.8; Murray 1949: 89). The large well-shaped head has carefully cut half-moon eyes, straight brows, circular ears with raylike motifs inside, a small, projecting nose and beautifully rendered parallel striations on the face and neck that represent scarification. The parallel zigzag lines of the coiffure cover the head. The blue pigment on the coiffure is probably indigo. Traces of encrustation in the middle of the forehead extend to the bridge of the nose, where *abrus* seeds were attached. In some

odumado masks, kaolin is rubbed on certain areas. A costume made of cloth was attached to the holes along the bottom of the mask.

Masks similar to this example reportedly are controlled and performed by the Orata clan, a highly ranked group that originated among the Akpoto (Sargent in Kasfir 1988: 33). While described as the indigenous population among the Igala, the Akpoto appear to have expanded northward from the Cross River Basin, perhaps around 1400 (19, 32–33). They have interacted extensively over the centuries with other cultures including those of the Benin Kingdom, the Igbo and the Tiv.

The *odumado* mask type represents the Akpoto population and is a symbol of the Akpoto dynastic era within the Igala political sphere. *Odumado* is especially important during the *Ocho* festival, an annual celebration of the New Yam Harvest in which the cleansing of the soil, recognition of land rights, the re-creation of sociopolitical relationships, and the connection between the monarchy and the indigenous population takes place. *Odumado* appears during the first phase of this festival, which celebrates the Akpoto as the original owners of the land (Sargent in Kasfir 1988: 32–33, 37, 38). AN

PROVENANCE
Pace Primitive, New York, 1997

64. MALE FIGURE

Chamba peoples, Upper Benue River
Valley region, Nigeria
20th century
Wood, pigments
H. 58.4 cm (23 in.)
Museum purchase, 89-7-1

This figure is attributed to the Chamba, of the
Upper Benue River Valley in Nigeria, on the
basis of its conformity to presumed Chamba
style: a small round head with a minimum of
detail; arms interpreted as a widespread lozenge
projecting from the front of the torso; and short,
blocklike legs, spread apart and flexed. Although
this figure conforms to these stylistic attributes,
its lack of collection history does not allow us
to determine its past use.

According to Stevens (1976: 30), figures
like this represented heroes and former chiefs;
Fardon (in press) reports that figures also may
have denoted ancestors or other spiritual pow-
ers and in the past may have been used to com-
bat illness. Insect damage and weather have
eroded the surface of this figure. PLR

PROVENANCE

Roux collection, Paris, c. 1965 to 1975
Hélène and Philippe Leloup, New York, 1975 to 1989

65. MASK

Kulere peoples, Nigeria
Wood, pigment
W. 51.8 cm (20⅜ in.)
Gift of Robert and Nancy Nooter, 81-11-16

The Kulere carved distinctive buffalo masks with highly abstract, graceful and elemental forms. The masks were usually undecorated except for parallel striations filled with light pigment. They combined three parts: open jaws, a hemispherical head, and horns—representing the spiritual energy of the natural, nonhuman environment.

The mask was used in ceremonies of the *munja*, a men's association in which all boys automatically became members during initiation. The main purpose of the *munja* was to protect the fields through certain rituals. The dancer, disguised from head to toe with a cos-tume of netting and a palm strip skirt, per-formed an energetic threatening dance. His movements, however, were restrained by ropes or a human chain, thus conveying the animalis-tic creature's powerful spirit to the human community.

This mask is similar in style to a buffalo mask worn by the Kulere's western neighbors, the Mama. The men's associations began to diminish in number in the 1970s, and such masks are no longer seen in the Nigerian cen-tral plateau and western lowlands where the Kulere and Mama live. LP

PROVENANCE
Christian Duponcheel, Belgium, 1965
Robert and Nancy Nooter, Washington, D.C.,
1970 to 1981

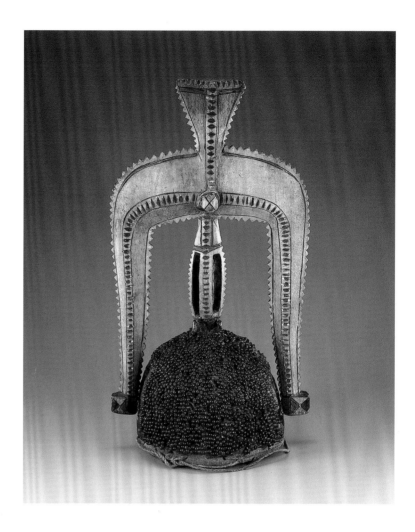

66. CREST MASK

Koro Ache peoples, Kafanchan plateau, Nigeria
Wood, *abrus* seeds, pigment, fiber, resin
H. 52.7 cm (20¾ in.)
Gift of Milton F. and Frieda Rosenthal, 85-13-1A, B

Among the mostly Islamized Koro peoples,
who live on the Kafanchan plateau in Central
Nigeria, highly abstract and nonrepresentational
masks are used in masquerades celebrating the
seasons of planting and harvesting. An example
similar to this one, collected by Roy Sieber in
1958, was called *ngambak*, or "man with bowed
legs." Sieber (1961: fig. 36) reported that such
crests served as village guardians. William Fagg
(1980a: 92) also witnessed masquerades employ-
ing this type of mask in 1949 in a Ham village.
According to Fagg, all the people of the Kafan-
chan plateau, the Ham, Koro, Kagoro and
Kamantan, practiced the same types of masked

dances. The Koro, who were the most populous,
probably produced masks for the other groups.

The decorations on this crest mask, chevrons
bordering the crest and bands of burnished
ridges, give emphasis to the form. In masquer-
ades, it is set on top of the dancer's head. A
woven, tentlike robe covers the dancer's head
and body. Some dancers represent the ancestral
mothers who give a welcoming embrace to
other dancers (Fagg 1980a: 92). LP

PROVENANCE

Barbier-Mueller collection, Geneva, — to 1980
Milton F. and Frieda Rosenthal, Westchester, New York,
1980 to 1985

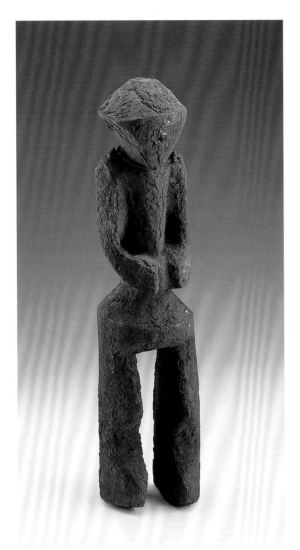

67. FIGURE *(njom)*
Possibly Keaka peoples, Cameroon
Wood, raffia, encrustation
H. 36.2 cm (14¼ in.)
Gift of Mr. and Mrs. Edgar F. Gross, 76-14-4

The Keaka, an Ejagham subgroup also known as
the Eastern Ejagham, live near the Cross River
in Cameroon close to the Nigerian border. Little
is known about their art traditions. Highly
stylized, often heavily encrusted figures attrib-
uted to the Keaka and other Cameroon groups
such as the Mambila, Mbem, Mbo or Mfumte
are depicted in ethnographic and art historical
literature. Called *njom,* the Ejagham term for
medicine, they are used by groups and individu-
als in antiwitchcraft activities (Ute Röschen-
thaler 1988: personal communication). *Njom*
assign blame for an illness or death to a witch
and punish her accordingly (Koloss 1984: 72).
Each figure has an individual name, which is
usually lost when the figure is removed from its
original context. AN

PROVENANCE
Edgar F. Gross, Los Angeles, before 1975–76

68. MALE FIGURE

Bamum peoples, Fumban, Grassfields region,
Cameroon
Wood, brass, cloth, glass beads, cowrie shells
H. 160 cm (63 in.)
Gift of Evelyn A. J. Hall and John A. Friede, 85-8-1

This life-size male figure from the kingdom of
Bamum in Cameroon is a visually compelling
example of the splendid beaded sculptures
Bamum artists created for the royal court in
the 19th and early 20th centuries. Resembling
other Bamum sculptures, the face is triangular
to oval and has large round eyes. The bridge
of the nose is flat and the nostrils flare. The
narrow, protruding mouth is framed by a beard,
indicated by blue and red glass beads. Colorful
beadwork attached to a fabric base covers most
of the carved wooden figure, which is elongated
and slightly angular. Artists also applied a thin
overlay of brass to the face, the back of the
head, and the hands and feet. Glass beads and
brass were rare and came from Europe in ex-
change for ivory and other African goods. In the
19th century, only the king could possess and
distribute these precious materials. A wooden
polelike extension at the base may indicate
that the figure was, at one time, planted in
the ground.

The figure wears a loincloth, a trapezoidal
headdress, bracelets, anklets and a collarlike
neck ornament. The beaded cover not only
articulates these elements of dress and adorn-
ment, it also envelops the entire figure in a
splendid array of two-dimensional motifs, all
meaningful within the Bamum system of
thought. A frog or toad design appears on the
back of the headdress and a more schematic
rendering of the same motif on the legs. For the
Bamum, both creatures allude to fertility and
propagation. Bracelets, armlets and anklets
display the zigzag configuration of a spear, a
motif referring to prowess in war, for the

Bamum relied on warfare to secure their political and economic might within the region. The checkerboard motif of the neck ornament is a rendering of the spots of the leopard, the powerful and elegant beast seen as the king's equivalent. Bold blue and white geometric designs on the torso represent the spider, wisdom incarnate and an important player in divination. Only royalty or noblemen were permitted, with the king's consent, to wear jewelry adorned with these motifs.

The left hand of the figure touches the bearded chin and the right hand the loincloth, a conventional pose common to 19th-century Bamum sculpture. It may allude to a gesture assumed by high-ranking courtiers when talking to the king. Important men would respectfully bow their heads and speak through their raised hand because no one was permitted to look the king in the face or address him directly. The king was sacred and commanded the highest respect and reverence from his subjects. Placing the right hand on the loincloth also alludes to proper behavior, for one is composed and restrained in the presence of the king.

The gesture, dress, adornment and multitude of motifs reserved for royalty and men of high rank found on this sculpture clearly indicate that it is either a commemorative portrait of a Bamum nobleman or even a king (Geary 1994). The precise meaning and function of this impressive figure, however, remains unknown.

CMG

PROVENANCE
Presented by King Njoya of Bamum to the family of German colonial officer Hans Glauning in his memory, April 1908
Museum für Völkerkunde, Berlin, late 1908
Arthur Speyer, Berlin, 1929
Ralph Nash, London, c. 1970 to c. 1980
Evelyn A. J. Hall and John A. Friede, c. 1980 to 1985

PUBLICATION HISTORY
Northern 1984: 99
Harter 1986: 162, pl. 13
Geary 1994

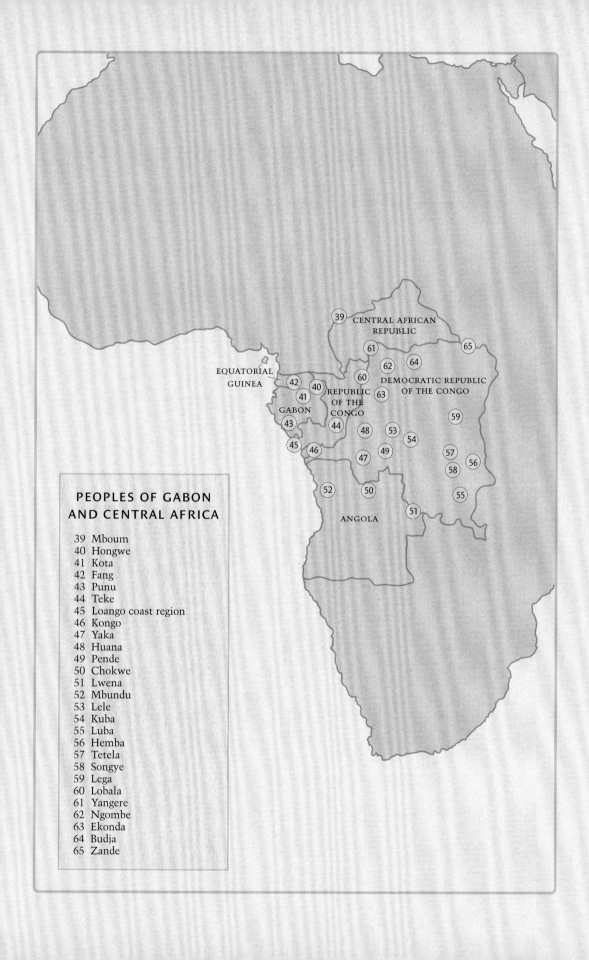

EQUATORIAL
GUINEA

CENTRAL AFRICAN
REPUBLIC

GABON

REPUBLIC
OF THE
CONGO

DEMOCRATIC REPUBLIC
OF THE CONGO

ANGOLA

PEOPLES OF GABON
AND CENTRAL AFRICA

39 Mboum
40 Hongwe
41 Kota
42 Fang
43 Punu
44 Teke
45 Loango coast region
46 Kongo
47 Yaka
48 Huana
49 Pende
50 Chokwe
51 Lwena
52 Mbundu
53 Lele
54 Kuba
55 Luba
56 Hemba
57 Tetela
58 Songye
59 Lega
60 Lobala
61 Yangere
62 Ngombe
63 Ekonda
64 Budja
65 Zande

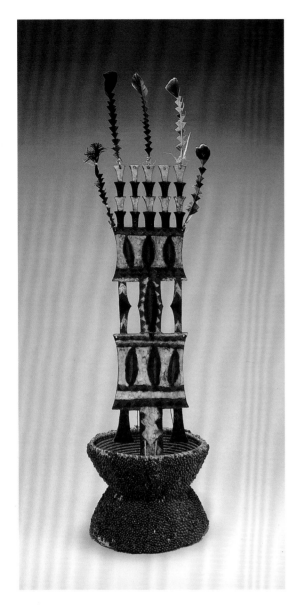

69. HEADDRESS

Mboum peoples, Bakala, Central African
Republic
Wood, *abrus* seeds, fiber, feathers
H. 86 cm (33⅞ in.)
Museum purchase, 97-16-1

This headdress exhibits an unusual combination of woven and carved elements. The woven fiber cap, decorated with red and black *abrus* seeds, is surmounted by an open-worked wood panel adorned with painted motifs and attached feathers.

The headdress makes its appearance during rituals celebrated in December after a good harvest and also at the time of national holidays. Photographs of dances in which they perform show the headdress attached to a raffia wig, which has a long raffia beard covering the dancer's cheeks, ears and neck (Paulme and Brosse 1956: 2). Aside from these photographs, little has been published about such headdresses.

The Mboum, who numbered only 20,000 in 1917, live in a remote area where northern Cameroon, the Central African Republic and Chad come together. They are divided into several settlements, some of which have developed into states, where government and religious powers reside in the *belaka*, or chief.

LP

PROVENANCE
Jacques Hautelet, La Jolla, Calif., 1997

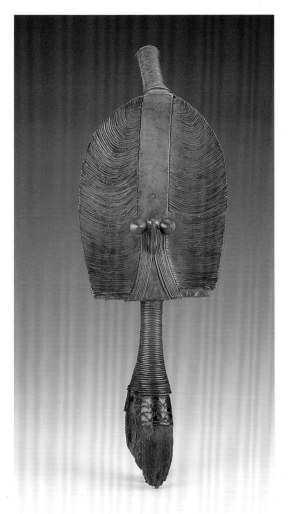

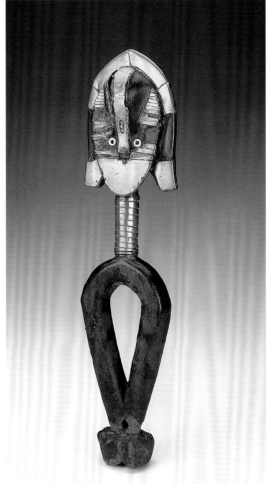

70A. RELIQUARY GUARDIAN FIGURE *(bwiti)*

Hongwe peoples, Ivindo Basin, Mekambo area, Gabon
Wood, copper alloy
H. 60 cm (23⅝ in.)
Acquisition grant from the James Smithson Society and museum purchase, 88-4-1

70B. RELIQUARY GUARDIAN FIGURE
(mbulu ngulu)

Obamba-Kota peoples, Ogowe-Ngunie River area, Gabon
Wood, copper alloy, eggshell, encrustation
H. 41.9 cm (16½ in.)
Gift of Mr. and Mrs. George Lois, 83-17-1

Several Bantu-speaking peoples, including the Hongwe and Kota peoples in Gabon and the Republic of the Congo (Brazzaville), preserved and revered the relics of important ancestral leaders in the belief that their extraordinary powers survived mortal death. The relics, customarily the skull and certain other bones, and magical substances were kept in bark boxes or woven baskets. Sculpted wood figures overlaid with metal were positioned on or tied to the reliquary to serve as its guardian. The creation of reliquary guardian figures ceased around 1930 as a result of aggressive proselytizing by Christian missionaries, the imposition of a new social organization centered on the Western-style nuclear family and indigenous witch-hunting movements. Consequently, many of

these sculptures were destroyed by burning or concealed by burial (Siroto 1968: 27). Extant examples are rare.

A long history of contact among the various peoples of the Gabon region has resulted in shared concepts and design forms. Thus the Obamba-Kota and Hongwe reliquary guardian figures have similar features. Both have a stylized head on a lozenge-shaped "body," with the head of the Hongwe figure perpendicular to the body and that of the Obamba figure parallel.

Each object was made by an unknown artist who honored the established canon but created a unique work. The metal strips on *bwiti,* for example, are usually applied to the form in a strict parallel manner that creates a sense of rigidity. In the example shown here (88-4-1), however, an innovative artist skillfully manipulated each metal strip to create an undulating effect that emphasizes the concavity of the underlying wood carving. In his hands, the strips of metal establish a rhythmic pattern and delineate the surface, resulting in a more dynamic sculpture than is usual for Hongwe *bwiti* figures. RAW

PROVENANCE

88-4-1:
Charles Ratton, Paris, — to 1954
Mr. and Mrs. Frederick Stafford, New York, 1954 to 1987
Michael Oliver, New York, 1987 to 1988

83-17-1:
George Lois, New York, — to 1983

PUBLICATION HISTORY

88-4-1:
Allen Memorial Art Museum 1956: pl. 49
Plass 1956: pl. 26E
Bolz 1966: pl. XLII, c, d
Issac Delgado Museum of Art 1967: 77, pl. 126
McLeod 1980: 127

71. RELIQUARY GUARDIAN FIGURE (eyema bieri)

Fang peoples, Gabon, Equatorial Guinea and
Cameroon
Wood, oil
H. 58 cm (22¹³/₁₆ in.)
Gift of Eugene and Agnes E. Meyer Foundation,
72-41-3

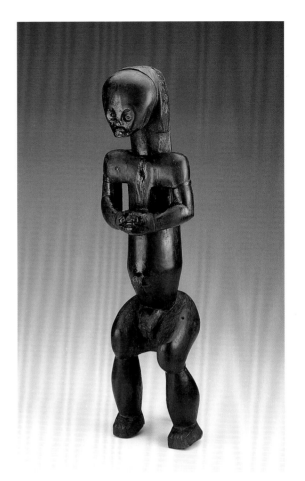

Honoring one's ancestors is an important act among the Fang peoples. This was done both by remembering their names and deeds and by keeping physical remnants of them as relics. At least a portion of the skull and other bones, if possible, were preserved in a barkwood box to which a carved wooden guardian figure or head was affixed. In the early 20th century it was not uncommon for *bieri* figures to be sold to Europeans, while the irreplaceable relics were retained.

During *bieri* rituals, individuals asked ancestors for help and protection through the services of an elderly man, himself almost an ancestor, and before undertaking any important or potentially dangerous activity: travel, hunting, land selection, marriage, political alliances, disputes or war. During the rituals, the bones and the figures would be anointed with palm oil, redwood *(padouk)* powder, medicinal plants and chicken or goat blood (Perrois in Perrois and Delage 1990, 42–44). This figure still has its oil patina but has lost the feather headdress and necklace it may have once worn (50).

According to the morphology developed by Perrois (1972), this *bieri* figure is in the *ntumu* style of northern Gabon and the adjoining areas in Cameroon and Equatorial Guinea. This identification is based on the proportions of the body: an elongated torso, neck and body that are equal in diameter, with the arms separated from the body and folded across the chest (Perrois in Perrois and Delage 1990: 12, 97 ff).

The figure's spherical head suggests both a child and a skull, an impression enhanced by the round eyes set into a concave, heart-shaped face. The open stare is typical of infants, as is the protruding stomach and peglike umbilicus (Fernandez 1966: 365). Both the umbilicus and the emphatic depiction of the genitals may refer to the continued fertility of the group, a concern of the ancestors. An adult trait is seen in the carved headdress that depicts the fiber wig (typically ornamented with imported buttons, brass tacks or cowrie shells) worn by Fang warriors and documented in early-20th-century photographs. These are all general traits, however, and the figure cannot be considered a portrait of any of the individuals whose bones were in the barkwood box to which the *bieri* was once attached. Fernandez believes that the contradictory aspects of infant and ancestor give the objects a vitality, and that this balanced opposition is central to Fang expression (366 ff). As a guardian image it might rely on this more subtle tension than on more overtly threatening gestures. BMF

PROVENANCE
Maurice de Zayas, Modern Gallery, New York, 1918
Agnes E. Meyer, before 1972

PUBLICATION HISTORY
Sheeler [1918]
Museum of African Art 1973: 36–37, no. 304
Walker 1983: no. 7
Webb 1991: 57

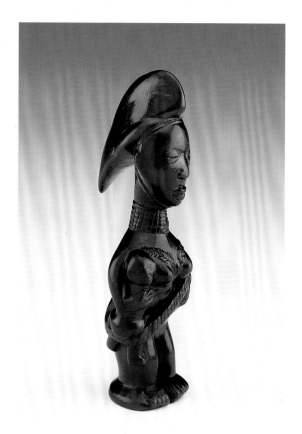

72. FEMALE FIGURE AND CHILD

Punu or related peoples, Ngunie River region, Gabon
Wood
H. 12 cm (4¾ in.)
Purchased with funds provided by the Smithsonian Collections Acquisition Program, 96-9-1

This female figure with child is a small, beautiful enigma. Judging from its smooth surface, it was handled, rubbed and cherished by its owner, but its exact origin and use are not known. The attribution to the Punu or related peoples is based not on field documentation but on a stylistic resemblance to the Ngunie River region's famed white-faced masks and larger wood female figures.

Older exhibition and auction catalogues identify miniature figures similar to this example as "Kongo" and group them with Kongo whistle finials associated with hunters and ritual specialists (cat. no. 82). While the hole in the base of this particular figure could have held the tip of a small antelope horn whistle, this is not true of all examples and the more general identification as a pendant could apply.

A more fundamental parallel exists with the *minkisi* ritual complex of the neighboring Kongo peoples. Although the modern political boundaries of Gabon and the Republic of the Congo separate the Punu and Kongo peoples, historical and cultural similarities connect them. Protective or medicinal amulets, pendants and miniature figures formed part of the paraphernalia of Kongo ritual specialists. Such small objects were worn by the human diviner or healer and also attached to a statue or assemblage of items. BMF

PROVENANCE
Charles Ratton, Paris, before 1950s
Donald Morris Gallery, Detroit and New York, 1996

73. MASK *(mukudj, okuyi)*
Punu peoples, southern Gabon and southwestern
Republic of the Congo
Wood, pigment, buttons
H. 29.5 cm (11⅝ in.)
Museum purchase, 90-6-1

Wooden masks whitened with kaolin have
been observed among the Ashira, Lumbo, Vuvi,
Sango and Punu peoples in south and south
central Gabon and southwestern Republic of
the Congo since the late 19th century (Perrois
1985: 101). Called *mukudj* and variant names
according to geographical location (e.g., *okuyi*),
the masks appeared in masquerades during
funeral celebrations, when masked male danc-
ers on stilts, concealed under fiber costumes,
performed acrobatic feats (100). Contemporary
Punu prominently display the masks in their
homes as a sign of ethnic identity and wear
mukudj masks made specially for performances
that celebrate a number of events (LaGamma
1996: 50, 257).

The masks range from highly naturalistic
to extremely abstract in style and are found in
distinct geographical locations. The clear natu-
ralism of this mask argues for a southern origin
among the Punu. The sculptor carefully gave
the mask feminine attributes such as the hair-
style and scarification patterns on the forehead
and temples. The white color, however, is
genderless: it symbolizes the afterlife and the
spirits of the dead. This particular mask is deco-
rated with imported buttons that were acquired
through trade and considered exotic and thus
used to enhance carvings. RAW

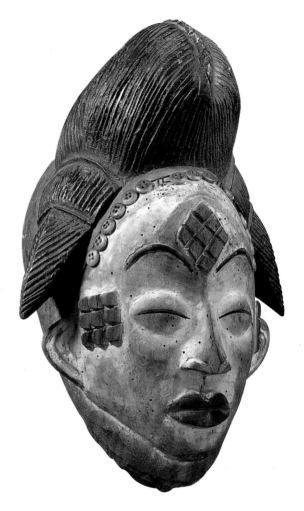

PROVENANCE
Private collection, Paris, — to 1960
André Fourquet, Paris, 1960 to 1990
Alain de Monbrison, Paris, 1990

PUBLICATION HISTORY
National Museum of African Art 1997: cover

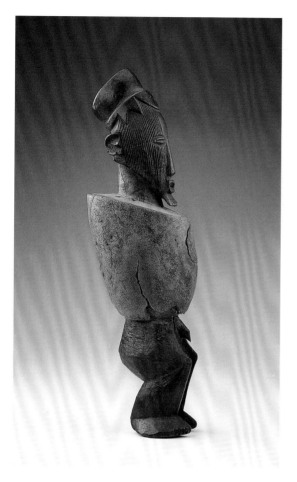

74. MALE FIGURE

Teke peoples, Republic of the Congo
Wood, clay, sand, *tukula*
H. 37.5 cm (14¾ in.)
Acquisition grant from the James Smithson
Society and museum purchase, 90-2-1

Among the major art forms of the Teke peoples
of the Republic of the Congo are wood figures
with medicines. The medicines are attached to
the trunk and embedded in an abdominal cavity
carved for that purpose.

The museum's example, a standing male
wood figure, displays bilateral symmetry. The
ovoid head, sitting squarely on the neck, has
horizontal slit eyes; a small, rectangular mouth;
a triangular nose; small, protruding, hemispheri-
cal ears; a trapezoidal beard; and a cylindrical
coiffure. This hairstyle, called *imwu*, is worn
by the elite or descendants of noble families
(Hottot 1956: 25, 37, pl. 1, fig. 4; Lehuard 1996:

222, 225, D1). The face has deeply carved,
evenly spaced vertical lines representing typi-
cal Teke scarification *(mbandjuala)* (Lehuard
1996: 53). The midregion of the figure is sur-
rounded by a bundle of compact material which
is embedded with a red pigment at the front-
center. The deeply undercut legs emphasize the
angularity of the knees, hips, ankles and feet.

X-ray photographs taken by the museum's
Conservation Department reveal an abdominal
cavity carved into the figure, into which an
unidentified spherical object, probably *bonga*
(medicine of some sort), was placed. The mate-
rial around the figure's middle is composed of
sand and clay, and the red substance is tenta-
tively identified as *tukula,* a pigment derived
from a type of redwood found in Central Africa.
The X-rays also show arms carved as part of the
trunk and curved inward toward the stomach
(Mellor, Moffett and Hexter 1990: 4). Robert
Hottot, who studied Teke figures in the French
Congo (now Republic of the Congo) during the
first decade of the 20th century, described how
Teke carvers gave only minimal definition to
the arms because they were to be covered and
not visible. He also noted that the forehead,
beard and hair were polished and darkened by
being burnished with a heated, but not red-hot
knife (Hottot 1956: 27, 28).

Teke figures closest in type to this example
are called *butti* (Hottot 1956: 29). Individually
owned, they represented and were named after
a deceased male ancestor or chief. A *butti* was
kept in its male owner's house, and when he
died, it was buried with him. A more recent
study suggests that these figures were used in
various ritual contexts (Lehuard 1996: 246).

AN

PROVENANCE

Belgian colonial official, c. 1930s
Jean-Pierre Jernander, Brussels, 1967
Alan Brandt, New York, 1990

PUBLICATION HISTORY

African-American Institute 1980: 41, fig. 51
Herreman 1986: 22, fig. 5
Kerchache, Paudrat and Stéphan 1993: 434, fig. 629
Société des expositions 1988: 209, fig. 169; 7,
cat. 169, fig. 5

This ivory tusk, possibly dating to the late 19th century, is an unusually fine example of an important tradition of export art. It was carved by an artist who lived along the Loango coast in the Congo region. Almost certainly using iron tools, he rendered with exquisite detail and lively animation a series of pictorial sequences in relief that spiral the length of the tusk. Figures in the scenes depict everyday Loango life as experienced by coastal peoples during the latter half of the 19th century.

The scenes are separate vignettes and not meant to be read as a continuous story. Among the important representations on the tusk are (from the bottom): an individual in a medallion who wears a hat and cape decorated with diamond-shaped motifs; a sacrifice; a slave caravan; a Kongo ritual specialist in full regalia; a coastal trading house; a European trading ship; a man attacked by an elephant; a woman carrying a child and goods while a monkey tries to lift her wrapper; and a woman nursing a child.

Certain motifs and details of the horn combined with its narrative composition point toward an interpretation that is linked to Kongo notions of death and the afterlife.

Blier compares the earlier tradition of non-figurative Kongo ivory horns carved and played in Kongo courts with the later figurative Kongo ivory horns carved for export to Europe. The spiral form is an important compositional device found on horns from both traditions. In the former Blier speculates that the open spiral compositional lines allude to the path the dead follow from earth to the ancestral realm and back again as newborns. In the latter she observes that the parade of figures suggests the long winding procession followed by both the living and the dead as they climb from the ocean to the mountains leading to the Kongo capital and the home of the ancestors (Blier 1993: 382). AN

75. TUSK WITH RELIEF CARVING
Kongo peoples, Loango coast, Republic of the Congo, Democratic Republic of the Congo and Angola
Ivory
L. 72 cm (28 in.)
Museum purchase, 96-28-1

PROVENANCE
Michael Graham-Stewart, London, 1996

PUBLICATION HISTORY
Nicolls 1998

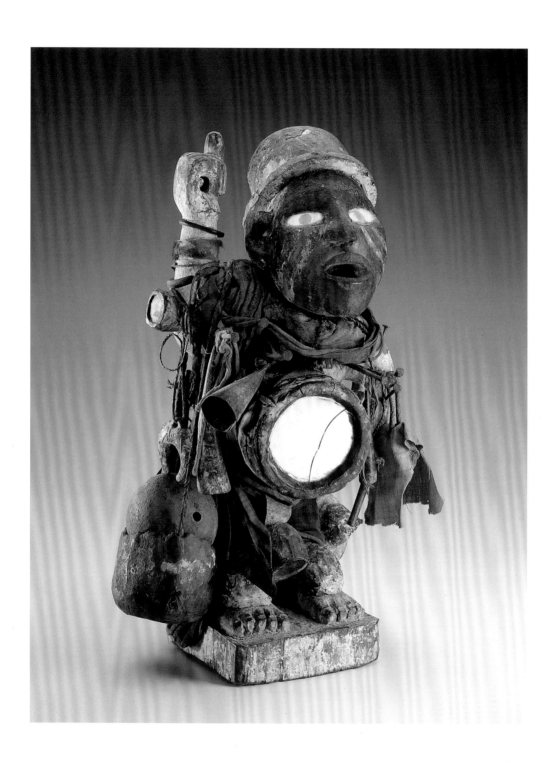

76. MALE FIGURE (nkisi nkondi)

Kongo peoples, Democratic Republic of the
Congo
Wood, glass, iron, horn, textile, pigments, fiber,
accumulative materials
H. 43.2 cm (17 in.)
Gift of Helen and Dr. Robert Kuhn, 91-22-1

The term *nkisi* (pl. *minkisi*) has no English
equivalent. In the past "fetish" and "power
figure" have been used as brief identifiers, but
they do not convey the word's meaning. A
nkisi is the physical container for a spirit from
the other world, the land of the dead. When
activated by a specialist, or *nganga,* it has the
power to heal, to protect or to punish. *Minkisi*
can be dramatic wooden sculptures with mirror-
covered resin boxes added to hold the em-
powering substances, or they can be ordinary
containers such as pots, net bags and baskets.
An active *nkisi* requires the rituals of its
nganga, and it always contains medicines, ma-
terials with potential spiritual powers. The
mirror-covered stomach pack and other amulets
and containers identify this figure as a *nkisi,* and
its aggressive pose (the upraised arm originally
held a blade) suggests it is a *nkondi* (hunter)
type. By occult means, this type of *nkisi* hunted
down unidentified witches, thieves, adulterers
and other wrongdoers (MacGaffey in MacGaffey
and Harris 1993: 76). It once had a personal
name and invocations that are now lost to us.

The public performance aspect of the rituals
would have made the purpose of the *nkisi* clear,
but much about the composition of its medi-
cines would have been known only to the
nganga, possessor of the ability to see into the
spirit world. There is a certain blurring of iden-
tity between the *nkisi* and the *nganga.* This
nkisi carries musical instruments like the ones
used by the *nganga*—antelope horn whistles,

a crescent-shaped wooden slit gong and a minia-
ture iron gong. The container hanging from the
right arm is in the shape of a gunpowder flask
(MacGaffey in MacGaffey and Harris 1993: 101),
a distinctive form with suspension cords run-
ning through interior channels on its sides. The
nganga commonly aroused the attention of the
nkisi nkondi by exploding gunpowder in front
of it (MacGaffey in T. Phillips 1995: 246). The
ball that closes the flask is a spherical seedpod
containing medicines. Not visible is another
medicine pack on the bottom of the flask, one
of about a dozen empowering additions, an
unusually large number. Because these medi-
cines are on the front and back, atop the head
and between the legs, on the shoulders, feet and
elbow, they literally cover all directions and,
like the reflective glass eyes, enable the *nkisi
nkondi* to see witches, those who would do
harm. The eyes are further emphasized by red
and white lines, the "tears" that come with
death (MacGaffey in MacGaffey and Harris
1993: 101). Literally every item, color and form
on this figure has a meaning, so that what began
as a relatively compact, solidly modeled sculp-
ture becomes an exposition of Kongo beliefs to
those with the eyes of knowledge. BMF

PROVENANCE

René Withofs, Brussels, 1950
Gallerie Zodiaque, Brussels, 1969
Christian Duponcheel, Belgium, 1969
K. John Hewett, London
Judith Small Nash, New York
Herbert Baker, Los Angeles, 1972
Dr. and Mrs. Robert H. Kuhn, Los Angeles, 1973 to 1991

PUBLICATION HISTORY

Lehuard 1989: I, 105, 239, no. D 4-4-1
MacGaffey in MacGaffey and Harris 1993: 11, 99–101,
no. 64
MacGaffey 1994: 123–31, fig. 1

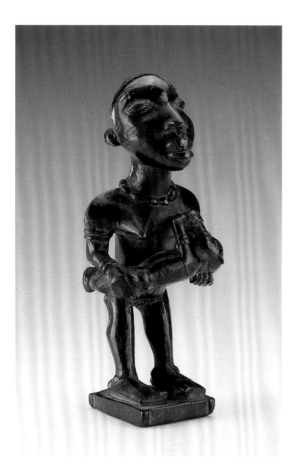

77. FEMALE FIGURE AND CHILD
(pfemba or *nkisi)*
Kongo peoples, Republic of the Congo and
Democratic Republic of the Congo
Wood
H. 15.5 cm (6⅛ in.)
Museum purchase, 86-12-13

While this figure holding a child to her breast
has obvious associations with maternity and
fertility, there are indications of use as a *nkisi*
(see cat. no. 76). The faint incised marks on the
back of the standing woman are all that remain
of a missing container for special empowering
materials. The hole atop the head also once held
a medicine horn or streamers. Feathers, strips
of cloth or leather are used because they flutter
when the *nkisi* is danced; this movement sug-
gests the presence of the "spirit" (MacGaffey in
MacGaffey and Harris 1993: 76).

An important *nkisi* had many components
and accessories. A male and female pair of
carved figures would be a male *nkisi* and his
wife. They exemplified the types of power con-
trolled and unleashed by the *nkisi.* The woman
softens the retributive violence of the male and
links these forces with fertility. Indeed a *nkisi
nkondi,* an aggressive *nkisi*, could be used to
treat a woman during childbirth and to end her
seclusion afterward (MacGaffey in MacGaffey
and Harris 1993: 35–37).

The woman depicted in this diminutive
carving is high in status. The child indicates
that she is married, and she may have been the
founding mother of a clan, for her head is cov-
ered by an *mpu,* a chief's hat. The concentric
circles of its design can be interpreted as a sign
that she holds the clan together (MacGaffey in
MacGaffey and Harris 1993: 147). Certainly her
pose suggests confidence and control—feet and
legs firmly planted, while shoulders, neck and
head lean forward almost aggressively. The
overall impression is meant to be one of beauty,
because that is the nature of a woman, espe-
cially a woman with a child. A sculptor who
could convey this Kongo belief was respected
and his work sought after (90–91). BMF

PROVENANCE
Collected in Africa, 1920
Nève de Mévergnies, Brussels, before 1970
Emile M. Deletaille, Brussels, before 1970 to 1986

PUBLICATION HISTORY
Lehuard 1977b: 107
Société générale de banque 1977: 60, no. 45
Bassani 1981: 69

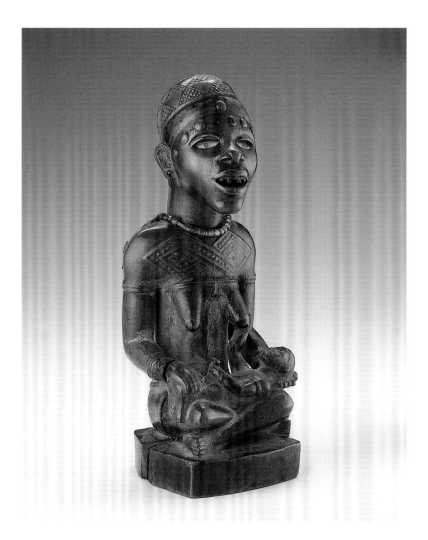

78A. FEMALE FIGURE AND CHILD *(pfemba)*
Kongo peoples, Mayombe region, Democratic
Republic of the Congo
Wood *(Nauclea latifolia)*, glass, glass beads, brass
tacks, pigment
H. 25.7 cm (10⅛ in.)
Museum purchase with funds provided by the
Smithsonian Collections Acquisition Program,
83-3-6

The figure of a mother and child is an icon of
Kongo art. It is not a simple genre theme, but
a statement of the spiritual power supporting
society, the need for fertility and the promise
of future generations. These figures possibly are
connected with *mpemba*, a women's cult said
to have been founded by a famous midwife, and
concerned with fertility and the treatment of
infertility. *Mpemba* seems to have grown at the
same time the slave trade intensified, from 1770
to 1850; an increased concern for children seems
a logical development (E. Pechuel-Loesche 1907
cited in Janzen 1982: 56). There are also ties to
the Lemba cult, which also arose during the
slave trade period, whose members were the
wealthy mercantile elite. Lemba was concerned
with healing, trade and marriage relations, and
it redistributed potentially disruptive wealth
among kin and shrines (Janzen 1982: 3, 20).

78B. HAT

Kongo peoples, Mayombe region,
Democratic Republic of the Congo
Pineapple fiber
Diam. 15.2 cm (6 in.)
Museum purchase, 84-6-4

Inside a special box, members kept significant
cult objects including a sack of red pigment,
symbolizing the female element, called *pfemba
lemba* (Janzen 1978: 89). Red pigment originally
was rubbed on these figures; only traces remain.
Costly and distinctively modeled metal brace-
lets were a Lemba emblem and may be repre-
sented on one of the figures (83-3-6).

Both figures are seated, legs crossed, atop
small bases. This pose conveys the prestige of
high political and social status, as do a number
of other details. One figure (83-3-6) is depicted
wearing a close-fitting hat, traditionally made
of knotted raffia or pineapple leaf fiber (84-6-4).
This type of hat was worn by chiefs at the time
of their investiture and by noblewomen who
would give birth to future rulers. Brass tacks
and imported glass beads adorn the figure as
well. The flaring hairstyle of the other figure is
also a traditional perquisite of high status, a
standing reinforced by the presence of imported
European brass tacks, a precious trade item
(85-15-3). The imported glass inset in the eyes
shares the same glittering aesthetic but also
refers to the ability to see the invisible spiritual
world (see cat. no. 76).

Other attributes of these figures are associ-
ated with beauty, perfection and high rank.
The chest cord serves to emphasize the breasts.

Scarification was viewed as erotic and beautiful;
it marked physical maturity and assured con-
ception. The chiseled teeth also were considered
beautiful.

Despite these similarities, striking differ-
ences distinguish the two figures: a straight
back versus a forward angle; precise detail
versus simplified forms, as seen especially in
comparison of the cap and hairstyle or the ears.
Examining even more figures makes it possible
to identify artists' hands or workshops. Six
extant figures are in the style of one of the fig-
ures (83-3-6), all of which have been attributed
by Ezio Bassani (1981) to a carver he designates
the Master of the de Briey Maternity (Africa
Museum, Tervuren, no. 24662). Stylistic differ-
ences exist among even these six, and further
research on attribution and dating is needed.

A final comparison should be made between
the children depicted. Both look like small
adults rather than real infants. Leo Bittremieux,
priest and ethnographer, in a 1939 letter to
the Africa Museum in Tervuren, wrote that
"*Phemba*" denotes "the one who gives children-
in-potentia." A *pfemba* child is a magically
conceived *nkisi* child, a fragile emissary of the
spirit world (Janzen 1978: 88). Because the child
is unexpressive and supine, it has been described
as dead (Lehuard 1977b: 34). Since a number
of the infants either nurse at or touch their
mother's breast, there are either two different
subjects or death takes an unusual definition.
On one figure, the child holds his penis erect
while touching the mother's breast. The gesture
could be a reference to fertility, metaphorically
referring to the seeds of creation or to the belief
that those who die will be reborn. So death, or
the spirit world, may not be estranged from life
in Kongo beliefs. SHW/BMF

PROVENANCE

83-3-6:
Belgian colonial official, before 1914
Private collection, Belgium
Jean-Pierre Jernander, Brussels
Alan Brandt, New York, 1983

84-6-4:
Belgian colonial official before World War II
Marie-Eliane d'Udekem d'Acoz, New York, 1984

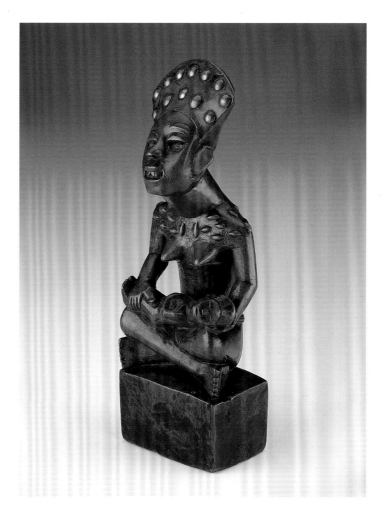

85-15-3:
Raoul Blondiau, Brussels, after 1900 to before 1926
Theatre Arts Monthly, as the Blondiau–Theatre Arts
Collection, New York, 1926
Edith J. R. Isaacs, New York, c. 1927 to death 1956,
family collection until 1983
Emile M. Deletaille, Brussels, 1983 to 1985

PUBLICATION HISTORY

83-3-6:
Bassani 1981: 79, pls. 21, 25
Park 1983: 377
Cole 1989: 90, fig. 100
Lehuard 1989: 464–65, fig. J 1-1-6
Robbins and Nooter 1989: no. 931
Arnoldi and Kreamer 1995: fig. 2.16

85-15-3:
The New Art Circle 1927: no. 19
Sweeney 1935: no. 443
Christie's 1983: 60, no. 296
Lehuard 1989: 565, fig. K 3-5-4

78C. FEMALE FIGURE AND CHILD *(pfemba)*

Kongo peoples, Democratic Republic of the
Congo, Republic of the Congo, and Cabinda
district, Angola
Wood, glass, brass tacks, pigment
H. 24.8 cm (9¾ in.)
Museum purchase, 85-15-3

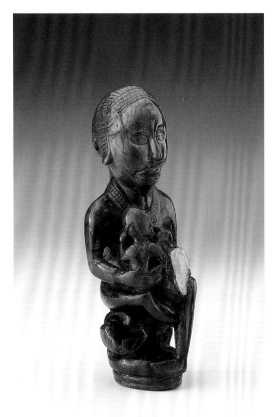

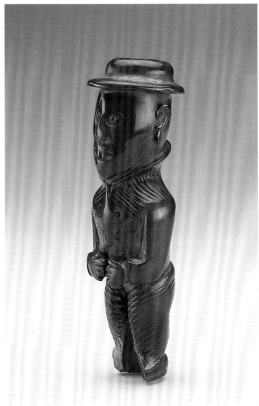

79A. STAFF TOP *(mvuala):* **SEATED FIGURE AND CHILD**

Kongo peoples, Angola, Democratic Republic of the Congo and Republic of the Congo
Ivory, redwood powder, mirror
H. 13.3 cm (5¼ in.)
Museum purchase, 86-2-1

79B. STAFF TOP *(mvuala):* **MALE FIGURE**

Kongo peoples, Angola, Democratic Republic of the Congo and Republic of the Congo
16th–19th century
Ivory, ceramic, pigment
H. 16.5 cm (6½ in.)
Museum purchase, 85-15-4

Among the Kongo peoples, carved wooden staffs with figurative tops and pointed iron ends were emblems of a ruler's power and wealth. A staff might be presented to a future chief at his initiation, and some were inherited (Cornet in T. Phillips 1995: 242–43). On staffs such as these, the tops were separately carved ivory figures; the red color is the result of added pigment and age. The value of ivory as a material is universally appreciated. Ivory refers to the blatant physical power of the elephant as a creature who cannot be controlled, who can kill a man—"the one with heavy feet, who walks by himself" (MacGaffey in MacGaffey and Harris 1993: 54).

The features of the standing figure are smoothed with age and use, but the mouth with the prominent chipped front teeth suggests a Kongo man, as does the beardless chin. The blue eyes and clothes, however, are European. The high-collared jacket, brimmed hat and earrings were part of the costume of a European male during the time of early contact (Bassani

and Fagg 1988: 213). While the exact style of trouser is undetermined, it is clearly not a Kongo wrapped garment. The Portuguese first entered the Kongo kingdom in 1482; by 1500 the Kongo king had been converted; and by 1550 churches and a cathedral had been built in the Kongo capital city of San Salvador, renamed from Mbanza Kongo. In addition to ordinary commercial trading, high level diplomatic exchanges were made between the Kongo and the Portuguese courts. European style clothing and hats were gifts and trade items, and their artistic representations continued long after the time of actual use had passed.

Similarly the seated figure wears a European tailcoat, suggestive of a later date, possibly in the 19th century. The hairstyle (with a long tail ending in a ball) could be entirely local or inspired by European wigs. More basic is the question whether the larger figure is male or female. There is a general assumption that women hold children, especially given the importance of the theme in Kongo art (see cat. no. 78). But the absence of breasts argues for identification as a male. A large number of staffs have explicitly female figures both with and without a child. On this staff the small figure is a miniature of the adult, implying that what is important is not the nurturing of a real infant but the continuity of the group, and specifically the ruler's heir. The figure's seated pose suggests high status. The animal that serves as a stool could be a leopard or a dog; both appear on other Kongo sculptures. The leopard is a royal emblem and, like the elephant, a potentially deadly animal. Chiefs sit on leopard skins at their installation (MacGaffey in MacGaffey and Harris 1993: 95). The dog is associated with spiri-

tual powers, the hunt for evildoers and the ritual specialist, or *nganga.*

The chief and the *nganga* should not be interpreted as opposites but as having similar powers. The power of the *nganga* is focused on his *nkisi* (see cat. no. 76), and for the chief, on his staff. It can act as a special kind of *nkisi* in governance. When placed upright, the staff indicated that a meeting or ceremony was in progress, but the staff's iron tip could also be driven into the ground to arouse an avenging spirit, just as nails were driven into a *nkisi nkondi* to activate it (MacGaffey in MacGaffey and Harris 1993: 95). The mirror-covered resin container attached to the standing figure's torso, an addition typical of a *nkisi,* would have contained ritual substances to allow the chief to invoke spiritual power. It is exceptionally rare to find such a container on a staff top, but this may be a reflection of Western collecting practices more than Kongo custom. BMF

PROVENANCE

86-2-1:
Belgian colonial official, Belgian Congo, early 1930s
Private collection, Belgium, 1930s to 1980s
Alan Brandt, New York, 1986

85-15-4:
Deleval family collection, Spa, Belgium, before 1940 to 1982
Madame Marchand, Brussels, 1982
Emile M. Deletaille, Brussels, 1982 to 1985

PUBLICATION HISTORY

86-2-1:
Leiris and Delange 1968: 84–85, nos. 77–78
Cole 1989: 147, fig. 172
Lehuard 1989: 497, J 6-1-7

85-15-4:
Ross 1992: 28, fig. 1-43

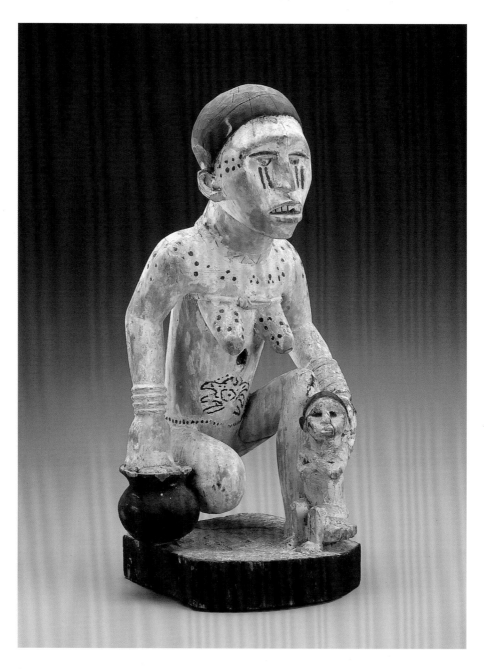

80. KNEELING FEMALE FIGURE AND CHILD

Kongo peoples, Mayombe region, Democratic
Republic of the Congo, Republic of the Congo,
and Cabinda district, Angola
Wood, pigment, mirror glass
H. 54 cm (21¼ in.)
Gift of the Eugene and Agnes E. Meyer
Foundation, 72-41-4

To the Kongo peoples, all exceptional powers result from some sort of communication with the dead, and the grave is one place that anyone, not just a ritual specialist or chief, can seek help (MacGaffey in MacGaffey and Harris 1993: 59, 61). Graves could be marked with imported ceramics, local terracottas (see cat. no. 81), glass liquor bottles, ivory tusks or stone figures. Differences in practice occurred over time and with locality, and with the character and importance of the deceased. Some Kongo peoples, notably those in the Mayombe region, placed wooden figures near their graves. These figures were sheltered in open-sided roofed structures (Sydow 1954: pl. 62C) that served to preserve their white pigment and protect the wood.

White is the color of the other world, the spirit world (MacGaffey in MacGaffey and Harris 1993: 88), and kaolin, or white clay, is a common ingredient in ritual medicines. In simplified terms, white clay in this context is the opposite of life, which is present in the skin of a person and the soil of fertile land. Even so, this figure, although in contact with the unseen world, seems very much alive.

The figure's inlaid eyes reflect light, and to the Kongo peoples, they suggest the ability to look into the spirit world. Her wide-open eyes *(meeso mapene)* express the attention she is paying to the words of an elder (the deceased ancestor in a funerary context) concerning the well-being of her child or, in an ancestor-descendant relationship, the future children of the entire family (Thompson in Thompson and Cornet 1981: 244). Her stare also emphasizes her presence in the world of the living (125).

Certainly she seems caught in a moment of time, ready to move. Kneeling on one bent leg is a less well documented pose than on both knees, a gesture of respect. The asymmetric posture also shows respect but is more dramatic, for further action is possible. This stance is also employed in figures of hunters. Both wood *nkisi nkondi* figures and stone grave figures with guns *(mintadi)* kneel as though ready to present their weapons to a person in authority (Thompson in Thompson and Cornet 1981: 109). This female

figure holds her left hand behind the child, supporting and protecting the next generation. The open palm of her right hand rests on a pottery vessel, as though offering food to those who have gone. The vessel may also relate to the use of common pottery cooking pots to hold ritual medicines. This nonfigurative type of *nkisi* was common among Kongo peoples and survives in the New World (MacGaffey in MacGaffey and Harris 1993: 67–68) but was not as likely to be collected by Europeans.

The figure's necklace may be a charm or amulet (Thompson in Thompson and Cornet 1981: 125–26). It does not seem to be an insignia of leadership, such as a leopard tooth necklace. Nor does she have the high-status flaring hairstyle or knotted fiber cap that appears on some figures. She does have a chest cord, chiseled teeth and scarification, meant to enhance her beauty. The scarification is painted rather than carved (see cat. no. 78). The groupings of three dots on the chest symbolize the "threeness" of the living represented by the child, the leader and the elder (Fukiau in Thompson and Cornet 1981: 125).

Although referred to as a child, the smaller figure does not match modern sentimental visions of childhood. He is a miniature adult in appearance. Without the genre aspects of childhood, he is a representation of the ongoing fertility of the group as a whole and the deceased's family in particular. His pose, with arms crossed upon the chest, is a gesture by which he encircles himself in silence, meaning "I have no more to say" (Thompson in Thompson and Cornet 1981: 167–68). BMF

PROVENANCE

Agnes E. Meyer, before 1972

PUBLICATION HISTORY

Museum of African Art 1973: 44, no. 316
National Museum of African Art 1981: cover
Smithsonian Institution 1982: 34, no. 185
Park 1983: 397
Walker 1983: no. 6
Robbins and Nooter 1989: 361, no. 938

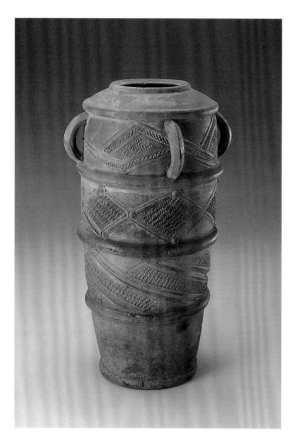

81. GRAVE OBJECT *(dibondo, nkudu)*
Kongo peoples, Democratic Republic of
the Congo
Terracotta
H. 45 cm (17¹¹⁄₁₆ in.)
Museum purchase, 89-13-7

Kongo women handbuilt the majority of domestic pottery, but male Kongo potters fashioned pipes and bowls for calabash water pipes and vessels with animal and human figures that they sold to outside markets. On occasion, men were observed creating water and cooking vessels for local use (Laman 1953: I, 126–27; Dartevelle 1935: 914–20; Coart and Haulleville 1907: 25, pl. IV).

More significantly, men produced important ritual pottery, including Kongo grave objects, the tall, hollow, open-based cylindrical terracotta forms known as *mabondo*. Although 17th-century Europeans described terracottas on Kongo graves that may be linked to *mabondo*, more recent scholarship suggests that the form originated in the 19th century (Thompson and Cornet 1981: 76, 78; Coart and Haulleville 1907: 20–21; Schrag 1985: 251). Wealthy Kongo commissioned *mabondo* to commemorate the dead. They were often highly decorated with figures or incised and impressed motifs. The diamond motifs with bosses at the corners of this vessel probably represent the journey the Kongo believe humans must take when they die, traveling between the land of the living and the land of the dead. Production ceased in the 1930s (Thompson and Cornet 1981: 27–28, 221).

Kongo men and women employed similar methods to create their vessels, but the men had exclusive use of some implements. For example, male potters sometimes handbuilt their vessels on turntables made of wood or clay. The turntable was attached to a wood plank which was fixed to the ground with a long spike or a small piece of wood, a stone or a clay pivot. Assistants turned the devices with their hands or if the edges of the turntable were serrated, the potters manipulated them with their feet. They then fired their vessels in the open (Coart and Haulleville 1907: 41–43; Thompson and Cornet 1981: 222; Dartevelle 1935: 915, 918). AN

PROVENANCE
Walshaert collection, Antwerp, before 1930
Marc Leo Felix, Brussels, late 1980s

PUBLICATION HISTORY
MacGaffey in MacGaffey and Harris 1993: 61, fig. 42

82. WHISTLE (nsiba)

Kongo peoples, Loango region, Republic of
the Congo
Wood, duiker antelope horn
H. 17.8 cm (7 in.)
Museum purchase, 91-4-3

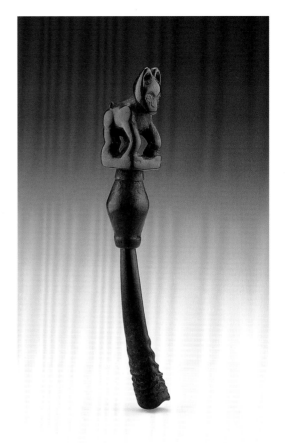

From a functional viewpoint, this whistle is
illustrated upside down; the musician would
have blown across the wide opening of the ante-
lope horn. The alert animal is the visual focus
and likely refers to a Kongo proverb, but with
the surface worn smooth from handling, identi-
fication of the subject is uncertain. Indeed,
there may be some deliberate obscurity, since
knowledge of spiritual forces is not for a casual
viewer.

The flat face is hard to define—almost hu-
man, with a nose rather than a muzzle—but
the crouching body is that of an animal. It has
neither the horns of an antelope nor the tail
and handlike paws of a monkey, animals found
on other whistles. A logical and probable iden-
tity is a dog, with body poised and ears pricked,
waiting for the hunt to begin.

The Kongo say that dogs have "four eyes"—
two for this world and two for the other. As
domestic animals, dogs are at home in the
village, the land of the living. As hunting dogs,
they go into the forest, the home of the dead
(MacGaffey in MacGaffey and Harris 1993: 42–
43). While whistles are used as hunter's signals
by many African peoples, including the Kongo,
there is another type of hunt with a more elu-
sive quarry that reflects the special classifica-
tion of the dog in Kongo thinking about the
world of spirits. A whistle owned by a ritual
specialist, or *nganga*, would be part of the pub-
lic performance that occurs when he activates
the spiritual forces contained in his *nkisi*, a
container that sometimes takes the form of a
figure and holds magical and medicinal sub-
stances. The dog in this context would symbol-
ize the ability to control spiritual forces and,
more particularly, skill at tracking witches,
beings that intend harm to another. The whistle
would be considered part of the *nkisi* and could

be worn by the *nganga*, hung on the carved
wood *nkisi* figure or incorporated into its bundle
of medicines. *Nsiba*, the Kongo name for this
type of whistle, comes from the verb "*siba*,"
which literally means to call on a *nkisi* (58).

A signed wood base (not illustrated) carved
by the sculptor Inagaki indicates that this
whistle was in Paris in the 1920s. It was in the
collection of Dr. Stephen Chauvet, the author
of a number of pioneering works on central
African music and medicine. BMF

PROVENANCE

Stephen Chauvet, Paris, probably before 1929 to 1950
Maurice Ratton, Paris, c. 1950
Private collection, c. 1965 to c. 1985
Anthony Slayter-Ralph, Santa Barbara, c. 1985 to 1991

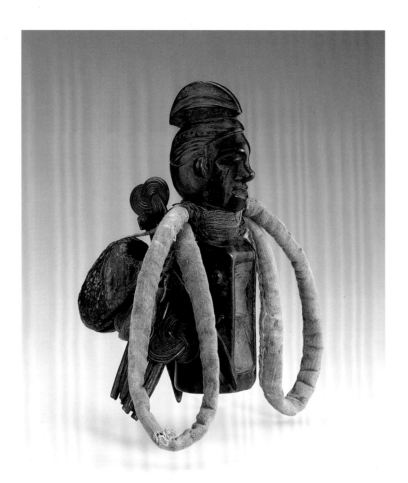

83. CHARM

Yaka peoples, Democratic Republic of the Congo
20th century
Wood, seed pod, cane, shells, cotton, metal,
accumulated materials
H. 18.7 cm (7¼ in.)
Gift of Marc Leo Felix, 83-3-4

This object resembles a *n-konu*, a sculpted slit
gong decorated with a fully realized human
head. Diviners used the *n-konu* to ascertain
the cause or meaning of continued misfortune,
untimely death or sustained illness. This piece,
however, is too small to have functioned as
such. *N-konu* range in size from 26 to 50.4 cm
(Bourgeois 1984: 96–106) and are also used as
musical instruments, mixing bowls for prepar-
ing medicines from vegetal ingredients and as
stools. Its diminutive size and the medicine
stored in it suggest that this piece functioned
as a protective charm that was worn or carried
during the hunt or while on a journey (Arthur P.
Bourgeois 1985: personal communication).

RAW

PROVENANCE
Walshaert collection, Antwerp, before World War II
Marc Leo Felix, Brussels, — to 1983

PUBLICATION HISTORY
African Arts 1984: 40–41

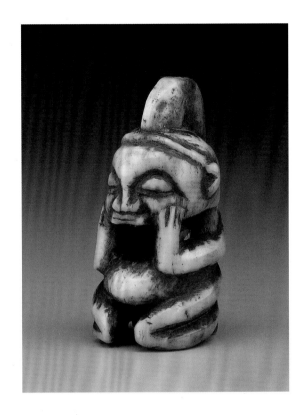

84. PENDANT

Huana peoples, Democratic Republic of
the Congo
Ivory
H. 6 cm (2⅜ in.)
Bequest of Mrs. Robert Woods Bliss, 69-20-3

The pose of this small Huana figure is typical
for objects of this sort—a kneeling female raises
her hands to her cheeks. Flat versions, both
profile and frontal, are more common than
this three-dimensional form. Unfortunately,
nothing is known of either type. The Huana
no longer make or use these ivories, or even
have accounts about when they did. Since
both styles are pierced, it is assumed they were
worn as pendants that served to protect or to
denote status. The crest hairstyle and large
stomach imply female sexuality and fertility.
More subtle is the suggestion of inward spiri-
tual force, conveyed by the closed eyes and
contained lines of the figure. BMF

PROVENANCE
Mrs. Robert Woods Bliss, Washington, D.C., before 1966
to 1969

PUBLICATION HISTORY
Robbins 1966: fig. 279

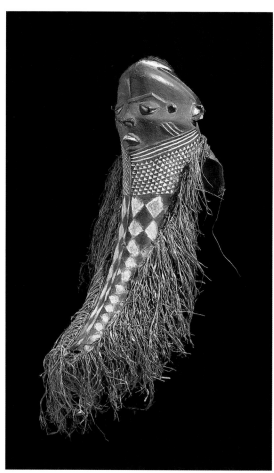

Photo by Jeffrey Ploskona, 1988

85. MASK *(giwoyo)*

Pende peoples, Democratic Republic of
the Congo
Wood, raffia, pigment
H. 71.1 cm (28 in.)
Museum purchase, 85-15-5

The form of this relatively naturalistic mask
(giwoyo) is defined by the head and the exten-
sion beneath the chin known as *gilanga* or
mutumbi (Strother 1998: 175). The head has
a jutting triangular-shaped forehead, partially
closed triangular-shaped eyes, eyebrows that
join to make an M-shaped line, prominent
cheekbones, an upturned nose and a small
downturned mouth. The extension, to which
a raffia border is attached, is embellished with
a series of striking light and dark triangles at
the top and diamond shapes below.

Pende describe *giwoyo* as one of their oldest
masking traditions which originally came from
Angola and predate the Pende migration into
the Democratic Republic of the Congo (Strother
1998: 174). It is the only Pende mask worn on
top of the head, like a baseball cap, and the
only major village mask to be performed in
the bush. The strongly chiseled features of the
mask allow the audience to view the mask's
profile at a distance during performances (175,
181). Citing the work of Congolese scholar
Mashini Gitshiola, Strother says that the mask
represents a cadaver on its funeral bier at a
wake (178). *Giwoyo* might represent the sur-
vival of an archaic ritual in which the masquer-
ade ushered the spirit of the departed out of the
village. Further scholarly speculation centers
on the possibility that in the past Pende mas-
querading may have been part of a complex of
funeral rituals (180). AN

PROVENANCE
Dr. Muller, collected in Belgian Congo, 1924 to 1938
Muller family collection, Brussels, until 1984
Emile M. Deletaille, Brussels, 1984 to 1985

86. MASK *(mwana pwo)*

Chokwe peoples, Muzamba region, Angola and
Democratic Republic of the Congo
Wood, raffia, metal, kaolin, pigment
H. 39.1 cm (15⅜ in.)
Museum purchase, 85-15-20

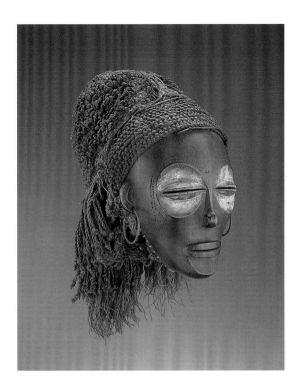

This mask represents a beautiful young woman
adorned with tattoos, earrings and an elaborate
coiffure. The original Chokwe name *(pwo)* re-
ferred to an adult woman who had given birth.
The more recent name, *mwana pwo*, probably
adopted under European influence, emphasizes
youthful, feminine beauty.

The artist carved this mask with very deli-
cate, even, thin walls from the wood *Alstonia*
(probably *congensis*). The surface is a rich,
reddish brown color, probably obtained from a
mixture of red clay and oil, and has a beautiful
patina, a sign of long use. The half-closed eyes
placed in large, concave sockets are covered
with white clay (kaolin). The eyes, slender nose,
elliptical mouth and hemispherical ears are
delicately carved on a face delineated by a softly
modeled forehead and concave chin.

The major components of the fiber coiffure
are a braided headband and a heavy fringe at
the rear. Chokwe women typically wore a hair-
style entirely coated with red earth and known
as *tota*.

The artist carved several different represen-
tations of tattoos on the mask. On the left
cheek and forehead are the triangles of the
tattoo known as *cingelyengelye*. Originally,
cingelyengelye occurred as a necklace in the
form of a cross, cut from tin plate, and worn
by the Chokwe as an amulet. During the 17th
century, Capuchin monks from the Order of
Christ of Portugal had distributed medals in the
form of a cross throughout Chokwe country,
and this cross was probably the prototype for
cingelyengelye. On the right cheek of the mask
is the tattoo known as *cijingo*, in combination
with a cross. *Cijingo* denotes a spiral brass
bracelet. On the forehead and extending to the
temples is the tattoo known a *mitelumuna*, or
"knitted eyebrows," an allusion to discontent-
edness or arrogance. Under the eyes are tattoos
known as *masoji*, signifying tears.

Pwo or *mwana pwo* is one the most popular
dancing masks among the Chokwe. Because

they follow matrilineal descent, the Chokwe
dance *pwo* to honor the founding female ances-
tor of the lineage. A male dancer is dressed
like a woman in a costume of braided fiber
that completely covers his body and hides his
identity. He wears a loincloth, carries a fan
and moves in slow, precise steps to emulate a
woman. When the mask becomes unusable,
it is discarded. When a masquerader dies, the
mask is buried with the dancer (Bastin 1980).

AN

PROVENANCE
Private collection, Brussels
Galerie Dierickx, Brussels, 1969
Emile M. Deletaille, Brussels, 1969 to 1985

PUBLICATION HISTORY
Kunsthaus Zürich 1970: pl. 85
Bastin 1974: 19, 35
Sabena Revue 1974: pl. 79
Société générale de banque 1974: pl. 81
Leuzinger 1978: pl. 108
Leuzinger 1979: 107
Bastin 1982: 104–5, pl. 15
Bodrogi 1982: pl. 349
Rubin 1984: I, 171
Damme 1987: 40, fig. 8
Kerchache, Paudrat and Stéphan 1993: 338, pl. 227
Jordán 1998: fig. 59 and front cover

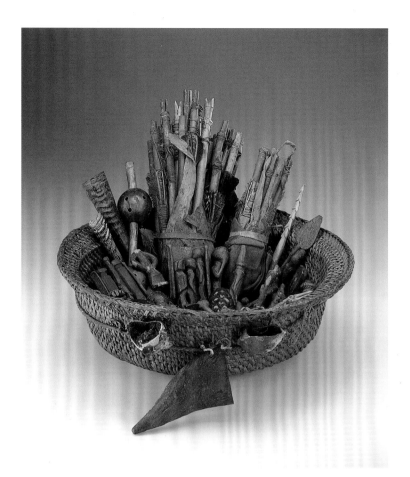

87. DIVINATION BASKET AND CONTENTS

Chokwe peoples, Democratic Republic of the
Congo and Angola
19th or early 20th century
Fiber, various materials
Diam. 30.7 cm (12 1/16 in.)
Museum purchase, 86-12-17.1

Part of a divination ensemble known as *ngombo ya cisuka*, this beautiful, well-made coiled basket, created by a post-menopausal woman (Silva 1999:16), contains more than 100 small objects of various types and materials. Each object has a name and meaning associated with daily affairs (Bastin 1982: 57).

People consult a diviner for many reasons, including illness, accidents, death, sterility or impotence. The diviner *(tahi)*, often the headman of his village, repeatedly shakes the basket with the objects inside. Depending upon where the objects come to rest in the basket, the diviner interprets the meaning of the pieces for his client. Sessions may last several hours (Bastin 1982: 57).

Created by the diviner and his assistants, the items in the basket include natural objects and representations of people and animals. For example, *kalamba kuku wa lunga*, or ancestor figures, squat with their elbows on their knees, indicating desolation because their descendants have neglected them. Another figure wears a *mukishi* mask, worn during circumcision rituals, and evokes the spirit of *cikunza*, associated with hunting and fertility. *Katwambimbi*, the weeping woman shown with her hands over her head, is a sign of imminent death (Bastin in T. Phillips 1995: 268–69). AN

PROVENANCE

Collected in Africa, before 1930
Private collection, Belgium
Pierre Loos, Brussels, before 1972
Emile M. Deletaille, Brussels, 1972 to 1986

PUBLICATION HISTORY

Jordán 1998: fig. 120

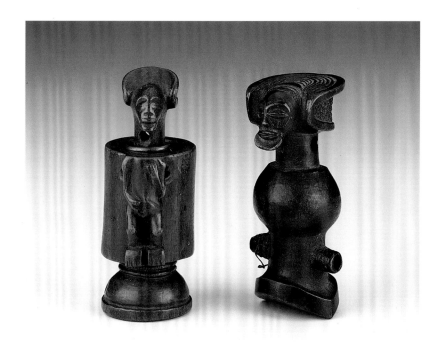

88. SNUFF MORTAR

Chokwe peoples, Angola, Democratic Republic
of the Congo and Zambia
19th century
Wood, brass
H. 8.9 cm (3½ in.)
Acquisition funds donated by the Honorable
and Mrs. Walter E. Washington and museum
purchase, 85-2-1 A, B

WHISTLE

Chokwe peoples, Angola, Democratic Republic
of the Congo and Zambia
19th century
Wood
H. 8.9 cm (3½ in.)
Acquisition funds donated by Dr. Richard Long,
the Honorable Frank E. Moss and Mrs. Helen
Neufeld, 85-2-3

Tobacco, a plant indigenous to the New World
and introduced to Africa by the Portuguese,
probably reached the Chokwe via the Kongo-
Kwilu peoples or the Benguela trade route in the
17th century (Vansinà 1978: 190, 348–49 n. 16).
In the beginning tobacco was smoked in pipes;
by the 18th century it was ground into snuff.
Because of the expense, snuff became the pre-
rogative of chiefs who offered it in hospitality
to visitors and to the spirits in religious rituals
(Bastin 1982: 133). Joachim John Monteiro, a

19th-century visitor to Angola, saw Chokwe
snuff mortars "carved out of wood and variously
ornamented" (1875: 2, 769). This snuff mortar
(85-2-1 A, B), for example, is decorated with a
human torso, whose head is a stopper. The head
probably represents a chief wearing a royal head-
dress. The mortar was carved from a fine wood
that did not require the application of pigment
to enhance its beauty. A beautiful patina even-
tually developed from handling.

Chokwe hunters used finely carved whistles
to communicate with their dogs and other
hunters. As items of royal regalia, they were
displayed on a chief's ceremonial spear. The
decoration on this whistle (85-2-3) may depict
a chief's head, like the snuff mortar stopper, or
a Chihongo mask (Bastin 1982: 238). RAW

PROVENANCE

85-2-1 A, B:
Emile M. Deletaille, Brussels, — to 1985
85-2-3:
Private collection, Belgium, before 1985
Emile M. Deletaille, Brussels, — to 1985

PUBLICATION HISTORY

85-2-1 A, B:
Walker 1991: 22

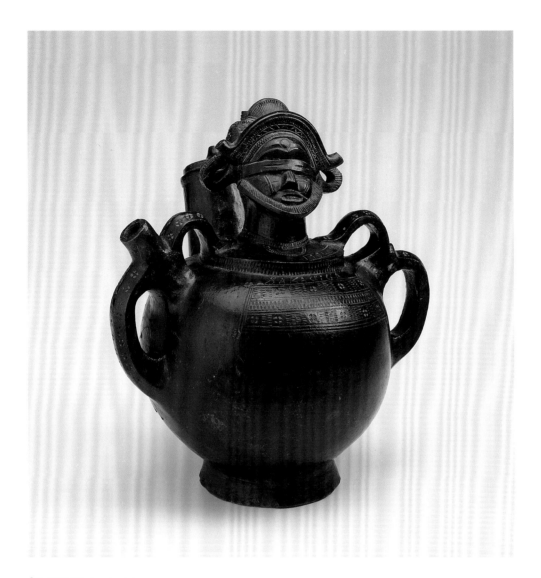

89. VESSEL *(mulondo)*

Artist: Sakadiba
Lwena peoples, Democratic Republic of
the Congo
1940
Terracotta
H. 28.9 cm (11⅜ in.)
Museum purchase, 83-3-5

Handbuilt by a Lwena man, this water vessel is
a type called *mulondo*. It is elliptical in shape
with a decorated surface burnished to a high
sheen. The top represents a Lwena male wear-
ing a fiber dance mask, called *cizaluke*, and a
crown traditionally worn by royal rulers. The
potter probably blackened the body of the vessel
immediately after firing with a concoction
made from the seeds of the locust pod or a tree
bark infusion (Darish 1990: 21).

The Lwena lived in Angola until the late
19th century when they migrated to what are
now the Democratic Republic of the Congo,
Angola and Zambia. The Lwena share cultural
traits with the Chokwe including traditions
such as handbuilt pottery. Among both groups
women produce domestic pottery while men
create *mulondo*, which were often sold to out-
side visitors. As in the rest of sub-Saharan
Africa, the potter's wheel was unknown. AN

PROVENANCE
Collected by an American nutritionist in Shaba prov-
ince, 1945, a gift from a relative of Maurice Tshombe,
a prime minister of the Democratic Republic of the
Congo
Mona Gavigan, Washington, D.C., 1983

90. FEMALE FIGURE

Lwena peoples, Angola
Wood, pigment, antelope horn, textile, glass
beads, cowrie shells, metal
H. 36.5 cm (14⅜ in.)
Museum purchase, 96-8-1

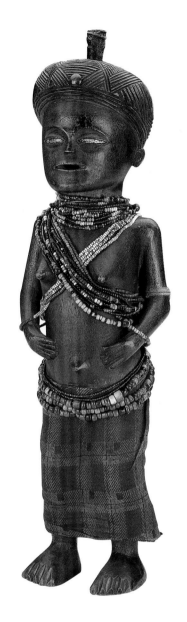

This female figure is in what is often described
as the classic Lwena style. The figure stands in
a restrained pose with arms drawn in over the
waist, framing the naval. The delicate, serene
facial features are surmounted by a flat-topped
cushion-shaped coiffure. Small almond-shaped
eyes are covered with metal inlay. The beads
and textile skirt worn by the figure are rare sur-
vivors, as is the antelope horn inserted into the
crown of the head. Often such additions were
removed by art dealers or collectors as elements
that obscured the basic sculptural form.

The inverted horn and the cloth bundles
on the upper left arm and back of this figure
strongly suggest a protective or medicinal
role, and it may have a connection to honoring
female ancestors or a diviner's tutelary spirits
(Bastin 1969a: 53). The figure's costume, hair-
style and general appearance seem to be associ-
ated with female initiation. This transferred
a girl's affiliation from her parents to her hus-
band. Particularly detailed documentation about
the process comes from the Lunda peoples. The
development of breasts is the criterion for their
ceremony, and the small breasts of the figure
seem to be that of a young girl. After a period
of seclusion, varying in length and featuring
instruction in traditional dances and sexual
matters, the girl emerges. She has scarification,
thought to be sexually attractive, which was
created during initiation; a shaved hairline; and
hair rubbed with red clay and castor oil to form
a caplike coiffure. She wears a wrap skirt, and
her chest is crossed with beads, including
the white beads she received on beginning the
period of seclusion. Medicine-filled rattles take
the form of little bundles that are worn on her
legs and at the small of her back (Turner 1953:
355–58, pl. 2). Another source writes of a Luvale
(Lwena in Zambia) coming out and wedding in
which the young woman is similarly treated: her
head is shaved and the remaining hair plaited,
her body and hair oiled and colored with red
clay, and she is adorned with beads around her
neck and between her breasts (White 1962: 11).
Both the Lunda and Lwena occasions emphasize
the importance of fertility as the defining dis-
tinction between child and adult. While not
used in this transitional ceremony, this type
of figure may very well have had some role in
promoting and protecting a woman's fertility,
perhaps during childbirth. BMF

PROVENANCE

Gaston de Havenon, New York, before 1988
Tambaran Gallery, New York, c. 1991 to 1996

PUBLICATION HISTORY

Sotheby Parke Bernet 1982: no. 291

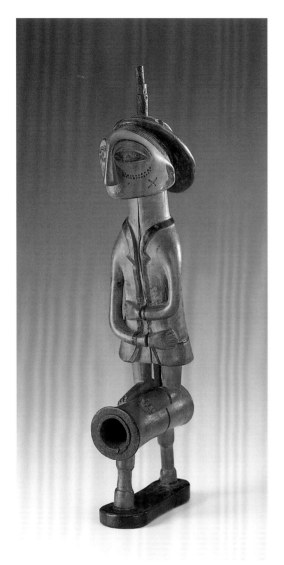

91. PIPE

Mbundu people, Angola
Wood, iron
H. 30.8 cm (12⅛ in.)
Gift of Ernst Anspach, 93-11-1

Not until 1949—when Robert Verly carried a collection of artifacts from Angola back to Belgium—was it known that the Mbundu people had a sculptural tradition (Bastin 1969b: 37). Their carvings were usually misidentified as Chokwe, whose art forms share stylistic characteristics of the Mbundu. Mbundu sculptures are distinguished by their light-colored wood, and they are often selectively embellished with pyroengraving. Figures have elongated faces, almost naturalistic proportions and characteristic hairstyles. In part because the Mbundu had a long association with the Portuguese, their sculpture is perhaps more likely to include European motifs.

One of the more frequent types of carved Mbundu objects is the pipe. Pipes, along with staffs, flywhisks and hatchets, were part of the treasured possessions of Mbundu chiefs. Upon investiture, each chief was entitled to select an object that would symbolize his reign and, upon his death, be returned to the chest of treasures.

Mbundu pipes usually incorporate one or more human figures. The carvings take two orientations: vertical, in which the iron stem extends through the back of the figure, or horizontal, in which the pipe stem forms a base for one or more figures. The figures may be male or female.

This vertical pipe depicts a male wearing European dress. The stem of the pipe goes through the body; the mouthpiece projects from the top of the head. The figure's face displays the characteristic scarification patterns of the Mbundu; his hairstyle mimics that of a young Mbundu woman. Hambly (1934: 31) identified the hairstyle, reporting that Mbundu women trained their hair into two long loops at the back of the head bound tightly with black cloth.

LP

PROVENANCE

Harvey Menist, Amsterdam, — to 1968
Ernst Anspach, New York, 1968 to 1993

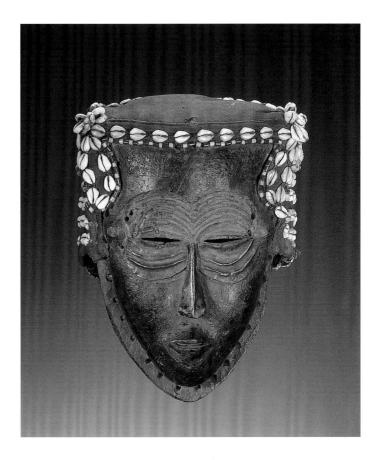

92. MASK

Lele peoples, Democratic Republic of the Congo
20th century
Wood, wood pegs, copper, iron, pigment, fiber,
cotton, wool, cowrie shells, glass beads
H. 28 cm (11⅟₁₆ in.)
Museum purchase, 94-14-1

Lele visual arts are rich in utilitarian objects
such as boxes, pipes and cups (Douglas 1963;
Alard 1984). Ritual masks, however, are rare,
and their functions are little known (Roy 1992:
231). This mask is one of the few that exists
outside Africa.

Lele stylistic traits exhibited by the mask
include a broad, flat face; wide forehead; round
narrowing chin; arched eyebrows; narrow slit
eyes; long, narrow triangular-shaped nose; and
a small mouth (cf. Roy 1992: fig. 26). Its head-
dress is elaborately decorated with cowrie shells
and blue and yellow glass beads. Until the early
decades of this century, in much of sub-Saharan
Africa beads and cowrie shells were valuable
trade items extensively used as currency and to
decorate regalia and ritual objects.

Particular elements of the masks of the

neighboring Kuba/Bushoong and Pende have
been appropriated by the Lele. The headdress
on this mask, for example, evokes the Bushoong
hairline and the practice of covering areas of
the face with metal. The flat wooden face and
headdress are also similar to face masks found
among the Akwa Pinda, a Pende group living
in the Kasai region (Herreman and Petridis
1993: 124; Roy 1992: fig. 94).

Lele masks are thought to have appeared in
dances accompanying the burial rites of chiefs
and in annual foundation/creation ceremonies
(Neyt 1981: 179; Roy 1992: 231). Masks have
a similar use among the Kuba, who share a
creation myth with the Lele (Roy 1992: 231).

RAW

PROVENANCE

Christian Van Lierde, Brussels, collected in Democratic
Republic of the Congo, 1974 to 1994

PUBLICATION HISTORY

Neyt 1981: 181, fig. VIII.24
Herreman and Petridis 1993: 125, cat. 57

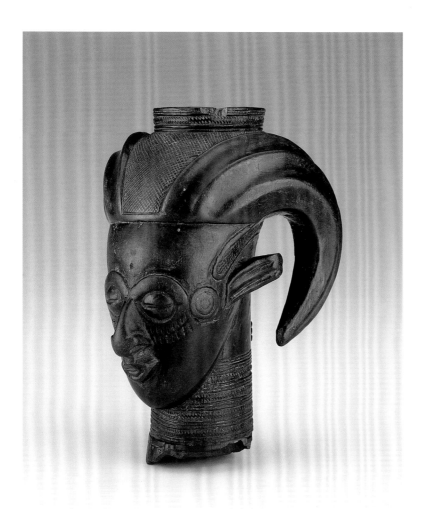

93. CUP
Kuba peoples, Democratic Republic of the Congo
Wood
H. 21 cm (8¼ in.)
Museum purchase, 86-12-15

This Kuba prestige cup is a deft combination of human and animal traits. The human face is topped by a hairstyle in the form of ram's horns. This cup may have been royal property. The ram was a royal animal whose horns symbolized the supernatural power of kings and princes. The dense geometric carved patterns on the cup reflect the Kuba preference for overall decorative patterning.

The cup was for palm wine, a popular drink served frequently. Such elaborately carved cups, highly prestigious possessions of Kuba men in the 19th and 20th centuries, have been gradually supplanted by metal or plastic vessels (Binkley in Koloss 1990: 48). AN

PROVENANCE
Pierre Dartevelle, Brussels, before 1974
Emile M. Deletaille, Brussels, 1974 to 1986

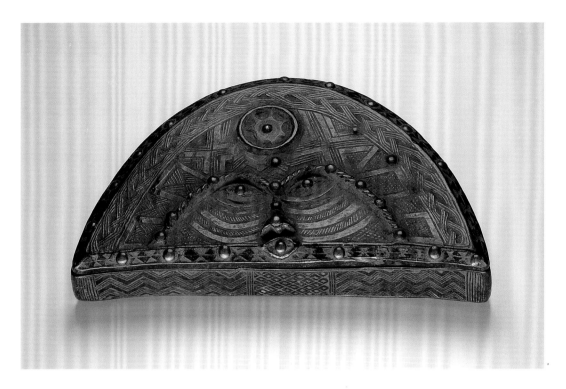

94. BOX

Kuba peoples, Democratic Republic of the Congo
Wood, pigment, brass tacks
L. 34 cm (13 ⅜ in.)
Museum purchase, 85-1-19

The Kuba carved and used an incredible variety of wooden boxes—taking the shape of semicircles, rectangles, faces, houses and baskets. The varied forms held small prized possessions such as razors, feathers and beads. As indicated by the residue inside, this box once held red powdered wood, a cosmetic.

Whatever the overall shape and function of the boxes, the lids and sides are usually decorated with incised geometric patterns. The same design preferences are reflected in Kuba textiles (see cat. no. 95), cups, pipes, drums and other objects. The lozenge forms carved on the outermost band of this lid represent cowrie shells. A longstanding form of currency in much of Africa, cowries literally are wealth. Originating in the Indian Ocean, the shells are the prizes of long distance trade. Similarly the imported brass tacks inserted into the decoration were valued because of their exotic origin and the effort involved in obtaining them.

A typical braided motif forms the second decorative band. Kuba artists often made their designs dynamic by avoiding exact repetition or symmetry, as can be seen here in the panels of geometric designs between the border bands and the face at the lower edge.

The human face is treated almost as another geometric pattern. The circular form above the face resembles the beadwork circle or section of conus shell that is worn on the center of Kuba headbands, items of court regalia. The same motif is carved on the top of Kuba knife handles.

Much of Kuba art demonstrates the basic relationship between the labor involved and the value of an object. The choice possessions held in boxes such as this would have inspired the investment of extra effort. BMF

PROVENANCE

Pierre Loos, Brussels, before 1980
Emile M. Deletaille, Brussels, 1980 to 1985

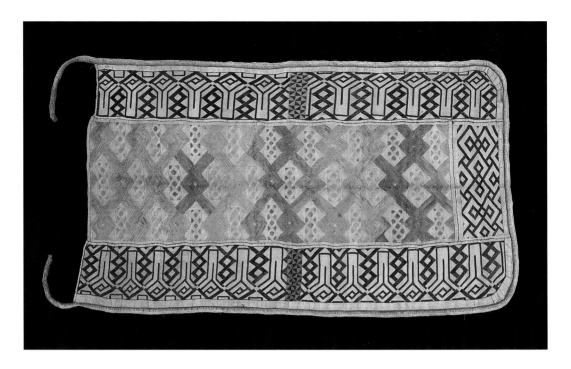

95. TEXTILE
Kuba peoples, Democratic Republic of the Congo
Raffia, pigment
150 × 81.5 cm (59⅛ × 32⅛ in.)
Gift of the Textile Arts Foundation, Robert D.
Barton and Nancy Hemenway, 96-43-1

Kuba textiles are made of raffia fiber. The foundation cloth is a plain weave, woven by men on an inclined loom. The fibers are softened before weaving by rubbing and, after, by kneading and beating the cloth. The embroidery thread is also raffia, which is dyed before stitching. After the embroidery, done by women, is completed, the edges are finished with either a hem or, as in this cloth, by bundling fibers and attaching the bundle with overstitching. Typically, neither the weft nor the plush are secured with knots.

The overall composition of this textile consists of interlacing diamonds and lozenges in two textures, the flat embroidery of the borders and the plush nap of the larger central panel.

Women wear this style of textile as an overskirt in combination with a much longer embroidered textile with a belt to hold it in place. Kuba peoples dress in elaborately embroidered textiles on many ceremonial occasions. They are worn at special events including funerals for notable persons and dance festivals or dramas that may reflect or defuse political tensions. The textiles also serve as shrouds or gifts to create reciprocal duties of support. LP

PROVENANCE
Pace Primitive, New York, — to 1986
Nancy Hemenway and Robert D. Barton (Textile Arts Foundation), Washington, D.C., 1986 to 1996

PUBLICATION HISTORY
Ravenhill 1997

Luba kingship flourished for more than 200 years in the area that is now Shaba province, and declined under Belgian rule in the late 19th century. Many of its ancient traditions have survived, however, among them the use of stools and staffs as emblems of leadership.

Usually one or two standing female figures, or more simply, a head carved in the round, may appear at the top of a Luba staff of office. Paired figures are thought to represent the twin spirits of Luba kingship, while a single figure or head represents a deceased king whose spirit is carried in a woman's body. This staff of office, which is decorated with a head, probably belonged to a village chief or a court dignitary among the Central Luba (Nooter 1984: 50, 1985: 75).

The accomplished artist who carved this staff was obviously respectful of the stylistic canon but seems also to have had a personal style. For example, he has carved a face less spherical than those found on other staffs from this area, and he has given it a small but bold chin. Behind the fillet, the plaited hair is depicted as sets of chevrons that begin at the center of the forehead, at each temple and at the nape of the neck. At the back of the head, the plaits that compose the resulting cruciform coiffure are carved in high relief, creating voids beneath them. The long neck exhibits a naturalistic detail in the laryngeal cartilage that gently projects from the throat.

The sticky, resinous black patina on the face, beneath the chin and on the coiffure is the result of frequent applications of an oily substance. Staffs were commonly treated in this manner from the late 18th to the late 19th century (Nooter 1984: 43). RAW

PROVENANCE
Dr. DeCostur, Brussels, — to 1937
Louisa Muller-Van Isterbeek, Brussels, c. 1937 to 1979
Pierre Dartevelle, Brussels, 1979
Michael Oliver, New York, 1979 to 1985
Alan Katz, Chicago, 1985 to 1991
Michael Oliver, New York, 1991

PUBLICATION HISTORY
Arts d'Afrique noire (14) 1975: inside back cover

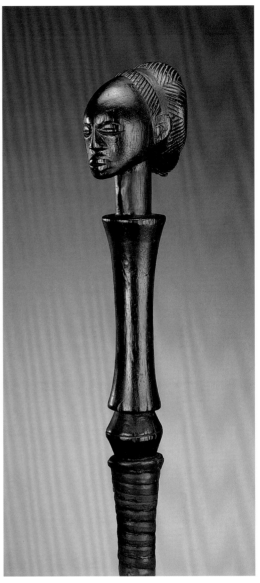

Detail

96. STAFF OF OFFICE (*kibango*)
Luba peoples, Shaba province, Democratic Republic of the Congo
c. 1880
Wood, copper, iron
H. 160.7 cm (63¼ in.)
Museum purchase, 91-19-1

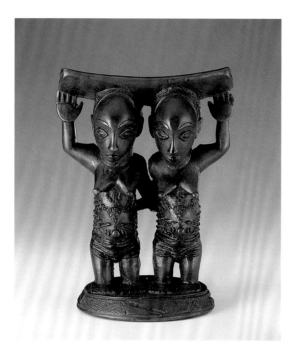

97. HEADREST

Attributed to the workshop of the Master of
Mulongo
Luba peoples, Democratic Republic of the Congo
19th century
Wood
H. 17.1 cm (6¾ in.)
Museum purchase, 86-12-14

The female form is abundantly represented in
the visual arts of the Luba peoples, whose king-
doms flourished in Central Africa from the
17th to the 19th century. Serving as priestesses,
political advisors, ambassadors and of course
as wives and mothers, Luba women were im-
portant members of society. In addition to
these roles, they served as spirit mediums for
deceased males. In the belief that only women's
bodies were strong enough for this sacred pur-
pose, a woman was selected to be the receptacle
of a deceased king's spirit and to inherit his
regalia and residence (Roberts and Roberts
1996: 41, 44). Thus women's images appear on
lukasas (memory boards), staffs of office (for
example, cat. no. 96), and spears and stools as
well as headrests.

Headrests are primarily utilitarian objects
used as pillows on which to sleep or rest and
to preserve intricate hairstyles. Decoration on
headrests may be symbolic. The pair of female
caryatids supporting this headrest, for example,
may depict spirit mediums who live together in
imitation of the *vidye*, twin guardian spirits of
Luba kings and other royals (Roberts and Rob-
erts 1996: 101).

This headrest and a nearly identical one at
the British Museum (1956 AF 27-270) have been
attributed to the workshop of the Master of
Mulongo on the Middle Lukuga River (Neyt
1994: 188, 121). RAW

PROVENANCE

Suys, collected in Africa, c. 1875
Huysmans, — to 1980
Emile M. Deletaille, Brussels, 1980 to 1986

PUBLICATION HISTORY

Neyt 1994: 188
Roberts and Roberts 1996: 101, cat. no. 40

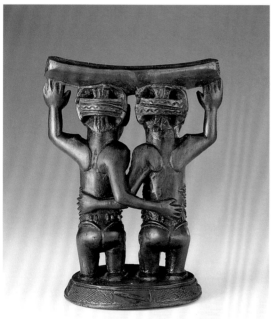

98. MALE FIGURE

Niembo chiefdom, Hemba peoples, Mbulula
region, Democratic Republic of the Congo
Wood
H. 66 cm (26 in.)
Museum purchase, 85-1-13

This figure conveys dignity and power with its
large ovoid head and delicately arched brows;
closed, almond-shaped eyes; cruciform coiffure;
elongated neck, arms and torso; protuberant
abdomen and square shoulders. These traits are
characteristic of a workshop in the Niembo
chiefdom in the eastern Democratic Republic
of the Congo.

The Hemba, like their Kusu and Tumbwe
neighbors, are a matrilineal people with a sculp-
tural tradition devoted mainly to representa-
tions of male ancestors. Although every figure
is the portrait of a specific person, the artist
portrays generalized, not particular, individual
traits. The figure is meant to reinforce notions
about the importance of family continuity and
the perpetuation of the clan (Roberts and Rob-
erts 1996: 215). AN

PROVENANCE

Pierre Dartevelle, Brussels, before 1971
Emile M. Deletaille, Brussels, 1971 to 1985

PUBLICATION HISTORY

Sabena Revue 1974: 81
Neyt 1975: cover
Neyt 1977: 53, fig. 20; 74, cat. 1, fig. 8
Bodrogi 1982: pl. 15

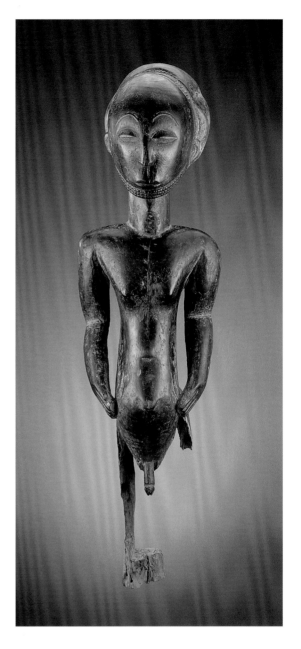

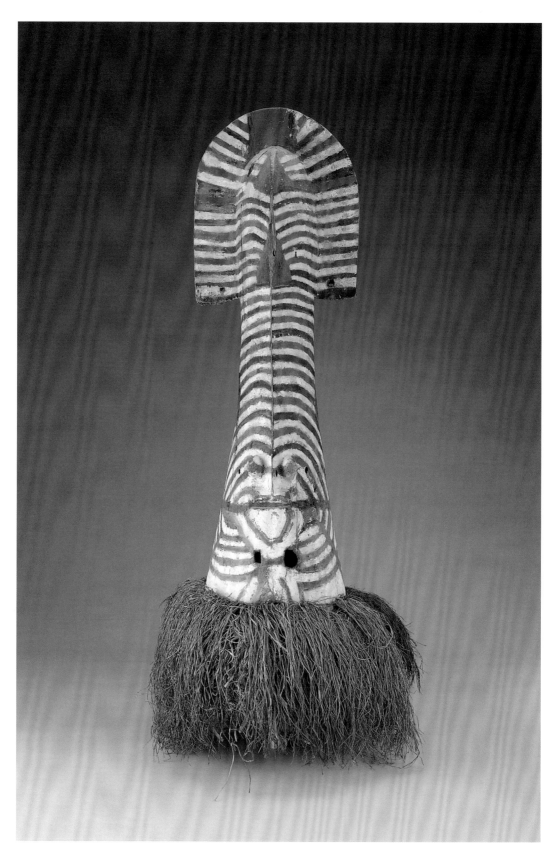

99. MASK (mwadi)

Sungu-Tetela peoples or Tempa-Songye peoples,
Kasongo, Democratic Republic of the Congo
Wood, kaolin, pigment, raffia
H. 89.2 cm (35⅛ in.)
Acquisition grant from the James Smithson
Society, 84-6-6.1

This mask is carved from a light-colored wood which has been completely covered with pigment that forms a coarse matte surface. Tubular projections near the midpoint of the mask suggest eyes, and an extended ridge indicates a nose. A photograph of this mask taken in 1924 shows that the mask's top crest held vulture and guinea fowl feathers, and the mask was worn with a raffia fringe that is still present. The costume for the mask included a fiber skirt (NMAfA 84-6-6.2) which was worn over an animal skin and a raffia cloth. The animal skin, identified as leopard, and feathers are emblems of power worn by chiefs (Ratner n.d. [c. 1983]: 19, illus. 7).

The collector and photographer of the mask was John Noble White, an educational missionary with the Methodist Mission at Minga in Shaba province (Ratner n.d. [c. 1983]). He identified the mask as "mwadi," the makers of the mask as "Tetela," and the owner of the mask as a "witch doctor," who used the masks for "the dance of the new moon" and for funerals and martial celebrations (White cited in Ratner n.d. [c. 1983]: 21–23).

There is a question whether this mask and the perhaps one dozen masks identified as Tetela in other collections are actually Tetela at all. Some of those masks are rather squat and cylindrical, with painted striped surfaces, projecting eyes and transverse crests. Some have incised linear decoration over concave faces and projecting brows, and they lack the top crest. The best known is in the British Museum (1979.AfI.2397). Emil Torday, an ethnographer collecting for the British Museum in 1908 in Kasongo and its vicinity, acquired masks termed moadi. He also named the people there as being Tetela, though his notes make "Sungu" seem like the preferred local designation (Mack 1990: 61–62). When Luc de Heusch did his fieldwork among the Hamba-Tetela in the forest heartland, in 1953–54, he was told that the Tetela

never made masks. And while the weetshi, a diviner-healer, is active among the Tetela, there was no evidence for the use of sculptures or masks (Heusch 1995: 193).

Kasongo, however, is on the edge of Tetela country, outside the forest, and the group there is the Sungu-Tetela. Kasongo is actually in the territory of the Songye peoples (Heusch in T. Phillips 1995: 281). Three masks identified as bwadi were collected in 1910 by a Belgian administrator named Müller from the Tempa-Songye people of this region. They are cylindrical helmet masks with transverse crests and painted stripes and are obviously closely related to Torday's and the museum's masks (Heusch 1995: 190–91, figs. 10–12).

The Songye are better known for their kifwebe masks with painted facial stripes. Unlike this helmet mask, however, Songye carvers tend to incise the stripes, and the entire form is executed more as a sharply sculpted face mask. Their dancers wear knotted fiber shirts that cover the body, arms and hands. Rather than a feather crest, Songye mask costumes in collections have a hide and feather "horn" projecting from the back of the head (for example, Africa Museum, Tervuren, RG30593). Despite White's and Torday's information, the word mwadi (or moadi) is not generally found elsewhere among the Tetela. However, the Songye phrase "bwadi bwa kifwebe" designates the mask society among the eastern Songye (Hersak in Heusch 1995: 18).

This mask may be either Sungu-Tetela or Tempa-Songye. It is a classic example of one problem besetting African art scholarship. Many objects lack field data, and others have misleading data. Yet two basic and true lessons apply: art and ideas travel, and change occurs.

BMF

PROVENANCE

John Noble White, collected in Kasongo, 1924 to c. 1975
John Buxton, c. 1975
Private collection, London, by 1979
Morton and Rebecca Lipkin, Phoenix and John Buxton, Dallas, c. 1983 to 1984

PUBLICATION HISTORY

Gillon 1979: 134, fig. 166, pl. 24
Heusch 1995: 1, photo 9

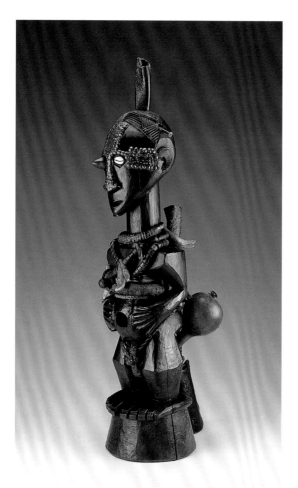

Among the sculptural traditions of the Songye of the southeastern Democratic Republic of the Congo is that of large, standing, often male figures with arms and hands placed at their sides or on their stomachs. The museum's figure has an awesome presence exemplified by masterfully carved geometric forms. The large ovoid head, columnar neck, bent legs and large flat feet set firmly on the base give the figure a secure place in its own space. The abdominal cavity once contained empowering medicines *(bisimba)*, which have been lost.

Among the Songye, such figures *(mankisi)* were associated with a magico-religious society known as the *bukisi*, which controlled initiation camps and circumcision ceremonies (Neyt 1981: 260–61; Mestach 1985: 140–43). A ritual specialist added magical substances, *bisimba*, to activate the figure as a source of power that would ensure the well-being of a community or individual (Hersak 1986: 118). Generally speaking, community *mankisi* serve a limited range of social needs such as procreation, protection against illness, sorcery, witchcraft, and war, and the preservation of territorial claims (Hersak 1986: 120). The large size of this *nkisi* suggests that it served the needs of a community. Because the figures were considered dangerous, specialists maneuvered them with sticks attached to their upper arms. A figure could be judged ineffectual because of the death of the ritual specialist who had furnished it with its powers, or after failing a series of tests to measure its power. In such instances, all of its empowering materials would be removed, and thus it would be deactivated (Mestach 1985: 161, 164–65). AN

100. MALE FIGURE *(nkisi)*
Songye peoples, Democratic Republic of the Congo
Wood, brass, iron, horn, glass beads, cowrie shell, leopard's teeth, gourd, reptile skin, fiber
H. 66 cm (26 in.)
Museum purchase and gift of Professor David Driskell, Friends of the National Museum of African Art, Robert and Nancy Nooter, Milton F. and Frieda Rosenthal, Honorable and Mrs. Michael Samuels, and Mr. Michael Sonnenreich, 86-4-1

PROVENANCE
R. Reisdorff, Belgian colonial administrator, acquired in then Belgian Congo (Democratic Republic of the Congo), 1912 to 1960s
Mrs. R. Reisdorff, Belgium, 1960s to 1986
Alan Brandt, New York, 1986

PUBLICATION HISTORY
Olbrechts 1959: pl. 176, XXXVI

101. HEAD

Lega peoples, Democratic Republic of the Congo
20th century
Ivory
H. 14.6 cm (5 ¾ in.)
Bequest of Eliot Elisofon, 73-7-315

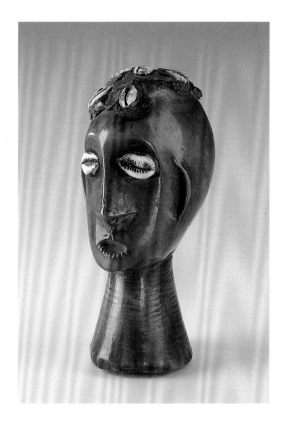

In the 19th century, prior to colonization by the Belgians, the Lega peoples had no centralized political system. They were governed by Bwami, a graded association open to all men and women in a given village. Bwami was both a political and an educational system by which esteemed Lega values were taught: moderation, nonviolence, solidarity, respect, constraint and moral as well as physical beauty. It was also a framework for political relationships, a means of establishing cross-kinship and cross-village solidarities and a source of entertainment. Above all, Bwami was a channel for prestige and the sole motivation for the visual arts (Biebuyck 1973; Klopper 1985).

Bwami sculptures were used as proverb images illustrating the principles of moral perfection. The name and precise meaning of this head is not known, but its features can be interpreted. The smooth, luminous bald head covered with a cap of cowrie shells, for example, represents a high-ranking Bwami elder who has, through successive initiations, achieved supreme wisdom (Biebuyck in Vogel 1981: 221).

Lega sculptures are rare because the Bwami society was outlawed in 1948, owing to the Belgian colonial government's misunderstanding of its beliefs and aspirations. Beginning in 1910, the Belgians also sporadically imposed a ban on elephant ivory, a primary raw material for Lega art. Theft or intentional destruction of hundreds of ivory carvings are a further cause of their rarity (Biebuyck 1970). RAW

PROVENANCE
Eliot Elisofon, New York, — to 1973

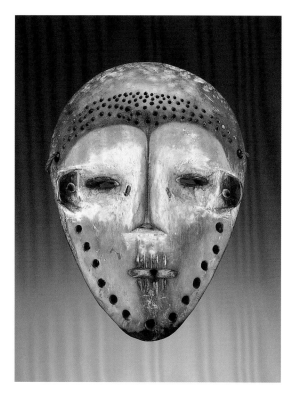

102. MASK *(idumu)*

Lega peoples, Kivu province, Democratic
Republic of the Congo
Wood, pigment
H. 29.2 cm (11½ in.)
Museum purchase, 93-4-1

Precolonial Lega society was governed by
Bwami, a graded association open to all men
and women in a given village. Bwami was also
an educational system through which esteemed
Lega values were taught. Above all, Bwami
conveyed prestige, and its activities were the
sole impetus for the visual arts (Biebuyck 1973,
1993: 183–97).

The highest grades in Bwami were *yananio*
and *kindi*, ranks comprising the intellectual,
moral and political elite of the society, who
were privileged to own or have access to the
most prestigious art forms. Among these were
carved wood and ivory or bone masks of various
sizes. In addition to serving as insignia of a
member's rank within Bwami, masks were also
symbols of the link between the living and their
deceased paternal relatives. They were also used
to teach Bwami initiates moral precepts.

Idumu masks celebrate the perpetuity of
the entire kinship unit and were collectively
owned by the lineage. They were handed down
from generation to generation and carefully
preserved; new masks were rarely carved. This
one was originally entirely whitened and prob-
ably had a fiber beard attached to it.

Like all Lega masks, the *idumu* was worn
not only on the face to conceal the wearer's
identity but also at the back of the head; it
could also be displayed on a fence or the sym-
bolic grave of a Bwami member. As teaching
aids, *idumu* masks illustrated proverbs about
correct behavior.

While Bwami was essential to Lega life,
the Belgian colonial government as well as
Christian missionaries saw it as immoral and
subversive. Consequently, the Belgian govern-
ment outlawed Bwami in 1948. RAW

PROVENANCE
Fernand Deville, Brussels, collected in Belgian Congo,
1920–39 to 1955
Private collection, Belgium, 1955 to 1993
Entwistle, London, 1993

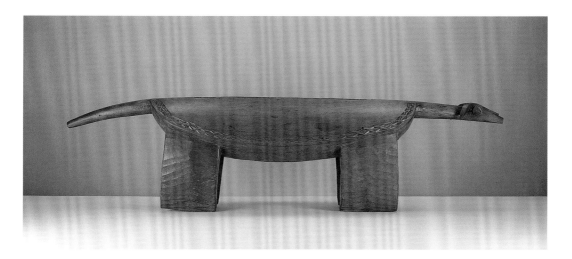

103. SLIT GONG

Lobala, Yangere and neighboring peoples,
Democratic Republic of the Congo and Central
African Republic
Wood
L. 248 cm (98 in.)
Acquisition grant from the James Smithson
Society and museum purchase, 92-12-1

Ownership of elaborately carved slit gongs was widespread among chiefs in north central Congo and southern Central African Republic. This monumental slit gong in the form of an animal, perhaps a buffalo, is carved from a single piece of wood.

A slit gong is an idiophone, a wooden drum without a drumhead. It is formed by hollowing out a log through a long narrow opening. One edge of the opening is thicker and emits a low tone when struck, while the thinner side gives a high tone. Slit gongs are played with sticks, the ends of which are sometimes covered with rubber. Because slit gongs can mimic the tones of human speech, they are used to transmit messages over long distances. They are also used to play music (Dietz and Olatunji 1965: 41; Laurenty 1995: II, 127–28).

This gong was probably part of an orchestra composed of slit gongs of different sizes, each of which made different tones. RAW

PROVENANCE
Collected by a Belgian army officer, before 1909
Private collection, Belgium, c. 1909 to 1982
Patrick Dierickx, Brussels, 1982 to 1992

PUBLICATION HISTORY
Arts d'Afrique noire (41) 1982: 28–29
Christie's 1992: 31, no. 96
Smithsonian Institution 1996: 84–85

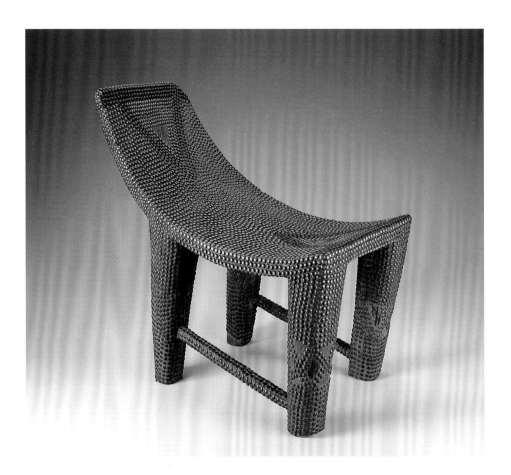

104. CHAIR
Ngombe peoples, Democratic Republic of
the Congo
Wood, brass and iron tacks
H. 61 cm (24 in.)
Museum purchase, 90-4-1

Except for the crosspieces between the legs, this chair was carved from a single block of wood. It is both a functional piece of furniture and an intriguing sculpture that combines the form of a traditional African stool with that of a European chair with a backrest (Sieber 1980: 160). The seat forms an integrated curve with the back, which is cantilevered away from the rear pair of legs. The top and bottom of the seat/backrest are narrower than the middle portion, creating a visually appealing silhouette. Special attention has been paid to the embellishment of the surface. Imported brass tacks cover the upper and lower parts of the stool, and iron tacks at each end create a special band-and-chevron decoration; the back and underside of the chair reveal carefully aligned adze marks whose parallel lines create a faceted surface.

Chairs like this one are illustrated in European travelers' accounts of their visits to Central Africa during the late 19th and early 20th centuries (Ward 1890: 128; Johnston 1895: 295; Johnston 1908: 945). Such chairs were apparently the prerogative of chiefs who could afford the European brass tacks used to decorate them. In Europe during the 1920s, the artist and designer Pierre Legrain (1899–29) designed chairs inspired by the Ngombe and other Central African peoples for his wealthy clients (Puccinelli 1998: 7). PLR/RAW

PROVENANCE
Alain de Monbrison, Paris, — to 1990

PUBLICATION HISTORY
Ravenhill 1991: pl. 1
Puccinelli 1998: cover, fig. 2

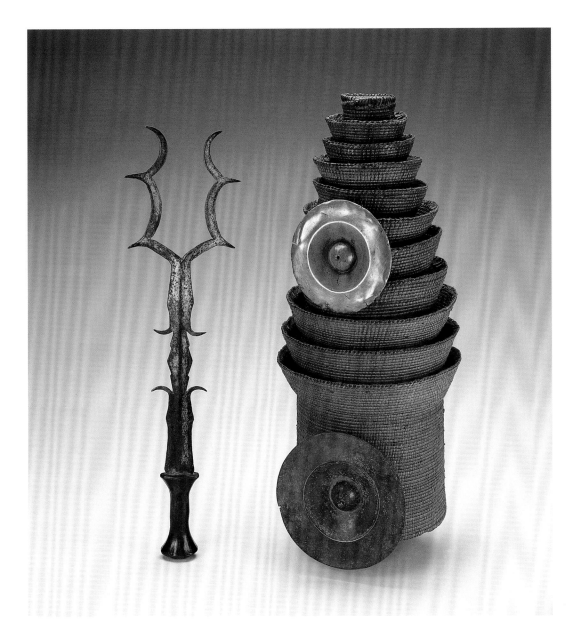

105A. CEREMONIAL BLADE

Ekonda peoples, Democratic Republic of
the Congo
Iron, wood, kaolin
H. 52.5 cm (20¹¹⁄₁₆ in.)
Museum purchase, 95-11-3

105B. HAT *(botolo)*

Ekonda peoples, Democratic Republic of
the Congo
Raffia, brass, copper
H. 54 cm (21¼ in.)
Museum purchase, 95-11-2

This elaborate and well-preserved hat, or
botolo, has eleven horizontal brims that gradu-
ally decrease in size from the base to the top. Its
pagoda-shaped structure readily accommodates
the metal disks at the front.

Always tall and cylindrical in form, with
several projecting horizontal brims or bands, a
botolo also has copper or brass disks, or *losánjá*,
attached to the front, top or back. The brass
disks may be produced locally or imported from
a neighboring group (Arnoldi and Kreamer 1995:
45). Copper was obtained through barter and
then worked, and copper and brass as well as

iron were once used as currency (Celis 1987: 134). The disks probably functioned as indicators of wealth and prestige, thus enhancing the visual power of the hat and emphasizing the prominence of the wearer (Arnoldi and Kreamer 1995: 45). On ceremonial occasions, the hat was often smeared with camwood powder (from the wood of *Baphia nitida*) mixed with oil, which gave it a reddish color (Brown 1944: 438–39).

This type of hat was the insignia of office worn by a key figure in Ekonda society, the *nkumu*, or chief of the village, whose authority derived from the village elders. The *nkumu* participated in all important rituals and ceremonies. If a chief was the first in his line to rule, he had to acquire a *botolo*; hats of deceased rulers were preserved and passed down to their successors (Arnoldi and Kreamer 1995: 44–45).

The Ekonda were also master metalsmiths who worked in iron, brass and copper. They created numerous forms of knives and spears, which were used as tools, weapons or ceremonial implements (Celis 1987).

This knife has an elaborately worked, bifurcated iron blade coated with kaolin, a fine, white clay, and hafted into a wood handle that is heavily patinated, indicating age and use. It was an insignia of office for the *nkumu*. Such a knife may also have been used as currency. Iron money used in bridewealth payments was widespread over large portions of Central Africa (Zirngibl 1983: 99; Herbert 1993: 112–13). AN

PROVENANCE
95-11-2:
Jacques Hautelet, La Jolla, Calif., c. 1983 to 1995

106. MASK

Budja peoples, Democratic Republic of the Congo
Wood, pigment
H. 25.4 cm (10 in.)
Gift of Marc Leo Felix, 84-16-1

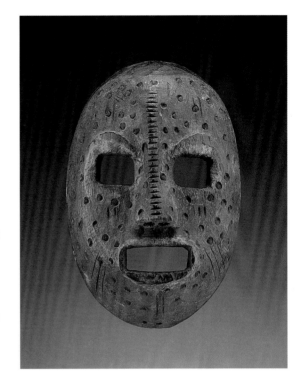

The Budja comprise several large chiefdoms and live along the banks of the Congo River in the northwestern part of the Democratic Republic of the Congo, where the terrain is heavily forested and crossed by numerous streams. They farm, fish, hunt and raise animals such as goats, chickens and ducks (Felix 1987: 18).

Budja art is largely associated with ceremonies involving agrarian and hunting activities (Felix 1987: 18). Budja artists carve highly stylized animal and human sculptures, particularly masks, practices reminiscent of the art traditions of other northern Congo peoples such as the Ngbaka, Banda, Baali and Ndaaka, among others.

This mask, with its oval face, small circular depressions, pierced square eyes and rectangular mouth, has traits that characterize many northern Congo masks. Above the triangular nose and extending into the middle of the forehead, the artist created a series of horizontal incisions similar to scarification patterns found on the faces of several northern Congo peoples. Additional incisions were made on forehead, cheeks and chin. The holes in the mouth once held bone or wood teeth, now lost. Two incised semicircular lines on either side of the face represent ears. Dark-colored lines above the eyes indicate eyebrows, and the rim of the mask has been darkened to indicate the hairline. Perforated slits on either side of the face probably held a leather thong to attach the mask to the face. The mask's surface has been stained brown.

The function of this mask is unclear, but it may have been used by members of one of the voluntary associations prevalent among northern Congo peoples. One of these associations, the Aniota, was probably organized by local Congolese to oppose the incursion of Islamic rulers into their territory (Felix 1992: 104). Older Aniota masks were made of bark, not wood (134). Wooden masks are less widespread in the northern Congo region than those of bark, leather or hide, and therefore, if this mask was used by an Aniota member, it may be a more recent development (137). AN

PROVENANCE
Marc Leo Felix, Brussels, field collected in 1979–80

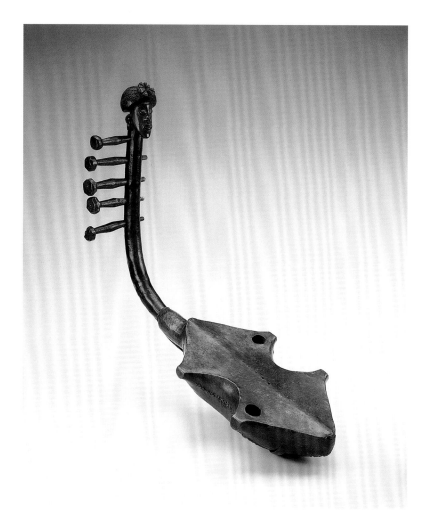

107. HARP
Zande peoples, Democratic Republic of
the Congo
Wood, hide, metal
H. 90.2 cm (35½ in.)
Museum purchase, 85-17-1

Artists living in the northeastern forest regions of the Democratic Republic of the Congo have carved several types of harps. This one has traits typical of Zande style: a beautifully carved head with detailed coiffure and earrings, and a carefully stitched animal hide that covers the sound box. Five pegs, separately carved and fitted into the neck, secured and tuned the now-missing strings, which would have been made of bast or hairs from the tail of a giraffe.

The Zande carve other objects such as bowls and stools, but harps are among their finest artistic achievements. In the 19th century

Schweinfurth described harps used by the Zande and published an engraving of a Zande musician holding a harp with a carved head (1874: I, 444). These musicians played for the entertainment of groups, reciting details of their travels and experiences as wandering minstrels (II, 30). Evans-Pritchard (1963: 191) describes harps as being the particular favorites of Zande notables. AN

PROVENANCE
K. John Hewett, London
James Freeman, Kyoto, 1985

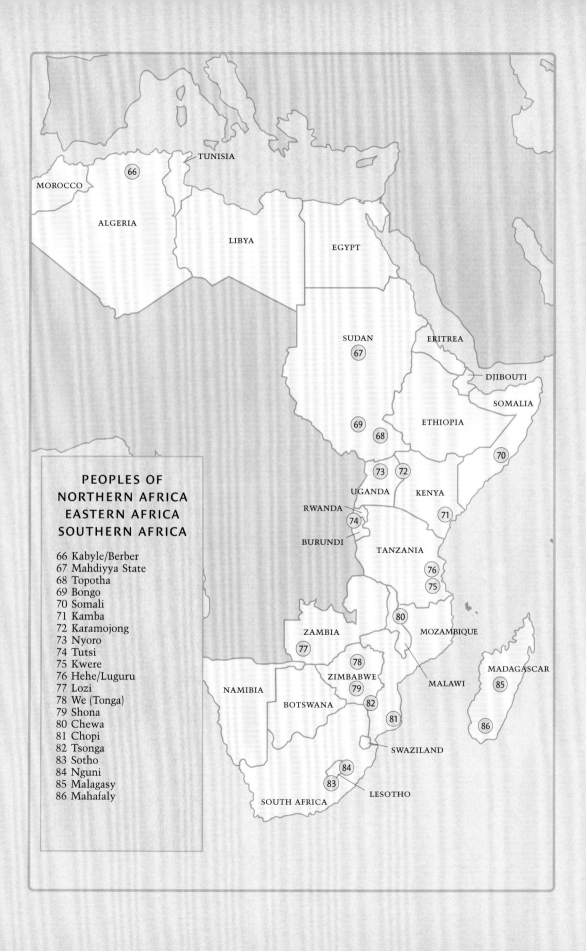

TUNISIA

MOROCCO

66

ALGERIA

LIBYA

EGYPT

SUDAN

67

ERITREA

DJIBOUTI

SOMALIA

ETHIOPIA

69

68

70

73 72

UGANDA

KENYA

RWANDA

71

74

BURUNDI

TANZANIA

76

75

PEOPLES OF
NORTHERN AFRICA
EASTERN AFRICA
SOUTHERN AFRICA

80

ZAMBIA

MOZAMBIQUE

66 Kabyle/Berber
67 Mahdiyya State
68 Topotha
69 Bongo
70 Somali
71 Kamba
72 Karamojong
73 Nyoro
74 Tutsi
75 Kwere
76 Hehe/Luguru
77 Lozi
78 We (Tonga)
79 Shona
80 Chewa
81 Chopi
82 Tsonga
83 Sotho
84 Nguni
85 Malagasy
86 Mahafaly

77

78

ZIMBABWE

79

MADAGASCAR

85

NAMIBIA

82

BOTSWANA

81

MALAWI

86

SWAZILAND

84

83

LESOTHO

SOUTH AFRICA

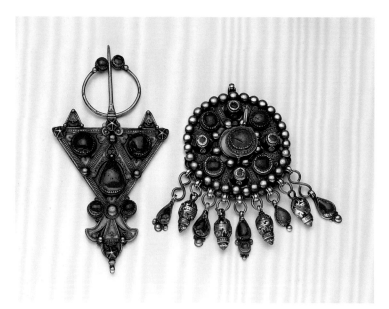

Front

108. BROOCH

Kabyle peoples, Algeria
Silver, coral, cloisonné enamel
H. 19 cm (7½ in.)
Bequest of Eliot Elisofon, 73-7-758

PENDANT *(tabzimt)*

Kabyle peoples, Algeria
Silver alloy, coral, cloisonné enamel
H. 9.2 cm (3⅝ in.)
Gift of Mr. and Mrs. James Phoenix in memory
of Charlotte McFadden, 92-11-1

The Kabyle of Algeria are one of the group of
indigenous peoples of North Africa generally
known as Berber. Jewelry with cloisonné enam-
eling is one of their highly developed cultural
expressions. Pieces are usually made of silver
decorated with green, yellow and blue enamels
and set with coral, colored glass and beads.
Pendants, rings, bracelets, anklets, earrings and
headdresses serve as a way of accumulating
family wealth and often make up the largest
share of a woman's dowry. The Kabyle region is
known as a center of enameled jewelry. Unlike
most other Berber jewelers, Kabyle artisans are
predominantly Muslim. It is thought that their
techniques came from Moorish Spain.

The brooch was used to pin a woman's
draped outer garment. The large round pendant
would have been worn suspended from a wide
necklace so that it rested in the center of a

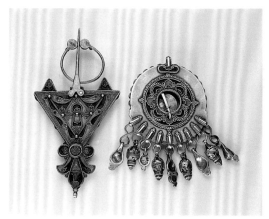

Back

woman's bodice. These ornaments share similar
design elements: braided or twisted wire border-
ing enameled areas, coral stones and silver
beads set on the front side, and flat enameled
patterns on the reverse. Each piece of jewelry
made by a Kabyle smith would exhibit a unique
composition of these elements. LP

PROVENANCE

73-7-758:
Eliot Elisofon, New York, collected in Morocco or
Tunisia, 1942–43

92-11-1:
Charlotte Mack, San Francisco, collected in Timbuktu,
Mali, c. 1905
Charlotte McFadden, Hawaii, 1930s to 1992
Joy Phoenix, San Rafael, Calif., 1992

109. DOUBLE VESSEL *(thibuk'alin)*
Berber peoples, Kabyle, Algeria
Ceramic, slip
16.9 cm (6⅝ in.)
Museum purchase, 93-3-3

The inhabitants of the mountainous Kabyle region along the Mediterranean coast in northeastern Algeria are primarily farmers. They are also superb artists noted for their jewelry making, textiles, mats, basketry, pottery and house mural decoration.

In North Africa, wheel-thrown pottery made by men dates from the 7th century B.C. when the Phoenicians introduced the potter's wheel to the Algerian coast. Handbuilt pottery made by women, including those from the Kabyle, an older, probably indigenous tradition, dates back 2000 years before the birth of Christ (Fagg and Picton 1978: 37). The vessel depicted here originates from earlier prototypes.

To this day, Kabyle women coil and decorate pottery with beautiful painted geometric designs for their own household use and for sale. Kabyle women handbuild vessels of various sizes and shapes for holding water, milk, oil, cooking and eating food, and oil lamps.

This vessel *(thibuk'alin)* was probably created for local use. It is composed of two interconnected containers joined at the neck and body by two channels through which liquid can flow. Each container has a pouring spout. Such vessels may have been used to pour libations or offerings during a ritual (d'Ucel 1932: 123). This vessel, colored with white slip, decorated with black geometric designs and with a short, thick body and flat bottom, probably originated in the Little Kabyle area in eastern Algeria (Wysner 1945: 121). The zigzag designs may refer to either a serpent or a fish, both thought to have apotropaic functions to counter evil (Bynon 1984: 144–46). The bottom of this pot contains a potter's mark consisting of a rectangular shape with cross-hatched lines. AN

PROVENANCE
Michael Graham-Stewart, London, 1993

110A. FLAG

Mahdiyya State, Sudan
1882–85
Cotton, silk
147 × 133 cm (58¾ × 52¼ in.)
Museum purchase, 91-20-1

110B. TUNIC

Mahdiyya State, Sudan
1882–98
Cotton, wool
103.4 × 130 cm (40¹¹⁄₁₆ × 51³⁄₁₆ in.)
Museum purchase, 92-13-1

In 1881 Mohammed Ahmed Ibn el-Sayyid Abdullah (1844–85) declared himself "al-Mahdi," the Proclaimed One, successor to the prophet Mohammed. A scholar and an ascetic, he criticized the corruption of both local religious leaders and the intrusive Egyptian colonial officials who governed the Sudan. Egypt was officially part of the Ottoman Empire of Turkey, but its ruling khedives (viceroys) had a great deal of autonomy and controlled the Sudan as a provincial colony. In 1882 a nationalist-driven revolt by the Egyptian army led the British to intervene and assume control in Egypt to counter what they perceived as a threat to the Suez Canal. England then found itself involved in an existing holy war in the Sudan—one that the Mahdi was winning, and would continue to win against the combined Anglo-Egyptian forces. Soon after taking the capital at Khartoum in 1885, the Mahdi fell ill and died suddenly. Khalifa Abdullah Ibn Mohamed, leader of one of the army divisions, was declared Khalifa al-Mahdi, the Madhi's successor. Under his direction, the Sudan took on more the aspect of an established administration than of a moving rebellion, a condition that prevailed until he met with a series of defeats by British Major General Sir Herbert Kitchener in the 1896–98 campaign to retake the Sudan. Khalifa al-Mahdi died in battle in 1899.

While most of the known flags, tunics and weapons were taken on the battlefield as mili-

tary trophies during this last campaign, they were originally created to convey specific religious principles as well as to unify the diverse regional army that gathered around the Mahdi. The Mahdi called his followers *ansar,* or helpers, after the men of Medina who supported the prophet Mohammed (Spring and Hudson 1995: 100). They were a diverse group—desert nomads, Nile farmers, hill herders, soldiers who had been employed by slave traders and former slaves from Central Africa.

These troops literally rallied around flags proclaiming the word of God. The flags' appliquéd inscriptions are invocations of God's might and mercy, but with some variations in the closing line that lists leadership descent from God and the Prophet. The museum's flag is typical:

O God! O Merciful! O Compassionate!
 O Living! O Unchanging!
O Lord of Majesty and Mercy! There is no
 God but God,
and Mohammed is the Prophet of God.
Mohammed the *Mahdi* is the representative
of the Prophet of God

(translation courtesy of Dr. Massumeh Farhad, Arthur M. Sackler Gallery/Freer Gallery of Art)

Many flags were white with colored borders, the letters in different colors on one side. Allah, the name of God, is often emphasized with green (Knight 1989: 37), a color associated with Islam. It is possible that other colors referred to the military unit that owned the flag, but even contemporaneous accounts give contradictory identifications as to division colors (Holt

1956: 205–6). This example is particularly impressive because of its well-preserved state, vivid colors and the use of silk for the central panel. The white tube on the side would have slipped over the shaft of a spear when the banner was carried.

Although the British regiments also valued their flag and regimental insignia, their ideas of uniform dress were quite different from the *ansar*. The first appliquéd tunics of the *ansar* were of loose, rough cotton with irregularly placed patches, the ordinary garment of a poor person. The use of wool patches relates to the wool tunics *(muraqqa'a)* worn by the founders of the Sufi Muslim religious order (*suf* is Arabic for wool), and this was the order to which the Mahdi had belonged (Spring and Hudson 1995: 100). Under the Mahdi, the tunic *(jibbeh* or *jubba)* was an emblem of holy poverty, a statement of the fight against the corruption of Islam. After the capture of the provincial capital of El Obeid in January 1883, arms and material became available and the Mahdi described a uniform for his followers to wear: the *jibbeh,* white trousers, sandals, plaited straw belt, beads, skullcap and a white turban wrapped in a distinctive way. But many groups not under the Mahdi's direct command continued to wear ordinary clothing. By the 1890s, factories were set up in Omdurman and the provincial capitals, and *jibbeh* designs became more standardized, with regularly placed block patches on the body, skirt and sleeves. Fabrics included cut-up Egyptian and British uniforms (Knight 1989: 33–

35). The soutache, or cord embroidery around the side pockets, is also reminiscent of the trimmings on British and Egyptian uniforms. The finely worked embroidery on the chest pocket is a further step away from the original ideal of poverty. Spring points out that the ragged Sufi tunic also had a patch of a different fabric over the heart. Although no documentation exists, he suggests that the *jibbeh* pocket may have held a Koranic verse amulet. The embroidery pattern recalls designs thought to repel evil (Spring and Hudson 1995: 103–4). It is not clear if these extra touches were signs of rank. They are generally described in collection data as *amir*'s tunics, but those of the highest rank may have chosen simpler ones, to demonstrate their allegiance to the Mahdi's principles (Knight 1989: 35).

While all these elements are directly linked to the military organization of the Mahdi, influence from a broader Islamic world emerges. It shows in the importance of calligraphy and the literal emphasis on the word for God, turning it in some contexts into an abstract pattern. The use of flags (Denny 1974: 67–81), parade costumes and chain mail was also widespread in the Islamic world. BMF

PROVENANCE

91-20-1:
Anthony Jack, London, mid-1970s
Michael Graham-Stewart, London, 1991

92-13-1:
Michael Graham-Stewart, London, 1992

111. MAN'S CAP

Topotha peoples, Sudan
Glass beads, plant fiber, human hair
W. 22.3 cm (8¾ in.)
Museum purchase, funds provided by the Friends
of the National Museum of African Art, 84-6-8

The beaded pattern of concentric circles on this man's cap may have evolved from a hair-style observed by the British explorer Samuel Baker in the 19th century. Baker (1866: 211) described the coiffure as an arrangement of hair "woven with fine twine formed from the bark of a tree." As the hair grew through the matted mesh, the process of twining continued until the hair formed a cap or helmet shape. To complete the coiffure, beads were attached in circular patterns. The headdress was then cut away from the head and used as a cap or wig. The Topotha share a cultural heritage with several peoples in the region who remove their mud-pack coiffures by cutting them off with a razor.

In the early 1900s, British colonial military officer Major Powell-Cotton described the coiffures as having several beaded leather disks attached to them that appeared almost metallic from a distance (1904: 387). Captain G. R. King, a British district commissioner, reported in the 1930s that "important men wore large skull caps entirely covered with beads arranged in circular patterns on human hair" (Nalder 1937: 77).

This example, one of two in the museum's collection, was probably owned by a man of high status, given its very precise and beautifully executed beadwork. The beads are attached to a woven fiber frame. The inner surface consists of short human hairs arranged like felting. LP

PROVENANCE
Rev. and Mrs. Hamilton, collected in Sudan, 1930
Colette Ghysels, Brussels, — to 1984

PUBLICATION HISTORY
Geary and Nicolls 1994: fig. 18

112. ORNAMENT

Topotha peoples, Sudan
20th century
Bone, leather
L. 39 cm (15½ in.)
Museum purchase, 83-3-13

The Topotha live in Equatoria, the southern-most area of the Republic of Sudan. A semi-nomadic, cattle-keeping people, they organize their society on the basis of age grades. The Topotha are culturally and linguistically related to the Karamojong cluster (Mack 1981).

The Topotha adorned their cattle with orna-ments like this one. The woven leather thong was looped around the horns, and the bone pendant rested on the cow's forehead (John Mack 1998: personal communication). RAW

PROVENANCE
Jean-Pierre Ghysels, Brussels, — to 1983

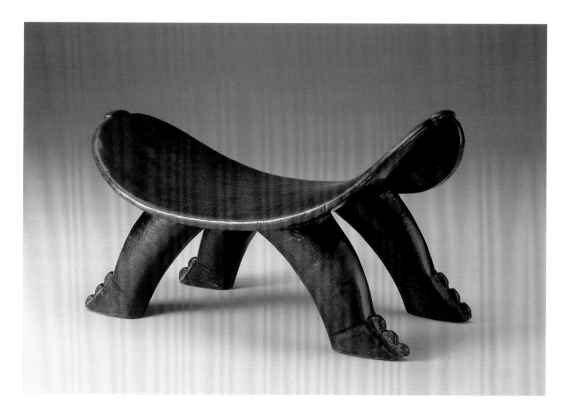

113. STOOL

Bongo peoples, Sudan
Wood
H. 17.8 cm (7 in.)
Acquisition grant from the James Smithson
Society, 89-8-2

This stool masterfully illustrates the preoccupation with the aesthetics of bovine forms shared by pastoral peoples of the Upper Nile region in Sudan. The form is "probably suggested by the shapes of the animals, something in each design resembling the head, limbs and tail," as noted by Captain S. L. Cummins (1904: 1960), a British medical officer who served in Sudan at the turn of the century.

If they do echo an animal form, the feet of this stool can be interpreted as an artistic rendition of hooves and fetlocks, while the lugs at each end of the seat may evoke the head and tail. In this stool, one finds a perfect integration of both types of supports: the shallow, receptive curve of the thin seat is gracefully counterbalanced by the tighter curve of the sturdy legs.

In the late 19th century, such stools were found in every household and used exclusively by women (Schweinfurth 1874: 283). PLR

PROVENANCE
Michael Graham-Stewart, London, — to 1989

PUBLICATION HISTORY
Ravenhill 1991: 12–13

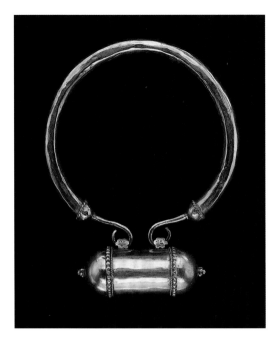

114. ARMLET WITH AMULET CASE *(dugaagad)*
Somali peoples, Somalia
Gold alloy
Diam. 8.3 cm (3¼ in.)
Gift of Ambassador and Mrs. John L. Loughran,
76-16-11

West African goldsmiths have long been known for their gold ornaments and jewelry. Although silver is the preferred metal of peoples in East Africa, gold ornaments are also common and eagerly sought by those who can afford them. This hollow armlet with amulet case was made by hammering sheets of gold into tubular shapes and applying tiny spheres and twisted wire on the surface in intricate patterns. The amulet was meant to contain verses from the Koran which were specially prepared and tightly wrapped by a specialist. In Somalia such amulets are worn close to the skin by both men and women who wish to promote health and well-being. On ceremonial occasions women wear gold jewelry with amulets, not only for protection but also as a symbol of their status.

Most of the silver and gold work on the Somalian coast is done by a guild of silversmiths and goldsmiths, who are considered an artisan caste. Although little has been published on the history of this tradition, Arnoldi (1986: 22) believes that Somali jewelers, like the woodcarvers, were inspired by Arabian and Indian prototypes. LP

PROVENANCE
Ambassador and Mrs. John Loughran, collected in Xamar Weyn, Somalia, 1975

PUBLICATION HISTORY
Arnoldi 1986: 22

115. PROCESSIONAL CROSSES

Ethiopian Orthodox style
Cast copper alloy

l. to r.:
13th century
H. 26.8 cm (10⅛ in.)
Museum purchase, 97-19-2

14th–15th century
H. 30.9 cm (12³⁄₁₆ in.)
Museum purchase, 97-19-1

15th century
H. 25.2 cm (9¹⁵⁄₁₆ in.)
Museum purchase, 97-19-3

Christianity has a long history in Ethiopia, dating from its introduction in Aksum under the reign of King Azana in about A.D. 330. Its spread among the peoples of the highlands, and the arrival of nine monks from Syria toward the end of the fifth century, is said to have introduced monasticism to Ethiopia and to have contributed strongly to the production and use of liturgical objects.

The cross is perhaps the most pervasive symbolic artifact. Every member of the clergy carries a cross at all times. The most beautiful and intricate are the processional crosses used in ceremonies and festivals throughout the liturgical calendar. They are mounted on long poles and sheltered by canopies and parasols of silk and velvet.

These crosses, dating from the 13th, 14th and 15th centuries, were each cast in one piece from a copper alloy. Later crosses, for which the favored material was brass, typically have separate arms and shafts joined with rivets. The oldest of the museum's three crosses (97–19–2) carries engravings of the four archangels on its arms. Their bodies form a Maltese cross. The basic form has been elaborated with smaller Maltese crosses and the horns of an ibex. A second cross (97–19–3) has a similar overall shape, but the lobes are filled with crosses formed from diamond shapes surrounding a central Maltese cross. The ibex horns are absent. The largest cross (97–19–1) has a design characteristic of those found in the monolithic churches at Lalibela in North Central Ethiopia. The overall shape is circular, finished with a fringe of triangles. The interior portion is composed of Latin crosses within crosses. LP

PROVENANCE
Rémy Audouin collection, Paris, 1980 to 1997

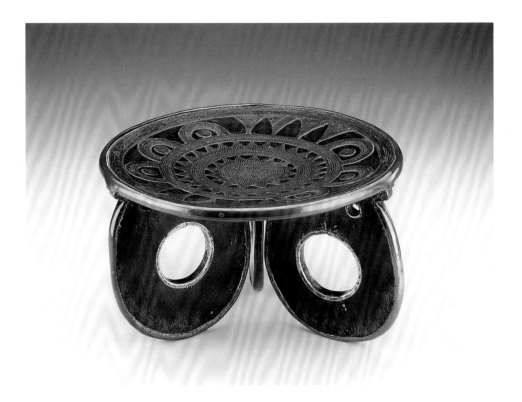

116. STOOL

Kamba peoples, Kenya
Wood, copper alloys
W. 24.8 cm (9¾ in.)
Museum purchase, 89-9-14

Kamba artists carve wooden stools whose circular seats are supported by three discoid legs. This stool, intricately ornamented with metalwork, is an example of Kamba art at its most richly decorated.

The metalwork inlay requires a skill that has been mastered by few East African groups. The technique requires that thin brass and copper wire be heated and drawn to the proper diameter, then cooled. The wire is spirally wrapped around a fine wire used as a mandrel, in a machine called *kilingi*. The mandrel is then withdrawn and the coiled wire is pounded into the surface of the stool seat, which has been wetted to soften it.

The design itself is first drawn on the stool's seat with the aid of a wire used as a compass, starting at the center and moving to the outer edge. Most of the finished patterns, called *milia*, have some origin based on the structural framework of a Kamba hut, a bead ornament, arrowheads or cattle brands. The patterns on this stool have not been identified. When the ornamentation is completed, holes are bored through the legs of the stool so that a cord or chain can be passed through it. Its owner, usually an elder male, could then carry the stool over his shoulder. LP

PROVENANCE
Michael Graham-Stewart, London, — to 1989

PUBLICATION HISTORY
Ravenhill 1991: 9–10

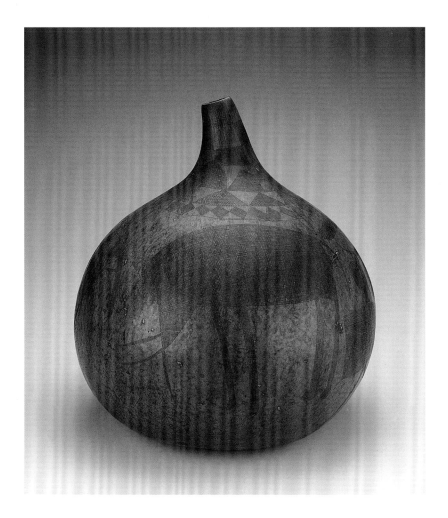

117. CONTAINER
Kamba peoples, Kenya
Gourd
H. 37.5 cm (14¾ in.)
Museum purchase, 89-8-42

The gourd is the container of choice through-out much of equatorial Africa. Growing in a number of shapes and sizes, it is put to a wide variety of uses as bottles, lids, rattles, drums, sounding boards for musical instruments, funnels, bowls, flasks, ladles, cups and storage containers. Often the gourd is combined with other materials, such as leather or basketry, and frequently it is decorated by carving or incising.

The Kamba have a long history of decorating gourd containers, and although this art was lost for a time during this century, it is again being revived (Kay 1978: 40). In other regions of Africa, designs on gourds are usually created by heating a knife blade and burning in the desired patterns. Kamba artists use another technique:
they work by incising the outer, often irregular surface of the gourd to create geometric patterns and stylized figures. Animals and other motifs taken from nature are cut into the vessel; then the lines are rubbed with ashes to produce a dark contrast with the light surface. The original color of the gourds is yellow, but over time, the surface darkens to a deep red or honey yellow.

This large container was probably used for storing water or beer. The dominant motif of the surface decoration, which includes stylized animals, a human figure and a tree, is a large elephant with long straight legs and a broad ear merging seamlessly into tusks and trunk. The figures are shaded with fine cross-hatching. Diamonds, triangles and checkerboard designs appear only on the neck of the vessel and within a single stripe down one side. LP

PROVENANCE
Michael Graham-Stewart, London, — to 1989

118. COIFFURE WIG

Karamojong peoples, Uganda and Kenya
Hair, clay, ostrich feathers, metal, pigment
W. 40.6 cm (18⅛ in.)
Gift of Emile and Lin Deletaille, 86-8-1

Among the pastoral Karamojong of eastern
Uganda, men wear mudpack coiffures after they
are initiated into adulthood. In celebration of
their new status, they assume the regalia of
young warriors, including an ornamented coif-
fure that involves packing clay into the hair
and forming a chignon at the back of the head.
When the clay has dried, it is painted with
pigments and decorated with beads or pieces
of chain, as is the front of this headdress.
This hairstyle generally remains the same
throughout a man's adult life. A man can dis-
play his status as an elder by adding ostrich
plumes through wire coils inserted into the
headdress. This wig is representative of those
in current use. LP

PROVENANCE

Michel Hughenin, Paris
Emile M. and Lin Deletaille, Brussels, — to 1986

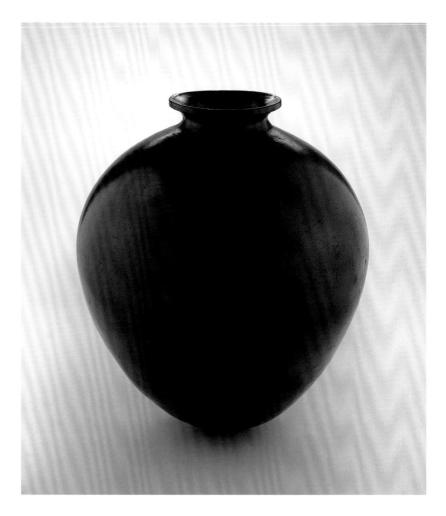

119. VESSEL

Nyoro peoples, Western Inter-Lacustrine
region, Uganda
Ceramic, graphite
H. 41 cm (16⅛ in.)
Museum purchase, 94-13-1

Handbuilt by a male potter, this glossy black-
ware vessel was used to hold water. It has an
ovoid body and a rounded base, a short neck,
and a relatively small mouth and everted rim.
It was coil built, pebble polished and fired at
a low temperature. After the firing, the potter
covered the entire surface of the vessel with
graphite and then rubbed it to produce the char-
acteristic silvery black sheen of Nyoro pottery
(Trowell 1941: 62–64; Trowell and Wachsmann
1953: 117–18).

Originally potters sold this blackware to
the local elite and to European visitors. Later,
middlemen carried these vessels to larger towns
(1941: 64, 59). AN

PROVENANCE
Michael Graham-Stewart, London

120. BRACER

Tutsi peoples, Burundi
c. 1890
Wood, copper
W. 21.9 cm (8⅝ in.)
Museum purchase, 93-18-1

Tutsi archers wore large wooden bracers to protect their wrists from the recoil of bowstrings. They are extremely rare, and the few extant examples have been ornamented with delicate designs formed by pieces of copper pounded into the surface. This bracer incorporates three sunburst designs, all edged with tiny copper brads that have been punched to appear like inlaid circles. Other brads form straight and curved lines that join 20 small copper rectangles which have been arranged harmoniously on the surface.

Although there is almost no mention of Tutsi bracers in the literature, one can assume that they were made for people of high rank. Collart's publication on the Burundi (1984) contains photographs in which several members of a royal Tutsi family wear bracers decorated with copper insets. LP

PROVENANCE
Michael Graham-Stewart, London, c. 1988 to 1993

121. STAFF

Possibly Kwere peoples, Bagamoyo district,
Tanzania
Before 1890
Wood, metal, pigment
H. 154.9 cm (61 in.)
Museum purchase, 88-7-1

This staff was brought to Europe in 1890. Its precise origin, however, has yet to be conclusively established. The figures on the staff finial depict a young girl or initiate on the back of an adult woman, a theme found among the sculptures of several ethnic groups living just inland from the Tanzanian coast (Felix 1990: 155). Many of these groups, including the Kwere, the Luguru and the Zaramo, share customs associated with the transition of young girls to adulthood. According to reports of initiation customs of the peoples of this area, girls were carried on the backs of their adult female sponsors during certain phases of the ceremonies (Kecskesi 1982: 55).

The hairstyles of these figures also conform to those worn by Kwere and Zaramo girls during initiation. The hair is parted into two high braids that are pulled tightly back to meet at the nape of the neck, and formed to jut out from the head. Kecskesi (1982: 52) believes this hairstyle originated in Zanzibar and was popular around the turn of the century.

This type of staff was planted in the ground to consecrate a site and to validate the role of the instructors and healers who presided over the ceremonies. Gourd containers filled with medicinal oils were hung from hooks on the shaft. LP

PROVENANCE

Private collection, England, 1890
Ernst Anspach, New York, 1966 to 1988

PUBLICATION HISTORY

Parke-Bernet Galleries 1966: no. 2490
Museum of Primitive Art 1967: 19
Felix 1990: 92

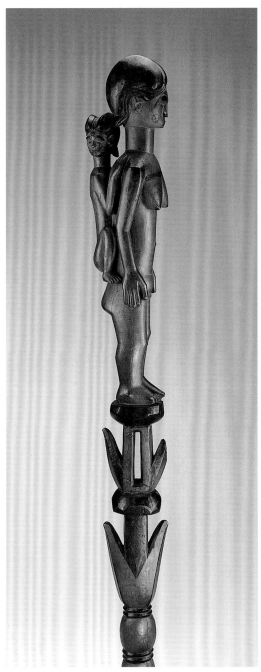

Detail

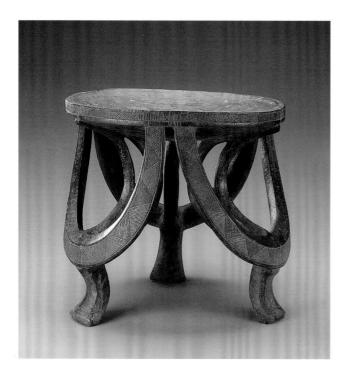

122. STOOL

Kwere peoples, Bagamoyo district, Tanzania
Wood
H. 37 cm (14⅝ in.)
Museum purchase, 94-10-1

This three-legged stool is a masterpiece of de-
sign. From a single piece of wood, the sculptor
has created a complex composition consisting
of three curved swags, each braced by a vertical
curved leg. An intricate interior space in the
stool support is produced by the relationship
between the curves of the legs. The stool's pro-
portions, complex design and refined technique
clearly mark it as the work of a master sculptor.

Because of its complexity, this stool was
most likely owned by a leader or a person of
high rank or status. Stools are associated with
the leadership of a lineage within a clan among
the Kwere peoples. Before the period of colonial
rule, clans provided the basis of governance, for
there was no centralized authority. Each lineage
was a separate social and political entity. Ascent
to leadership was made in a ceremony that is a
form of initiation. It included a period of isola-
tion, after which the leader was carried to and
placed upon a stool, and his new name and
status were publicly announced. LP

PROVENANCE
Tambaran Gallery, New York, — to 1994

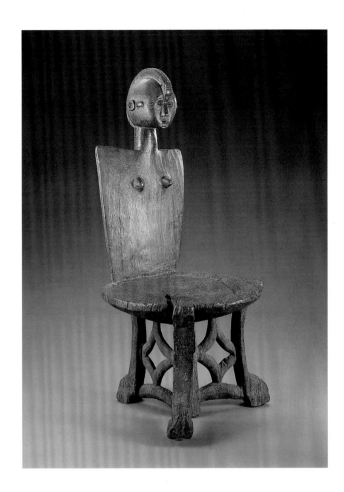

123. HIGH-BACKED STOOL/THRONE
Hehe or Luguru peoples, Tanzania
Wood
H. 80 cm (31½ in.)
Gift of Robert and Nancy Nooter, 89-10-1

In East Africa, elaborate high-backed stools generally signify the governing authority of their owners; in effect, they become thrones that are used in official ceremonies (Nooter 1995: 50). Some stools were also important ritual objects; they could hold sacred figures or simply be placed in the ceremony and never sat upon.

The distinguishing feature of this stool is the high backrest in the form of a stylized female torso with small, sharply defined breasts. The backrest is surmounted by a head carved in the round, with a central crested hairstyle and small scarification nodes on each side of the face. A discoid seat rests on a tripartite openwork support.

Most of the published examples of such high-backed stools represent females. This may symbolize the chief's female ancestors and the matrilineal organization of many central Tanzanian societies. According to John Wembah-Rashid (1989: letter to Roy Sieber), formerly with the National Museum of Tanzania in Dar es Salaam, stools from this region of Africa were often found in pairs, one female, the other male. The stools were used by chiefs and other notables, including their wives or consorts. LP

PROVENANCE
Collected in Tanganyika by a Belgian military officer, c. 1919
Jef van der Straete, Belgium, 1956
Aaron Furman, New York, 1961 to 1975
Prince Sadruddin Aga Khan, 1975 to 1983
Robert and Nancy Nooter, Washington, D.C., 1983 to 1989

PUBLICATION HISTORY
Gillon 1979: fig. 189
Sotheby's 1983: no. 73
Maurer and Roberts 1985: ill. 62
Sieber and Walker 1987: 113
Nooter 1995: 48

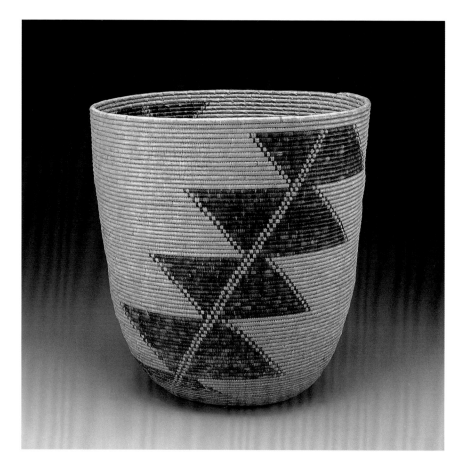

124. BASKET
Lozi peoples, Zambia
Plant fiber, dye
H. 38.7 cm (15¼ in.)
Museum purchase, 89-9-1

The Lozi of southwestern Zambia have long been known for their skill as basket makers. Women weavers produce a variety of well-constructed baskets of fibrous tree root or palm-leaf fiber using coiling, twining or plaiting techniques. Large, tightly coiled baskets such as this are usually constructed with palm fiber. The weaver binds thin pliable weft strands of palm firmly and evenly around the warp, which consists of bundles of fibers (Newman 1978: 2). She then coils the warp in a counterclockwise direction to the required depth, beginning at the base.

Using an overstitch technique to sew the coils together, and at the same time working with tinted strands in the weft, the weaver creates darker designs in the basket, working upward from the base to the rim. The typical Lozi design of this basket is composed of diagonal rows of lozenges divided through the center by double lines.

Lozi weavers use the coil technique to produce strong, compact baskets. Many are woven tightly enough to hold liquids. Because of its size and shape, this one may have been used to carry clothing. LP

PROVENANCE
Michael Graham-Stewart, London, — to 1989

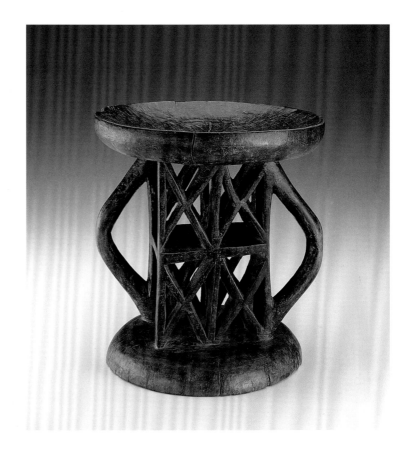

125. STOOL

We (Tonga) peoples, Zimbabwe
Wood
H. 27 cm (10⅜ in.)
Museum purchase, 89-8-1

Although round stools are ubiquitous in sub-Saharan Africa, their degree of refinement varies. Most stools are carved from a single block of wood. Cylindrical stools are carved with the grain running bottom to top. The circular seat is usually supported by a single central column joined to a round base. Wide variation occurs in the carving of the central column that supports the seat. Some exhibit a straight, simple column, others a latticed or perforated column, and others figurative supports.

In many cases, artists from particular areas produce stools that have a uniformity of design.

Although the similarities may occur as the result of the specialized function of stools, individual self-expression is highly prized. Each carver has his distinctive style. In this stool, the artist created an integrated column of two openwork rectangles joined at the center by a horizontal shelf. He carved handles that echo the diagonals of the openwork column, yet all the elements are contained within the basic cylinder of the original tree trunk. LP

PROVENANCE
Michael Graham-Stewart, London, — to 1989

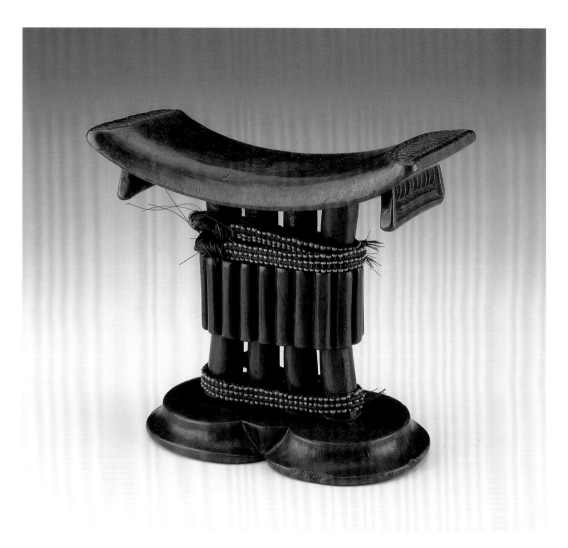

126. HEADREST

Shona peoples, Zimbabwe and Mozambique, or
Tsonga peoples, Mozambique and South Africa
Wood, glass beads, plant fiber
H. 12.7 cm (5 in.)
Museum purchase, 89-14-26

Shona and Tsonga headrests share similar stylistic features. This headrest is typical of the Shona style in two of its three structural elements. The upper platform is rectangular with ends curved slightly upward and with flaplike appendages. The base is a flat double circle that forms a figure eight. The supporting column, however, is unusual. It is composed of 4 cylindrical posts encircled at the midpoint by 18 shorter cylinders. Whereas the main supports are spaced evenly with openings between them, the central structure is solid, lending both visual and structural weight to the entire composition.

Dewey (1991: 202) theorizes that certain features on these headrests allude to the female gender—the triangular form at the center of the base, the chip-carved areas on the top ends of the upper platform that simulate female scarification *(nyora)*, and the beaded bands wrapped around the support. Dewey (149, fig. 126) places the origins of a comparable headrest in Chipinga in southeastern Mozambique, giving it a Tsonga attribution.

The original use for the headrest was as a wooden pillow to keep elaborate, well-oiled coiffures from being flattened or soiled by dust. Headrests were used exclusively by adult males. Although elaborate hairstyles of tufts ornamentally arranged and tied up with beads are no longer prevalent among the Shona or Tsonga, headrests continue to have religious or ritual functions. They are reported to be used in praying to the ancestors. They are also part of the paraphernalia of spirit mediums; their association with ancestors lends authentication to the medium's practices. According to Dewey (1991: 150), one informant, Chief Nyoka, a judge, has linked their use to the widespread belief in Shona society that dreams are an important means for acquiring knowledge, in this instance to assist in resolving disputes that were brought before him. Dreams are also believed to assist artists, especially musicians and sculptors, in realizing their creations.

The use of headrests in southern Africa is ancient. Excavations at Great Zimbabwe have revealed gold plates that probably covered headrests buried with their owners as long ago as the 12th century A.D. (Dewey 1991: 141). Other headrests have been recovered from caves that have served over the centuries as burial places for the Shona. In more recent times, Shona headrests that were not buried with their owners have been passed down to male heirs, probably the continuation of a longstanding practice.

LP

PROVENANCE
Werner Muensterberger, New York, — to 1989

PUBLICATION HISTORY
Ravenhill 1991: 14–15

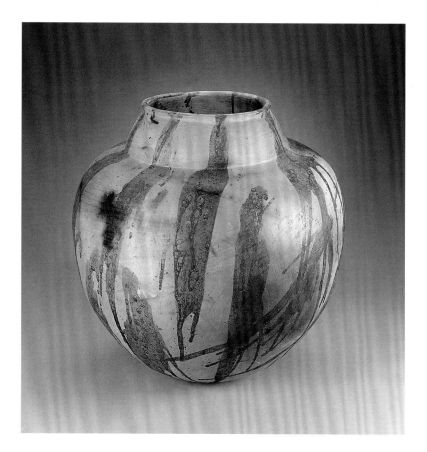

127. VESSEL

Chewa peoples, Lilongwe region, Malawi
Terracotta, pigment
H. 63.5 cm (25 in.)
Museum purchase, 87-2-1

This large ovoid vessel was handbuilt by a Chewa woman potter and fired at a low temperature. She decorated it by splashing a vegetable decoction on the body immediately after firing, resulting in an aesthetically vibrant surface. The dark spots on the surface are caused by a reduced oxygen atmosphere in the kiln during firing. Although created accidentally, they add to the pot's aesthetic effectiveness.

These vessels are typical of pottery forms found throughout Africa that function as containers for foodstuffs. Chewa women keep vessels of this type near the cooking area. They use them to store locally brewed maize beer, *kuchasu,* which is consumed before traditional ceremonies of the Gule Wamkulu (Great Dance) performed at funerals and initiations (Faulkner 1988: 28). AN

PROVENANCE
Laurel Birch de Aguilar [Faulkner], collected in Lilongwe, Malawi, c. 1985–86
Affrica Gallery, Washington, D.C., 1986 to 1987

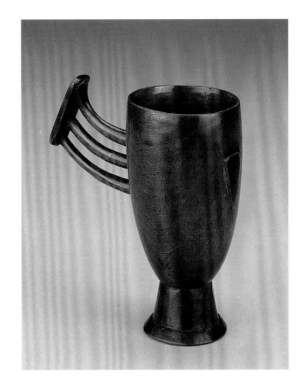

128. CUP

Chopi peoples, Mozambique
Wood
H. 15.2 cm (6 in.)
Museum purchase, 90-7-1

Although the Chopi are known for their elegant carvings of headrests and staffs, their carved cups are rare. This example has a truncated conical body and a gracefully curved tripartite handle. There is an unornamented triangular crest opposite the handle. A Chopi artist designed this cup for utility more than for the elaboration of its surface. Junod (1912: 130) reported the use of African mahogany, called *gombe,* by Thonga artists for carving spoons, bowls and cups, although he did not describe this particular type of cup.

Leaders and men of high status probably used cups of this type. Many African societies observe ritual libations that utilize cups and pots. Missionary Julian Rea, who collected a similar cup (now in the collection of the Peabody Museum, Cambridge, Massachusetts), indicated that it was used in a ceremony in which the chief poured out a sacrifice of beer. The Peabody's collection data notes that its cup was collected in 1937 in the area of Inhambane in southern Mozambique. This cup probably dates to the same period. LP

PROVENANCE
Merton Simpson, New York, — to 1990

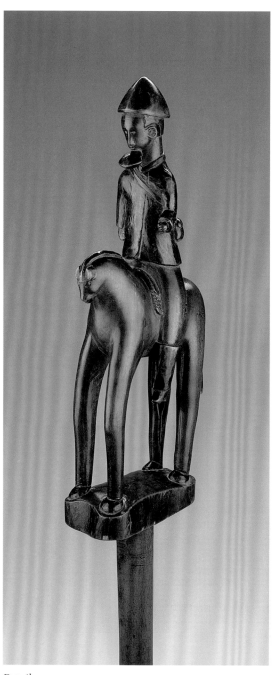

Detail

129. STAFF

Tsonga peoples, South Africa, Mozambique
and Zimbabwe
Wood
H. 100.4 cm (39½ in.)
Museum purchase, 91-14-2

This staff was once attributed to the Zulu
peoples, as were most figurative carvings col-
lected in southern Africa since the mid-19th
century. Recent research by Anitra Nettleton
(1988: 48) suggests, however, that Tsonga sculp-
tors may actually have produced most of these
carvings. Nettleton found no reference to figure
carving by Zulu sculptors in accounts of 19th-
century visitors to the Zulu Kingdom. The only
suggestion that the Zulu created figurative staffs
came from oral historian James Stuart (1936;
cited in Klopper 1989: 34), who reported that
Zulu men preferred knobkerries with knobs
carved in the shape of a human head wearing a
headring. Among the Zulu, a headring was an
indication of a man's status as a husband.

There is evidence that the Tsonga migrated
to the Natal from southern Mozambique as
early as the 1850s. Recognized for their carv-
ing skills, they were soon producing artifacts,
primarily for Europeans who had settled in
the region.

Two related staffs, purchased in 1985, are
in the collection of the Standard Bank Founda-
tion in Johannesburg. One staff is surmounted
by a baboon and the other by a male figure with
a beard. Both are said to be turn-of-the-century
staffs carved by the same hand—an artist dubbed
the Baboon Master, who is possibly of Tsonga
origin (Klopper 1985: 34). LP

PROVENANCE

Michael Graham-Stewart, London, — to 1991

PUBLICATION HISTORY

Sotheby's 1991: 80, no. 179

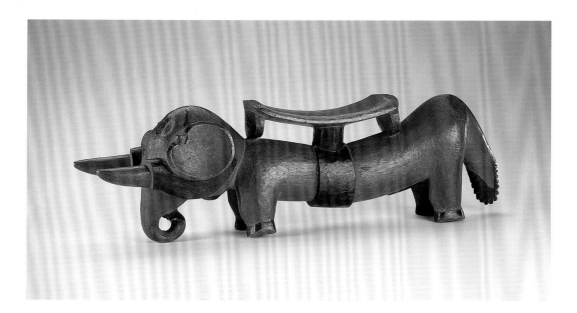

130. HEADREST
Tsonga peoples, Mozambique and South Africa
c. 1890
Wood
L. 53.7 cm (21⅛ in.)
Museum purchase, 91-14-1

This delightful headrest incorporating the figure of an elephant is unusual in both its representation and large size. It derives from a Tsonga aesthetic tradition of carving headrests with animal figures. Widely used by Tsonga cattle herders before the turn of the century, these headrests were portable and functional personal objects meant to protect elaborate hairstyles.

The size of this headrest, the expression on the elephant's face, and the lack of signs of use suggest it might have been produced for sale to Europeans. Only two other comparable headrests exist; both are in the Rijksmuseum in Holland. So close in style are the three headrests that it seems possible that they were produced by the same hand or workshop. Rogier Bedaux, curator of African Collections at the Rijksmuseum, states that the headrests in their collection originated in Marabastad, in the northwest Transvaal region of South Africa, and were collected before 1890 (Rogier Bedaux 1991: personal communication). If it had been produced for an outside market, this headrest would be a remarkably early example of "tourist" art. LP

PROVENANCE
Private collection, Germany
Michael Graham-Stewart, London, — to 1991

PUBLICATION HISTORY
Ross 1992: 12

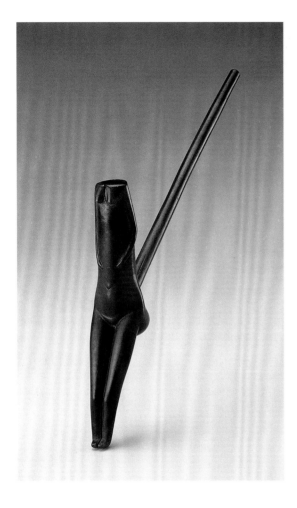

131. PIPE

South Sotho or Nguni peoples, South Africa
Wood, iron
L. 37 cm (14⅞₆ in.)
Museum purchase, 89-14-16

This pipe has been attributed to the Nguni-speaking peoples of the eastern Cape in South Africa or their Sotho-speaking neighbors in Lesotho (Nel in T. Phillips 1995: 211). It is a superb example of the figurative pipes carved in this region, most of which were capped with separately carved heads as stoppers (Shaw 1938).

The artist has brilliantly conceived the bowl of the pipe as a long and subtly elegant female torso. The thin arms are held at waist level and tight to the body, just above the delicately carved navel. The sharp lines of the separately carved stem, inserted into the lower back, emphasize the curves of the hips and buttocks. The tapered legs and diminutive feet are angled forward, echoing the forward thrust of the arms and reflecting the sense of the figure as a vibrant body at rest. As Nel (in T. Phillips 1995: 211) has observed, one senses in this pipe "the every-day pleasure given to maker, user and viewer."

Pipes were carved by men for use by both men and women. While smoking tobacco and taking snuff were everyday activities, tobacco products were associated with the power and generosity of individuals as well as the ancestral spirits. It follows that the paraphernalia for their use should have a pleasing design and be well made. PLR

PROVENANCE
Norman Hurst, Cambridge, Mass., — to 1984
Werner Muensterberger, New York, 1984 to 1989

PUBLICATION HISTORY
T. Phillips 1995: 211, no. 3.29b

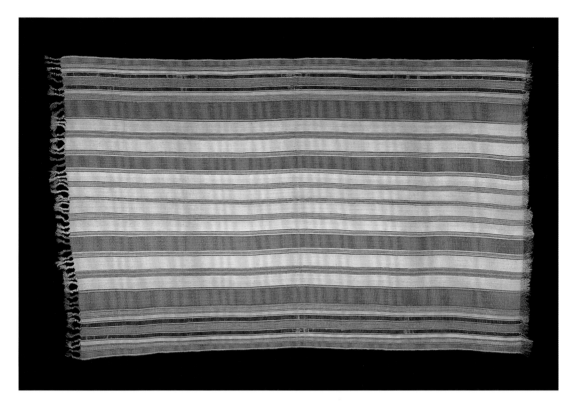

132. MAN'S GARMENT *(lamba)*
Malagasy peoples, central plateau region,
Madagascar
20th century
Raffia fibers, natural dyes
L. 198 cm (78 in.)
Museum purchase, 87-9-1

Hand weaving has traditionally been an important women's industry among the various Malagasy peoples. In addition to silk, they weave cotton, bast and raffia fibers or combinations thereof into cloth for clothing and for burial shrouds (Picton and Mack 1979: 134–45).

The pattern in this finely woven cloth is carried in the warp, where narrow and wide stripes of brown, natural, green and black alternate. The natural color of the weft is invisible. The cloth is composed of two panels joined together to create a symmetrical pattern. The subdued colors derive from natural dyes.

Both men and women wore warp-stripe cloths like this one wrapped around their upper bodies. Called a *lamba* by some Malagasy groups, such everyday garments were removed only to execute the most vigorous tasks. RAW

PROVENANCE
James Freeman, Kyoto, — to 1987

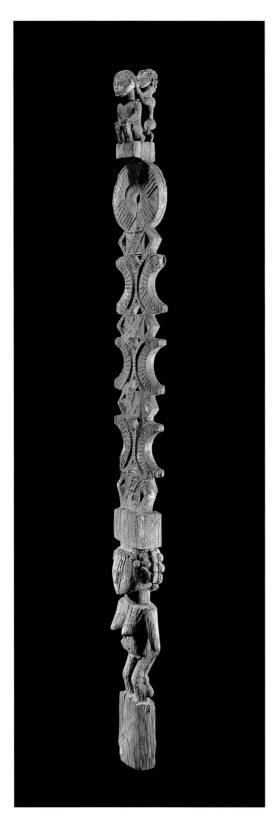

133. TOMB SCULPTURE
Mahafaly peoples, Madagascar
Wood
H. 207 cm (81½ in.)
Museum purchase, 85-1-20

The Mahafaly peoples who live on the south-
west coast of Madagascar carve elaborate poles
to set atop the tombs of deceased royalty or clan
leaders. Classic examples of older tomb sculp-
tures typically have a lower part consisting of
a single unclothed figure, a central openwork
section of geometric motifs, and a top with
representations of humped cattle or birds. This
sculpture is characteristic of the classic style
except that the top element depicts human
rather than bovine or avian figures. More recent
funerary sculptures are more explicitly com-
memorative, depicting one or more scenes from
the life of the deceased, in which the figures are
portrayed fully clothed.

Throughout Madagascar, the relationship
between the living and the dead is an important
cultural theme. The complex of artifacts, in-
cluding tomb sculptures among some groups,
is designed to mark the transition of the body
to the status of ancestor. The term for these
sculptures, *aloalo,* has been defined variously as
a messenger or intermediary between members
of the family and the ancestors.

Mahafaly tombs are constructed of stone or
concrete directly over the buried body (there is
no reburial, as in other areas of Madagascar).
Cattle skulls and as many as 16 sculptures are
then set atop the tomb. LP

PROVENANCE
Lucien Van de Velde, Antwerp, 1970s
Emile M. Deletaille, Brussels, 1970s to 1985

ABOUT THE AUTHORS

BRYNA M. FREYER is Assistant Curator of the National Museum of African Art and Collections Manager for the curatorial department. Her research interests are Benin royal arts and the history of collecting African art. (BMF)

CHRISTRAUD M. GEARY is Curator of the Eliot Elisofon Photographic Archives of the National Museum of African Art. Dr. Geary, a cultural anthropologist, has written extensively on the arts of Cameroon, photography in Africa and historical postcards from Africa. (CMG)

EDWARD LIFSCHITZ, Curator of Education of the National Museum of African Art, manages the museum's education program. His studies in African art history concentrated on the arts of West Africa. (EL)

ANDREA NICOLLS is an art historian and Assistant Curator at the National Museum of African Art. Dr. Nicolls's research has focused on the pottery of west and central Africa. (AN)

LYDIA PUCCINELLI, an art historian, is a Curator at the National Museum of African Art. She has concentrated her research on east and southern Africa. (LP)

PHILIP L. RAVENHILL (1945–1997) was Chief Curator of the National Museum of African Art from 1987 to 1997. His principal research interest was in the art and culture of the Baule people of Côte d'Ivoire. (PLR)

ROY SIEBER is Rudy Professor Emeritus of Indiana University, Bloomington. Formerly Associate Director of the National Museum of African Art, Dr. Sieber continues to advise the museum as Research Scholar Emeritus.

ROSLYN A. WALKER is Director of the National Museum of African Art. A former Curator of the museum, Dr. Walker's research has concentrated on the visual arts of the Yoruba peoples of Nigeria. (RAW)

SYLVIA H. WILLIAMS (1936–1996) was Director of the National Museum of African Art from 1983 until her death in February 1996. She maintained a strong research interest in the Kongo, combining a high aesthetic sense with historical perspective. (SHW)

Adams, Marie Jeanne. 1978. "Kuba Embroidered Cloth," *African Arts* 12 (1): 24–39, 106.

African-American Institute. 1980. *Masterpieces of the People's Republic of the Congo.* New York: African-American Institute.

African Arts. 1984. "The National Museum of African Art." 17 (3): 40–41.

———. 1987. "The National Museum of African Art: Opening September 1987." 20 (4): 31.

Akindélé, Adolphe. 1953. *Contribution à l'étude de l'histoire de l'ancien royaume de Port-Novo.* Dakar: IFAN.

Alard, Mireille. 1984. "Coupes gravées chez les Bashilele du Kasaï occidental." *Arts d'Afrique noire* (51): 11–21.

Allen Memorial Art Museum. 1956. "Exhibition of African Art, Feb. 6–Mar. 6." *Bulletin* 12 (2).

Allison, Philip. 1944. "A Yoruba Carver." *Nigeria* 22: 49–50.

———. 1952. "The First Travelling Commissioners of the Ekiti Country." *The Nigerian Field* 17 (3): 100–115.

Anderson, Martha G., and Christine Mullen Kreamer. 1989. *Wild Spirits, Strong Medicine: African Art and the Wilderness.* New York: The Center for African Art.

Arman & l'art africain. 1996. Marseille: Musées de Marseille.

Arnoldi, Mary Jo. 1986. *Somalia in Word and Image.* Bloomington: Indiana University Press.

Arnoldi, Mary Jo, and Christine Mullen Kreamer. 1995. *Crowning Achievements: African Arts of Dressing the Head.* Los Angeles: Fowler Museum of Cultural History, University of California.

Arts d'Afrique noire. 1977. "Les expositions." 23 (Autumn).

Awolalu, Omosade J. 1979. *Yoruba Beliefs and Sacrificial Rites.* London: Longman.

Baker, Samuel White. 1866. *The Albert N'yanza: Great Basin of the Nile, and Explorations of the Nile Sources.* London: Macmillan & Co.

Barley, Nigel. 1994. *Smashing Pots: Feats of Clay.* Washington, D.C.: Smithsonian Institution Press.

Bascom, William R. 1969a. *Ifa Divination: Communication between Gods and Men in West Africa.* Bloomington: Indiana University Press.

———. 1969b. *The Yoruba of Southwestern Nigeria.* New York: Holt, Rinehart and Winston.

Basden, George. 1966. *Niger Ibos: A Description of the Primitive Life, Customs, and Animistic Beliefs, etc., of the Ibo People.* Bibliographical note by John Ralph Willis. 2nd ed. New York: Barnes and Noble (originally published 1938).

Bassani, Ezio. 1979. "Sono from Guinea Bissau." *African Arts* 12 (4): 44–47, 91.

———. 1981. "Due grandi artisti yombe." *Critica d'arte africana* (Florence) 1 (July–Sept. 1981): 66–84.

———. 1983. "A Note on Kongo High-Status Caps in Old European Collections." *Res* 5 (Spring): 74–84.

Bassani, Ezio, and William Fagg. 1988. *Africa and the Renaissance: Art in Ivory.* New York: The Center for African Art; Munich: Prestel.

Bastin, Marie-Louise. 1969a. "Arts of the Angolan Peoples: II, Lwena." *African Arts* 2 (2): 46–53, 77–80.

———. 1969b. "Arts of the Angolan Peoples." *African Arts* 2 (4): 30–37, 74–76.

———. 1974. "Les styles de la sculpture tshokwe." *Arts d'Afrique noire* 19 (Autumn): 35.

———. 1980. "Le masque féminin à yeux blancs de la collection E. Deletaille." Unpublished paper.

———. 1982. *La sculpture tshokwe.* Trans. by J. B. Donne. Meudon, France: Alain et François Chaffin.

———. 1984. *Introduction aux arts d'afrique noire.* Arnouville, France: Arts d'Afrique Noire.

Bay, Edna G. 1985. *Asen: Iron Altars of the Fon People of Benin.* Atlanta: Emory University Museum of Art and Archaeology.

———. 1987. "Metal Arts and Society in Nineteenth and Twentieth Century Abomey." In *Discovering the African Past: Essays in Honor of Daniel F. McCall,* ed. by Norman R. Bennett. Boston: African Studies Center, Boston University.

Bedaux, Rogier. 1988. "Tellem and Dogon Material Culture." *African Arts* 21 (4): 38–41, 91.

Beier, Ulli. 1982. *Yoruba Beaded Crowns: Sacred Regalia of the Olokuku of Okuku.* London: Ethnographica in association with the National Museum, Lagos.

Bellis, James O. 1982. *The Place of the Pots.* In *Akan Funerary Custom.* Bloomington: Indiana University Press.

Ben-Amos, Paula Girshick. 1976. "Men and Animals in Benin Art." *Man,* n.s. 2: 243–52.

———. 1995. *The Art of Benin.* Rev. ed. Washington, D.C.: Smithsonian Institution Press.

Bernatzik, Hugo Adolph. *Im Reich der Bidyogo: Geheimnisvolle Inseln in Westafrika.* Leipzig: Koehler and Voigtlander, 1944.

Biebuyck, Daniel. 1970. "Effects on Lega Art of the Outlawing of the Bwami Association." In *New African Literature and the Arts,* vol. 1, ed. by Joseph Okpaku. New York: Thomas Y. Crowell.

———. 1973. *Lega Culture.* Berkeley: University of California Press.

———. 1984. *The Power of Headdresses: A Cross-Cultural Study of Forms and Functions.* Brussels: Tendi.

———. 1985. *The Arts of Zaire. Volume 1: Southwestern Zaire.* Berkeley: University of California Press.

———. 1993. "Masks and Initiation among the Lega Cluster of Peoples." In *Face of the Spirits: Masks from the Zaire Basin,* ed. by Frank Herreman and Constantijn Petridis. Gent: Snoeck-Ducaju.

Bivar, A. D. H. 1964. *Nigerian Panoply: Arms and Armour of the Northern Regions.* Lagos: Department of Antiquities, Federal Republic of Nigeria.

[Blandin, André.] 1976. "African Art: A Selection from Two Private Collections." N.p.

———. 1988. *Afrique de l'ouest: Bronzes et autres alliages.* Marignane, France: André Blandin.

Blier, Suzanne Preston. 1993. "Imaging Otherness in Ivory: African Portrayals of the Portuguese ca. 1492." *Art Bulletin* 75 (3): 375–96.

———. 1995. *African Vodun: Art, Psychology, and Power.* Chicago: University of Chicago Press.

Bodrogi, Tibor. 1982. *Stammeskunst.* Budapest: Corvina.

Bolz, Ingeborg. 1966. "Zur Kunst in Gabon, Stillkritische Untersuchungen an Masken und Plastiken des Ogowe-Gebietes." In *Beiträge zur Afrikanischen Kunst,* ed. by W. Frölich. Cologne: Brill.

Boston, J. S. 1968. *The Igala Kingdom.* Ibadan: published for the Nigerian Institute of Social and Economic Research [by] Oxford University Press.

———. 1977. *Ikenga: Figures among the North-west Igbo and the Igala.* London: Ethnographica.

Bourgeois, Arthur P. 1984. *Art of the Yaka and Suku.* Meudon, France: Alain and Françoise Chaffin.

Boyer, Alain-Michel. 1993. "Art of the Yohure." In *Art of the Côte d'Ivoire,* 2 vols., ed. by Jean-Paul Barbier. Geneva: The Barbier-Mueller Museum.

Brain, James L. 1978. "Symbolic Rebirth: The *Mwali* Rite among the Luguru of Eastern Tanzania." *Africa* 48 (2): 176–88.

Brasseur-Marion, P., and G. Brasseur. 1953. *Porto-Novo et sa palmeraie.* Dakar: IFAN.

Bravmann, René. 1983. *African Islam.* Washington, D.C.: Smithsonian Institution Press; London: Ethnographica.

Brooklyn Museum. 1954. *Masterpieces of African Art.* New York.

Brown, H. D. 1944. "The Nkumu of the Tumba: Ritual Chieftainship on the Middle Congo," *Africa* 14 (8): 431–47.

Bynon, James. 1984. "Berber Women's Pottery: Is the Decoration Motivated?" In *Earthenware in Asia and Africa: A Colloquium held 21–23 June 1962,* ed. by John Picton. London: University of London, Percival David Foundation for Chinese Art.

Camps-Fabrer, Henriette. 1990. *Bijoux berbères d'Algérie: Grande Kabylie, Aurs.* La Calade, Aix-en-Provence: Edisud.

Carnegie Institute, Department of Fine Arts. 1959. *Exotic Art from Ancient and Primitive Civilizations: Collection of Jay C. Leff.* Pittsburgh.

Carnegie Institute, Museum of Art. 1969. *The Art of Black Africa, Collection of Jay C. Leff.* Pittsburgh.

Carroll, Kevin. 1967. *Yoruba Religious Carving.* London: Geoffrey Chapman.

Casajus, Dominique. 1987. "Crafts and Ceremonies: The Inadan in Tuareg Society." In *The Other Nomads: Peripatetic Minorities in Cross-Cultural Perspective,* ed. by A. Rao. Cologne: Bohlau.

Celis, Georges. 1970. "The Decorative Arts in Rwanda and Burundi." *African Arts* 4 (1): 41–42.

———. 1987. "Fondeurs et forgerons ekonda (Equateur Zaïre)." *Anthropos* 8: 109–34.

Cerulli, Ernesta. 1957–64. *Somalia, scritti vari editi ed inediti: A cura dell'amministrazione Fiduciaria Italiana della Somalia.* Vol 2. Rome: Istituto Poligrafico dello Stato.

Christie's. 1983. *Tribal Art and Antiquities.* Auction catalogue (May 11). New York.

———. 1992. *Important Tribal Art.* Auction catalogue (June 23). London.

Coart, E., and Haulleville, A. de. 1907. *Notes analytiques sur les collections ethnographiques du Musée du congo: Les industries indigènes, la ceramique.* Tervuren: Musée du Congo.

Cole, Herbert M. 1989. *Icons, Ideals and Power in the Art of Africa.* Washington, D.C.: Smithsonian Institution Press.

Cole, Herbert M., and Chike Aniakor. 1984. *Igbo Arts: Community and Cosmos,* Los Angeles: Museum of Cultural History, University of California.

Cole, Herbert M., and Doran H. Ross. 1977. *The Arts of Ghana.* Los Angeles: Museum of Cultural History, University of California.

Collart, René. 1984. *Burundi: Trente ans d'histoire en photos, 1900–1930.* 2nd ed. Belgium: Collart.

Cornet, Joseph. 1978. *A Survey of Zairian Art: The Bronson Collection.* Raleigh: North Carolina Museum of Art.

Culin, Stewart. 1896. "Mancala, the National Game of Africa." In *Annual Report of the Board of Regents of the Smithsonian Institution, Year Ending June 30, 1894.* Washington, D.C.: Government Printing Office.

Cummins, S. L. 1904. "Sub-Tribes of the Bahr-el-Ghazal Dinkas." *The Journal of the Anthropological Institute of Great Britain and Ireland,* no. 34: 160.

Curnow, Kathy. 1983. "The Afro-Portuguese Ivories: Classification and Stylistic Analysis of a Hybrid Art Form." 2 vols. Ph.D. diss., Bloomington: Indiana University.

Damme, Wilfried van. 1987. "A Comparative Analysis Concerning Beauty and Ugliness in Sub-Saharan Africa." *Africana Gandensia* 4: 1–97.

Darish, Patricia. 1990. "Fired Brilliance: Ceramic Vessels from Zaire" (exh. booklet). Kansas City: University of Missouri–Kansas City Gallery of Art.

Dartevelle, E. 1935. "La poterie au Bas-Congo." *XVI Congrès International d'Anthropologie et d'Archeologie Prehistorique,* 914–21.

Datta, Ansu K., and R. Porter. 1971. "The Asafo System in Historical Perspective." *Journal of African History* 12 (2): 279–97.

Decalo, Samuel. 1995. *Historical Dictionary of Benin.* African Historical Dictionaries, no. 61. Lanham, Md.: Scarecrow Press.

Delange, Jacqueline. 1967. *Arts et peuples de l'Afrique noire.* Paris: Gallimard.

DeMott, Barbara. 1982. *Dogon Masks: A Structural Study of Form and Meaning.* Ann Arbor: UMI Research Press.

Denny, Walter B. 1974. "A Group of Silk Islamic Banners." *Textile Museum Journal* (Washington, D.C.) 4 (1): 67–81.

Dewey, William J. 1991. "Pleasing the Ancestors: The Traditional Art of the Shona People of Zimbabwe." Ph.D. diss., Indiana University, Bloomington.

———. 1993. *Sleeping Beauties: The Jerome L. Joss Collection of African Headrests at UCLA.* Los Angeles: Fowler Museum of Cultural History, University of California.

Dietz, Elizabeth, and Michael Babatunde Olatunji. 1965. *Musical Instruments of Africa.* New York: John Day.

Douglas, Mary. 1963. *The Lele of the Kasai.* London: Oxford University Press.

Drewal, Henry John. 1992. "Image and Indeterminacy: Elephants and Ivory among the Yoruba." In *Elephant: The Animal and Its Ivory in African Culture,* ed. by Doran Ross. Los Angeles: Fowler Museum of Cultural History, University of California.

Drewal, Henry John, and John Pemberton III with Rowland Abiodun. 1989. *Yoruba: Nine Centuries of African Art and Thought.* Ed. by Allen Wardwell. New York: The Center for African Art in association with Harry N. Abrams.

Drewal, Margaret Thompson. 1977. "Projections from the Top in Yoruba Art." *African Arts* 11 (1): 43–49, 91–92.

———. 1986. "Art and Trance among Yoruba Shango Devotees." *African Arts* 20 (1): 60–67, 98–99.

d'Ucel, Jeanne. 1932. *Berber Art: An Introduction.* Norman: University of Oklahoma Press.

Duquette, Danielle Gallois. 1979. "Woman Power and Initiation in the Bissagos Islands." *African Arts* 12 (3): 31–35, 93.

Elisofon, Eliot, and William Fagg. 1958. *The Sculpture of Africa.* New York: Frederick A. Praeger.

Evans-Pritchard, E. E. 1960. "A Contribution to the Study of Zande Culture." *Africa* 30 (4): 309–23.

———. 1963. "A Further Contribution to the Study of Zande Culture." *Africa* 30 (3): 183–97.

Ezra, Kate. 1986. *A Human Ideal in African Art: Bamana Figurative Sculpture.* Washington, D.C.: Published for the National Museum of African Art by the Smithsonian Institution Press.

———. 1988. *Art of the Dogon: Selections from the Lester Wunderman Collection.* New York: Metropolitan Museum of Art.

Fagg, William B. 1963. *Nigerian Images: The Splendor of African Sculpture.* New York: Frederick A. Praeger.

———. 1968. *African Tribal Images.* Cleveland: Cleveland Museum of Art.

———. 1969. "The African Artist." In *Tradition and Creativity in Tribal Art,* ed. by Daniel P. Biebuyck. Berkeley: University of California Press.

———. 1980a. *Masques d'Afrique dans les collections du Musée Barbier-Müller.* Geneva: Editions Fernand Nathan.

———. 1980b. *Yoruba Beadwork: Art of Nigeria.* Descriptive catalogue by John Pemberton III, ed. by Bryce Holcombe. New York: Rizzoli.

———. 1982. *Yoruba: Sculpture of West Africa.* Descriptive catalogue by John Pemberton III, ed. by Bryce Holcombe. New York: Alfred A. Knopf.

Fagg, William B. and John Picton. 1978. *The Potter's Art in Africa.* 2nd ed. London: Published for the Trustees of the British Museum by British Museum Publications.

Faraut, F. 1981. "Les Mboum." In *Contribution de la recherche ethnologique à l'histoire des civilisations du Cameroun.* Vol. 1. Paris: Éditions du Centre national de la recherche scientifique.

Fardon, Richard. Forthcoming. "The Highlands." In *Arts of the Benue Valley*, ed. by Arnold Rubin and Marla Berns. Los Angeles: Fowler Museum of Cultural History, University of California.

Faulkner, Laurel Birch. 1988. "Basketry Masks of the Chewa." *African Arts* 21 (3): 28–31, 86.

Fechter, Rudolf. 1973. "Ethiopian Icons and Crosses." In *Religious Art of Ethiopia/Religiöse Kunst Athiopiens*. Stuttgart: Institut für Auslandsbeziehungen.

Felix, Marc L. 1987. *One Hundred Peoples of Zaire and Their Sculpture: The Handbook*. Brussels: Zaire Basin Art History Research Foundation.

———. 1990. *Mwana Hiti: Life and Art of the Matrilineal Bantu of Tanzania/Leben und Kunst der Matrilinearen Bantu von Tansania*, Munich: Fred Jahn.

———. 1992. *Ituri: The Distribution of Polychrome Masks in Northeast Zaire*. Munich: Fred Jahn.

Fernandez, James W. 1966. "Principles of Opposition and Vitality in Fang Aesthetics." In *The Journal of Aesthetics and Art Criticism* 24 (1). Reprinted in *Art and Aesthetics in Primitive Societies; a Critical Anthology*. Ed. by Carol F. Jopling, New York: E. P. Dutton, 1971.

Fiberarts. 1990. (Summer).

Fischer, Eberhard. 1996. "Dan." In *The Dictionary of Art*, ed. by Jane Turner. New York: Macmillan.

Fischer, Eberhard, and Hans Himmelheber. 1984. *The Arts of the Dan in West Africa*. Zurich: Museum Rietberg.

Fortune, Leasa Farrar. 1997. "Adinkra: The Cloth That Speaks" (exh. booklet). Washington, D.C.: National Museum of African Art, Smithsonian Institution.

Foss, Perkins. 1976a. "The Arts of the Urhobo Peoples of Southern Nigeria." Ph.D. diss., Yale University, New Haven.

———. 1976b. "Urhobo Statuary for Spirits and Ancestors." *African Arts* 9 (4): 12–23.

Frank, Barbara. 1990. "From Village Autonomy to Modern Village Administration Among the Kulere of Central Nigeria." *Africa* 60 (2): 270–93.

Freyer, Bryna. 1987. *Royal Benin Art in the Collection of the National Museum of African Art*. Washington, D.C.: Published for the National Museum of African Art by the Smithsonian Institution Press.

———. 1993. "Asen, Iron Altars from Ouidah, Republic of Benin" (exh. booklet). Washington, D.C.: National Museum of African Art, Smithsonian Institution.

Freyer, Bryna, and Edward Lifschitz. 1983. "From the Earth: African Ceramic Art" (exh. booklet). Washington, D.C.: National Museum of African Art, Smithsonian Institution.

Galhano, Fernando. 1971. *Esculturas e objectos decorados da Guiné Portuguesa*. Lisbon: Junta de Investigaçoes do Ultramar.

Garrard, Timothy F. 1979. "Akan Metal Arts." *African Arts* 13 (1): 36–43, 100.

———. 1980. *Akan Weights and the Gold Trade*. London: Longman.

———. 1989. *Gold of Africa*. Geneva: Barbier-Mueller Museum.

Geary, Christraud M. 1989. "Slit Gongs in the Cameroon Grassfields: Sights and Sounds of Beauty and Power." In *Sounding Forms: African Musical Instruments*, ed. by Marie-Thérèse Brincard. New York: American Federation of the Arts.

———. 1994. *The Voyage of King Njoya's Gift: A Beaded Sculpture from the Bamum Kingdom, Cameroon, in the National Museum of African Art*. Washington, D.C.: National Museum of African Art, Smithsonian Institution.

Geary, Christraud, and Andrea Nicolls. 1992. "Elmina: Art and Trade in the West African Coast" (exh. booklet). Washington, D.C.: National Museum of African Art, Smithsonian Institution.

———. 1994. "Beaded Splendor" (exh. booklet). Washington, D.C.: National Museum of African Art, Smithsonian Institution.

Gilfoy, Peggy Stoltz. 1987. *Patterns of Life: West African Strip-Weaving Traditions*. Washington, D.C.: Published for the National Museum of African Art by the Smithsonian Institution Press.

Gillon, Werner. 1979. *Collecting African Art*. London: Studio Vista and Christie's.

Glaze, Anita J. 1978. "Senufo Ornament and Decorative Arts." *African Arts* 2 (1): 3–71, 107–8.

———. 1981. *Art and Death in a Senufo Village*. Bloomington: Indiana University Press.

Goldwater, Robert. 1960. *Bambara Sculpture of the Western Sudan*. New York: Museum of Primitive Art, University Publishers.

Göttler, Gerhard. 1989. *Die Tuareg: Kulturelle Einheit und regionale Vielfalt eines Hirtenvolkes*. Cologne: DuMont.

Griaule, Marcel. 1938. *Masques Dogon*. Paris: Institut d'ethnologie.

———. 1965. *Conversations with Ogotemmeli: An Introduction to Dogon Religious Ideas*. London: Published for the International African Institute by Oxford University Press.

Gruner, Dorothee. 1973. *Die Berber-Keramik*. Wiesbaden: Franz Steiner.

Grunne, Bernard de. 1980. *Terres cuites ancienne de l'Ouest Africain*. Louvain-la-Neuve: Institut Supérieur d'archéologie et d'histoire de l'art, College Erasme.

———. 1987. "Divine Gestures and Earthly Gods: A Study of the Ancient Terracotta Statuary from the Inland Niger Delta in Mali." Ph.D. diss., Yale University, New Haven.

———. 1991. "Heroic Riders and Divine Horses: An Analysis of Ancient Soninke and Dogon Equestrian Figures from the Inland Niger Delta Region in Mali." *The Minneapolis Institute of Arts Bulletin* 66: 78–96.

———. 1995. "An Art Historical Approach to the Terracotta Figures of the Inland Niger Delta." *African Arts* 28 (4): 70–79.

Gulliver, Pamela, and P. H. Gulliver. 1953. *The Central Nilo-Hamites.* London: International African Institute.

Hambly, Wilfrid Dyson. 1934. *The Ovimbundu of Angola.* Frederick H. Rawson–Field Museum ethnological expedition to West Africa, 1929–30. Chicago.

Harley, George W. 1950. *Masks as Agents of Social Control in Northeastern Liberia.* Cambridge, Mass.: Peabody Museum of American Archaeology and Ethnology, Harvard University.

Harris, Rosemary. 1965. *The Political Organization of the Mbembe, Nigeria.* Overseas Research Publication 10. London: Her Majesty's Stationery Office.

Harter, Pierre. 1986. *Arts anciens du Cameroun.* Arnouville: Arts d'Afrique noire.

Herbert, Eugenia W. 1984. *Red Gold, Copper Arts of Africa.* South Hadley, Mass.: Mount Holyoke College Art Museum.

———. 1993. *Iron, Gender, and Power: Rituals of Transformation in African Societies.* Bloomington: Indiana University Press.

Herreman, Frank. 1986. *The Skin of the Statue: Scarification and Body Painting on Central African Sculpture.* Waasmunster, Belgium: Galeij van de Akademie.

Herreman, Frank, and Constantijn Petridis, eds. 1993. *Face of the Spirits: Masks from the Zaire Basin.* Ghent: Snoeck-Ducaju and Zoon.

Hersak, Dunja. 1986. *Songye Masks and Figure Sculpture.* London: Ethnographica.

Herskovits, Melville J. 1938. *Dahomey: An Ancient West African Kingdom,* New York: J.J. Augustin.

Heusch, Luc de. 1995. "Beauty is Elsewhere: Returning a Verdict on Tetela Masks, Historical and Ethnological Notes on the Nkutshu." In *Objects: Signs of Africa.* Ed. by Luc de Heusch. Ghent: Snoeck-Ducaju and Zoon.

Hobley, Charles. 1910. *Ethnology of A-Kamba and Other East African Tribes.* 3rd ed. London: Cass.

Holt, P. M. 1956. "Correspondence." *Sudan Notes and Records* (Khartoum), 36 (2): 205–6.

Holy, Ladislav. 1967. *Masks and Figures from Eastern and Southern Africa.* Lonson: Paul Hamlyn.

Hôtel Drouot. 1966. *Art Primitif.* Auction catalogue (November 21). Paris.

Hôtel Drouot (Ader Picard Tajan). 1989. *Afrique-Océanie.* Auction catalogue (October 16). Paris.

———. 1990. *Arts Primitifs: Afrique-Océanie.* Auction catalogue (December 18). Paris.

Hottot, Robert. 1956. "Teke Fetishes." *Journal of the Royal Anthropological Institute of Great Britain and Ireland* 86 (1): 25–40.

Houlberg, Marilyn Hammersley. 1973. "Ibeji Images of the Yoruba." *African Arts* 7(1); 20–27, 91.

Huet, Michel. 1978. *The Dance, Art, and Ritual of Africa.* New York: Pantheon Books.

Idowu, E. Bolaji. 1962. *Olodumare: God in Yoruba Belief.* London: Longmans.

Issac Delgado Museum of Art. 1967. *Odyssey of an Art Collector.* New Orleans: Delgado Museum of Art.

Jacob, Alain. 1974. *Bronzes de l'Afrique noire.* Paris: C.P.I.P.

———. 1976. *Statuaire de l'Afrique noire.* Paris: ABC Décor.

Janzen, John M. 1978. "Book Review: *Les Phemba du Mayombe.*" *African Arts* 11 (2): 88–89.

———. 1982. *Lemba, 1650–1930: A Drum of Affliction in Africa and the New World.* New York: Garland Publishing.

Janzen, John M., and Reinhild Kauenhoven-Janzen. 1975. "Pende Masks in Kauffman Museum." *African Arts* 8 (4): 44–47.

Johnson, Mary, Derry Joe Yakuba, and Betty Wass. 1980. *African Cultural Heritage.* East Lansing, Mich.: Michigan 4-H Youth Programs, Cooperative Extension Service, Michigan State University.

Johnston, Harry H. 1895. *The River Congo.* London: Sampson Low, Marstone.

———. 1908. *George Grenfell and the Congo.* London: Hutchinson.

Jones, G. I. 1984. *The Art of Eastern Nigeria.* Cambridge: Cambridge University Press.

Jordán, Manuel, ed. 1998. *Chokwe! Art and Initiation among Chokwe and Related Peoples.* Munich: Prestel-Verlag.

Junod, Henri. 1912. *The Life of a South African Tribe.* Vol. 2. New York: University Books.

Kamer, Hélène. 1974. *Ancêtres M'Bembe.* Paris: H. Kamer.

Kasfir, Sidney L., ed. 1988. *West African Masks and Cultural Systems.* Tervuren: Musée royal de l'Afrique centrale.

Kay, Stafford. 1978. "Peter Nzuk: Calabash Carver of Kenya." *African Arts* 12 (1): 40–41, 108.

Kecskesi, Maria. 1982. "The Pickaback Motif in the Art and Initiation of the Rovuma Area." *African Arts* 16 (1): 52–55, 94.

Kerchache, Jacques, Jean-Louis Paudrat and Lucien Stéphan. 1993. *Art of Africa.* New York: Harry N. Abrams.

Klopper, Sandra. 1985. "Speculations on Lega Figurines." *African Arts* 19 (1): 64–69, 88.

———. 1989. "The Art of the Traditionalists in Zululand-Natal." In *Catalogue: Ten Years of Collecting (1979–1989).* Johannesburg: University of Witwatersrand.

Knight, Ian. 1989. *Queen Victoria's Enemies (2): Northern Africa.* London: Osprey Publishing.

Knops, P. C. 1980. *Anciens Senufo 1923–1935.* Bergen Dal, Netherlands: Afrika Museum.

Koloss, Hans-Joachim. 1984. "Njom Among the Ejagham." *African Arts* 18 (1): 71–73, 90–93.

———. 1990. *The Art of Central Africa: Masterpieces from the Berlin Museum für Völkerkunde,* New York: Metropolitan Museum of Art.

Krieger, Kurt. 1969. *Westafrikanische Plastik II.* Berlin: Museum für Völkerkunde.

Kunsthaus Zürich. 1970. *Die Kunst von Schwarz-Afrika.* Recklinghausen: A. Bongers, 1970.

LaGamma, Alisa. 1996. "The Art of the Punu Mukudji Masquerade: Portrait of an Equatorial Society." Ph.D. diss., Columbia University, New York.

Laman, Karl Edvard. 1953. *The Kongo.* Studia Ethnographica Upsaliensia. Uppsala.

Lamb, Venice, and Alastair Lamb. 1975. *The Lamb Collection of West African Narrow Strip Weaving.* Washington, D.C.: Textile Museum.

———. 1984. *Sierra Leone Weaving.* Hertingfordbury, Hertfordshire: Roxford Books.

Lamp, Frederick. 1983. "House of Stones: Memorial Art of Fifteenth-Century Sierra Leone." *Art Bulletin* 65 (2): 219–36.

———. 1996. *Art of the Baga: A Drama of Cultural Reinvention.* New York: Museum for African Art; Munich: Prestel.

Lander, Richard L. 1832. *Journal of an Expedition to Explore the Course and Termination of the Niger.* New York: J & J Harper.

Laurenty, Jean-Sébastien. 1995. *L'organologie du Zaire.* 3 vols. Tervuren, Belgium: Musée royal de l'Afrique centrale.

Lawrence, C. T. 1924. "Report on Nigerian Section, British Empire Exhibition," *West Africa* 9: 1212–16.

Lehuard, Raoul. 1973. "La collection René Lavigne." *Arts d'Afrique noire* 7 (Autumn).

———. 1977a. "Les expositions." *Arts d'Afrique noire* 23 (1): 20.

———. 1977b. *Les Phemba du Mayombe.* Arnouville, France: Arts d'Afrique noire.

———. 1989. *Art Bakongo: Les centres de style.* 3 vols. Arnouville, France: Arts d'Afrique noire.

———. 1992. "A propos de 'Entre l'homme et les dieux.'" *Arts d'Afrique noire, arts premiers* 82 (Summer): 25–28.

———. 1996. *Les arts Bateke: Congo-Gabon-Zaire.* Arnouville, France: Arts d'Afrique noire.

Leiris, Michel, and Jacqueline Delange. 1968. *African Art.* New York: Golden Press.

Leloup, Hélène. 1994. *Dogon Statuary.* Trans. by Brunhilde Biebuyck. Strasbourg, France: Editions Amez.

Leuzinger, Elsy. 1972. *The Art of Black Africa.* Trans. by R. A. Wilson. London: Studio Vista.

———. 1978. *Kunst der Naturvolker.* Frankfurt-am-Main: Propylaen.

———. 1979. *Art de l'Afrique noire.* Barcelona: Ediciones Poligrafa.

Levenson, Jay A., ed. 1991. *Circa 1492: Art in the Age of Exploration.* Washington, D.C.: National Gallery of Art; New Haven: Yale University Press.

Lindblom, Gerhard. 1969. *The Akamba in British East Africa: An Ethnological Monograph.* 1916; Reprint, New York: Negro Universities Press, 1969.

Loughran, Kristyne. 1995. *Art from the Forge.* Washington, D.C.: National Museum of African Art.

Luschan, Felix von. 1919 [1968]. *Die Altertümer von Benin.* Reprint (3 vols. in 1). New York: Hacker Art Books.

MacGaffey, Wyatt. 1994. "Notes and Comments: African Objects and the Idea of Fetish." *Res* (25): 123–31.

MacGaffey, Wyatt, and Michael Harris. 1993. *Astonishment and Power.* Washington, D.C.: Smithsonian Institution Press for the National Museum of African Art.

Mack, John. 1981. "Material Culture and Ethnic Identity in South Eastern Sudan." *Museum Ethnographers Newsletter* 12 (October): 1–32.

———. 1990. *Emil Torday and the Art of the Congo, 1900–1909.* Seattle: University of Washington Press.

Mato, Daniel. 1987. "Clothed in Symbol: The Art of Adinkra among the Akan of Ghana." Ph.D. diss., Indiana University, Bloomington.

Maurer, Evan, and Allen F. Roberts. 1985. *Tabwa: The Rising of the New Moon.* Ann Arbor: University of Michigan Museum of Art.

McIntosh, Susan, and Roderick McIntosh. 1988. "From Stone to Metal: New Perspectives on the Later Prehistory of West Africa." *Journal of World Prehistory* 2 (1): 89–133.

McLeod, Malcolm D. 1980. *Treasures of African Art.* New York: Abbeville Press.

———. 1981. *The Asante.* London: Trustees of the British Museum by British Museum Publications Ltd.

———. 1987. "Asante Gold-weights, Images and Words." *Word and Image* (London) 3 (3): 289–95.

McNaughton, Patrick. 1988. *The Mande Blacksmiths: Knowledge, Power, and Art in West Africa.* Bloomington and Indianapolis: Indiana University Press.

———. 1996. "Bamana." *The Dictionary of Art.* Vol. 3. New York: Grove's Dictionaries.

Melikian, Sourer. 1983. "Melikian's Thoughts: Private Collections, Is the End in Sight?" *The International Art Market* 23 (7): 131.

Mellor, Stephen, Dana Moffett, and Madeleine Hexter. 1990. Conservation report 90-2-1. National Museum of African Art, Smithsonian Institution.

Meneghini, Mario. 1972. "The Bassa Mask." *African Arts* 5 (1): 44–48, 88.

Menzel, Brigitte. 1968. *Goldgewichte aus Ghana.* Berlin: Museum für Völkerkunde.

Mercier, Paul, and J. Lombard. 1959. *Guide du Musée d'Abomey.* Republic of Dahomey: Institut fondamental d'Afrique noire (IFAN).

Mestach, Jean Willy. 1985. *Etudes songye: Formes et symbolique, essai d'analyse/Songye Studies: Form and Symbolism, An Analytical Essay.* Munich: Galerie Jahn.

Mickelsen, Nancy R. 1976. "Tuareg Jewelry." *African Arts* 9 (2): 16–19.

Mobolade, Timothy. 1971. "Ibeji Custom in Yorubaland." *African Arts* 4 (3): 14–15.

Monteiro, Joachim John. 1875. *Angola and the River Congo.* 2 vols. London: Macmillan.

Muller, Hendrick. 1893. *Industrie des Cafres du sud-est de l'Afrique collection recueillie sur les lieux et notice ethnographique.* Leiden: E. J. Brill.

Murray, H.J.R. 1952. *A History of Board Games Other than Chess.* Oxford: Clarendon Press.

Murray, Kenneth C. 1949. "Idah Masks." *Nigerian Field* 14 (3):, 85–92.

Musée des Beaux-Arts–La Chaux-de-Fonds. 1971. *Sculptures de l'Afrique noire: Exposition.* La Chaux-de-Fonds, Switzerland: Musée des Beaux-Arts.

Musée d'ethnographie. 1973. *Arts africains dans les collections genevoises.* Geneva: Musée d'ethnographie de la ville de Genève.

Musée de l'homme. 1967. *Arts primitifs dans les ateliers d'artistes.* Paris: Société des amis du Musée de l'homme.

Museum of African Art. 1973. *African Art in Washington Collections: A Loan Exhibition at the Museum of African Art 1972.* Washington, D.C.: Museum of African Art.

Museum of Primitive Art. 1967. *African Tribal Sculpture from the Collection of Ernst and Ruth Anspach.* New York: Museum of Primitive Art, dist. by New York Graphic Society.

Nalder, Leonard Fielding, ed. 1937. *A Tribal Survey of Mongalla Province.* London: Oxford University Press for the International Institute of African Languages and Culture.

National Museum of African Art. 1981. "Life . . . Afterlife, African Funerary Sculpture" (exh. booklet). Washington, D.C.: National Museum of African Art, Smithsonian Institution.

———. 1997. "National Museum of African Art 1987–1997" (brochure). Washington, D.C.: National Museum of African Art, Smithsonian Institution.

Nebout, A. 1975. "Notes sur le Baoulé." *Arts d'Afrique noire* (15): 8–33.

Nettleton, Anitra. 1988. "History and the Myth of Zulu Sculpture." *African Arts* 21 (3): 48–51, 86–87.

Nevadomsky, Joseph. 1986. "The Benin Bronze Horseman." *African Arts* 19 (4): 40–47, 85.

New Art Circle. 1927. Blondiau-Theatre Arts Collection of Primitive Art. New York: New Art Circle.

Newman, Sandra. 1978. *African Grass and Fiber Arts.* New York: African American Institute.

Neyt, François. 1975. *Approche des arts Hemba.* Villiers-le-Bel: Arts d'Afrique noire.

———. 1977. *La grand statuaire Hemba du Zaire.* Louvain-le-Neuve: Institut Supérieur d'archéologie de et d'histoire de l'art.

———. 1981. *Arts traditionnel et histoire au Zaire: Cultures forestières et royaumes de la Savane.* Brussels: Société d'arts primitifs; Louvain-le-Neuve: Institut Supérieur d'archéologie et d'histoire d l'art.

———. 1985. *The Arts of the Benue to the Roots of Tradition: Nigeria.* Np.: Editions Hawaiian Agronomics.

———. 1994. *Luba: The Source of the Zaire.* Trans. by Murray Wyllie. Paris: Editions Dapper.

Niangoran-Bouah, G. 1987. *The Akan World of Gold Weights: The Weights and Society.* Abidjan: Les Nouvelles editions africaines.

Nicklin, Keith. 1981. "Rape and Restitution: The Cross River Region Considered. *Museum* (Paris) 23 (4): 259–60.

Nicklin, Keith, and Jill Salmons. 1984. "Cross River Art Styles." *African Arts* 18 (1): 28–43.

Nicolaisen, Johannes. 1963. "Ecology and Culture of the Pastoral Tuareg." Ph.D. diss., National Museum, Copenhagen.

Nicolaisen, Johannes, and Ida Nicolaisen. 1997. *The Pastoral Tuareg: Ecology, Culture, and Society.* 2 vols. New York: Thames and Hudson; Copenhagen: Rhodos International Science and Art Publishers.

Nicolls, Andrea. 1991. "A Cloth of Honor" (exh. brochure). Washington, D.C.: National Museum of African Art, Smithsonian Institution.

———. 1998. "A Spiral of History: A Carved Tusk from the Loango Coast" (exh. booklet). Washington, D.C.: National Museum of African Art, Smithsonian Institution.

Nooter, Mary. 1984. "Luba Leadership Arts and the Politics of Prestige." Master's thesis, Columbia University, New York.

———. 1985. "Catalogue." In *Sets, Series and Ensembles in African Art* by George Nelson Preston and introduction by Susan Vogel. New York: The Center for African Art and Harry N. Abrams.

Nooter, Nancy Ingram. 1994. "Ostafrikanische Hochlehnige Hocker: Eine Transkulturelle Tradition." In *Tanzania: Meisterwerke Afrikanischer Skulptur.* Munich: Haus der Kulturen der Welt.

———. 1995. "East African High-Backed Stools: A Transcultural Tradition." *World of Tribal Art* 2 (1): 48.

Northern, Tamara. 1984. *The Art of the Cameroon.* Washington, D.C.: Smithsonian Institution Traveling Exhibition Service.

Notre colonie: Le Congo Belge. 1909. Brussels: A. de Boeck.

Odeleye, A. O. 1977. *Ayo: A Popular Yoruba Game.* Ibadan, Nigeria: Oxford Univeristy Press.

Olbrechts, Frans. 1959. *Les arts plastique du Congo Belge.* Brussels: Editions Erasme.

Park, Edwards. 1983. *Treasures of the Smithsonian.* Washington. D.C.: Smithsonian Books.

Parke-Bernet Galleries. 1966. *The Helena Rubinstein Collection: African and Oceanic Art.* Auction catalogue (April 21, 29) New York.

Paulme, Denise. 1962. *African Sculpture.* New York: Viking Press.

Paulme, Denise, and Jacques Brosse. 1956. *Parures africaines.* Paris: Hachette.

Pemberton, John. 1989. "The Carvers of the Northeast." In *Yoruba: Nine Centuries of African Art and Thought,* ed. by Allen Wardwell. New York: The Center for African Art and Harry N. Abrams.

Perrois, Louis. 1972. *La statuaire Fan, Gabon.* Paris: Office de la recherche scientifique et technique d'outremer (ORSTOM).

———. 1979. *Arts du Gabon.* Arnouville, France: Arts d'Afrique noire.

———. 1985. *Ancestral Art of Gabon from the Collections of the Barbier-Mueller Museum.* Trans. by Francine Farr. Geneva: Barbier-Mueller Museum.

Perrois, Louis, and Marta Sierra Delage. 1990. *Art of Equatorial Guinea, the Fang Tribes.* New York: Rizzoli; Barcelona: Folch Foundation.

Phillips, Ruth B. 1995. *Representing Women: Sande Masquerades of the Mende of Sierra Leone.* Los Angeles: Fowler Museum of Cultural History, University of California.

Phillips, Tom, ed. 1995. *Africa: The Art of a Continent.* London: Royal Academy of Arts; Munich: Prestel.

Phiri, Kings Mbacazwa. 1975. "Chewa History in Central Malawi and the Use of Oral Tradition, 600–1920." Ph.D. diss., University of Wisconsin, Madison.

Picton, John, and John Mack. 1979. *African Textiles: Looms, Weaving and Design.* London: British Museum Publications.

Pitt-Rivers, Augustus. [1900] 1976. *Antique Works of Art from Benin.* New York: Dover.

Plass, Margaret. 1956. *African Tribal Sculpture.* Philadelphia: University Museum.

Powell-Cotton, Percy Horace. 1904. *In Unknown Africa.* London: Hurst and Blackett.

Preston, George. 1969. *The Innovative African Sculptor.* Ithaca: College Museum of Art.

Puccinelli, Lydia. 1998. "African Forms in the Furniture of Pierre Legrain" (exh. booklet). Washington, D.C.: National Museum of African Art, Smithsonian Institution.

Rasmussen, Susan J. 1988. *Art or money?: Ceremonial, Aesthetic and Economic Aspects of the Blacksmith-Artisan Role in Tuareg Rural and Urban Settings.* N.p.: African Studies Center.

Ratner, Julie A. n.d. [c. 1983]. "The Major John N. White Collection of Tetela Art." Unpublished research paper, Indiana University, Bloomington.

Rattray, Robert S. 1923. *Ashanti.* Oxford: The Clarendon Press.

———. 1927. *Religion and Art in Ashanti.* Oxford: The Clarendon Press.

Ravenhill, Philip L. 1980. *Baule Statuary Art: Meaning and Modernization.* Philadelphia: Institute for the Study of Human Issues (ISHI)

———. 1991. *The Art of the Personal Object.* Washington, D.C.: National Museum of African Art, Smithsonian Institution.

———. 1992. "Of Pachyderms and Power: Ivory and the Elephant in the Art of Central Côte d'Ivoire." In *Elephant: The Animal and Its Ivory in African Culture,* ed. by Doran H. Ross. Los Angeles: Fowler Museum of Cultural History, University of California.

———. 1993. "Dreaming the Other World: Figurative Art of the Baule, Côte d'Ivoire" (exh. booklet). Washington, D.C.: National Museum of African Art, Smithsonian Institution.

———. 1996. *Dreams and Reverie: Images of Otherworld Mates among the Baule.* Washington, D.C.: Smithsonian Institution Press.

———. 1997. "Gifts to the National Collection of African Art" (exh. brochure). Washington, D.C.: National Museum of African Art, Smithsonian Institution.

Richter, Dolores. 1979. "Senufo Mask Classification." *African Arts* 12 (3): 66–73, 93.

Robbins, Warren. 1966. *African Art in American Collections.* New York: Frederick A. Praeger.

Robbins, Warren M., and Nancy Ingram Nooter. 1989. *African Art in American Collections.* Washington, D.C.: Smithsonian Institution Press.

Roberts, Allen F. 1995. *Animals in African Art: From the Familiar to the Marvelous.* New York: Museum for African Art; Munich: Prestel.

Roberts, Mary Nooter, and Allen F. Roberts, eds. 1996. *Memory: Luba Art and the Making of History.* New York: Museum for African Art; Munich: Prestel.

Rolin, F. 1977. *Traditional African Metal Works.* New York: F. Rolin.

Ross, Doran H. 1979. *Fighting with Art: Appliquéd Flags of the Asafo.* Los Angeles: Museum of Cultural History, University of California.

———, ed. 1992. *Elephant: The Animal and Its Ivory in African Culture.* Los Angeles: Fowler Museum of Cultural History, UCLA.

Roy, Christopher D. 1982. "Mossi Chiefs' Figures." *African Arts* 15 (1): 52–59.

———. 1987. *Art of the Upper Volta Rivers.* Meudon, France: Alain and François Chaffin.

———. 1992. *Art and Life in Africa: Selections from the Stanley Collection, exhibitions of 1985 and 1992.* Iowa City: University of Iowa.

Royal Museum for Central Africa. 1996. *Masterpieces from Central Africa.* Ed. by Gustaaf Verswijver et al. Munich and New York: Prestel for the Royal Museum for Central Africa, Tervuren.

Rubin, Arnold Gary. 1969. "The Art of the Jukun-Speaking Peoples of Northern Nigeria." Ph.D. diss., Indiana University, Bloomington.

Rubin, William, ed. 1984. *Primitivism in 20th-Century Art: Affinity of the Tribal and the Modern.* 2 vols. New York: Museum of Modern Art.

Ryder, Alan. 1969. *Benin and the Europeans 1485–1897.* New York: Humanities Press.

Sabena Revue. 1974. "Arts d'Afrique noire," 39 (1).

Sarpong, Peter K. 1974. *Ghana in Retrospect.* Tema: Ghana Publishing.

Schrag, Norman G. 1985. "Mboma and the Lower Zaire: A Socioeconomic Study of a Kongo Trading Community, c. 1785–1885." Ph.D. diss., Indiana University, Bloomington.

Schweinfurth, Georg August. 1874. *The Heart of Africa. Three Years' Travels and Adventures in the Unexplored Regions of Central Africa, from 1868–1871.* New York: Harper.

Shaw, T. 1938. "Native Pipes and Smoking in South Africa." *Annals of the South African Museum* 24 (3): 141–62.

Sheeler, Charles. [1918]. *African Negro [Wood] Sculpture,* photographic portfolio. New York, n.p.

Sieber, Roy. 1961. *Sculpture of Northern Nigeria.* New York: Museum of Primitive Art.

———. 1967. "Islamic Characteristics in Akan Metalwork." Paper presented at the Tenth Annual African Studies Association Meeting, New York.

———. 1973. *African Textiles and Decorative Arts.* New York: Museum of Modern Art.

———. 1980. *African Furniture and Household Objects.* Bloomington: Indiana University Press; New York: American Federation of Arts.

Sieber, Roy, and Roslyn Adele Walker. 1987. *African Art in the Cycle of Life.* Washington, D.C.: Smithsonian Institution Press for the National Museum of African Art.

Siegmann, William C. 1977. *Rock of the Ancestors: namôa k ni: Liberian Art and Material Culture from the Collections of the Africana Museum.* With Cynthia Schmidt. Suakoko, Liberia: Cuttington University College.

Silva, Sonia. 1999. "Chokwe Baskets: Cultural Continuity in Exile." *American Visions* (Dec./Jan.): 16–21.

Silverman, Raymond A. 1982. "14th and 15th Century Syrio-Egyptian Brassware in Ghana." *Nyame Akuma* (20): 13–16.

———. 1983. *History, Art and Assimilation: The Impact of Islam on Akan Material Culture.* Ann Arbor, Mich.: University Microfilms International.

Siroto, Leon. 1968. "The Face of the Bwiti." *African Arts* 1 (3): 22–27, 86–89, 96.

Smithsonian Institution. 1996. *America's Smithsonian, Celebrating 150 Years.* Washington, D.C.: Smithsonian Institution Press.

Smithsonian Institution. Office of Folklife Programs and Renwick Gallery of the National Museum of American Art. 1982. *Celebration, a World of Art and Ritual.* Washington, D.C.: Smithsonian Institution Press.

Société des expositions. 1988. *Utombo: L'art d'Afrique noire dans les collections privées belges.* Brussels: Société des expositions du Palais des Beaux-Arts.

Société générale de banque. 1974. *Masques du monde.* Brussels: Société générale de banque.

———. 1977. *La maternité dans les arts premiers: [exposition: Bruxelles] 13 mai–30 juin 1977.* Brussels: Société générale de banque.

Sotheby Parke Bernet. 1982. *Fine African and Oceanic Art.* Auction catalogue (January 20). New York.

Sotheby's. 1954. *Catalogue of Ethnographical Art.* Auction catalogue (July 5). London.

———. 1980. *Fine African and Oceanic Art.* Auction catalogue (November 14). New York.

———. 1983. *Prince Sadruddin Aga Kahn Collection of African Art.* Auction catalogue (June 29). London.

———. 1991. *Important Tribal Art.* Auction catalogue (June 17). London.

Sousberghe, Léon de. 1958. *L'art Pende.* Brussels: Académie royale de Belgique.

Spring, Christopher, and Julie Hudson. 1995. *North African Textiles.* Washington, D.C.: Smithsonian Institution Press.

St. Paul Art Center. 1963. *Africa: Images and Realities, the Arts of Africa.* St. Paul: St. Paul Art Center.

Stafford, Kay. 1978. "Peter Nzuki: Calabash Carver of Kenya." *African Arts* 12 (1): 40–41, 108.

Stevens, Philips. 1976. "The Danubi Ancestral Shrine." *African Arts* 10 (1): 30–37, 98–99.

Stössel, Arnulf. 1984. *Afrikanische Keramik.* Munich: Himer.

Strother, Zoe. 1998. *Inventing Masks: Agency and History in the Art of the Central Pende.* Chicago: University of Chicago Press.

Stuart, James. 1936. *uTulasizwe.* Trans. E. R. Dahle. Durban, South Africa: Killie Campbell Library.

Sweeney, James Johnson. 1935. *African Negro Art.* New York: Museum of Modern Art.

Sydow, Eckart von. 1954. *Afrikanische Plastik.* Berlin: Gebr. Mann.

Tagliaferri, Aldo, and Arno Hammacher. 1974. *Fabulous Ancestors: Stone Carvings from Sierra Leone and Guinea.* New York: Africana.

Talbot, P. Amaury. 1912. *In the Shadow of the Bush.* London: William Heinemann.

Tamzali, Wassyla. 1984. *Abzim: Parures et bijoux des femmes d'Algérie.* Paris: Dessain et Tolra; Algeria: Entreprise Algérienne de Presse.

Thompson, Robert Farris. 1970. "Sign of the Divine King: An Essay on Yoruba Beaded Crowns with Veil and Bird Decoration." *African Arts* 3 (3): 8–17, 74–80.

———. 1971. "Sons of Thunder: Twin Images among the Oyo and Other Yoruba Groups." *African Arts* 4 (3): 8–13, 77–80.

———. 1972. "The Sign of the Divine King: Yoruba Bead-Embroidered Crowns with Veil and Bird Decorations." In *African Art and Leadership,* ed. by Douglas Fraser and Herbert M. Cole. Madison: University of Wisconsin Press.

Thompson, Robert Farris, and Joseph Cornet. 1981. *Four Moments of the Sun: Kongo Art in Two Worlds.* Washington, D.C.: National Gallery of Art.

Townshend, Philip. 1986. "Games in Culture: A Contextual Analysis of the Swahili Boardgame and its Relevance to Variations in African Mankala." Ph.D. diss., University of Cambridge.

Trowell, Margaret. 1941. "Some Royal Craftsmen of Buganda." *Uganda Journal* 8 (2): 47–64.

———. 1954. *Classical African Sculpture.* New York: Frederick A. Praeger.

Trowell, Margaret, and Hans Nevermann. 1968. *African and Oceanic Art.* New York: Harry N. Abrams.

Trowell, Margaret, and K. P. Wachsmann. 1953. *Tribal Crafts of Uganda.* London and New York: Oxford University Press.

Turner, V[ictor] W[itter]. 1953 [1974]. "Lunda Rites and Ceremonies." In *Occasional Papers of the Rhodes-Livingstone Museum,* no. 10. Manchester: Reprint on behalf of the Institute for African Studies, University of Zimbabwe by Manchester University Press.

Underwood, Leon. 1947. *Figures in Wood of West Africa.* London: John Tiranti.

University of Pennsylvania, University Museum. 1974. *Africa Dolls.* Photographs by William Kohler. Philadelphia: University of Pennsylvania.

Van Gennep, A. 1911. *Etudes d'ethnographie algérienne.* Paris: Ernest Leroux.

Vansinà, Jan. 1978. *The Children of Woot: A History of the Kuba People.* Madison: University of Wisconsin Press.

Visonà, Monica. 1978. "The Asen of Dahomey: Iron Altars from the People's Republic of Benin." Master's thesis, University of California, Santa Barbara.

Vogel, Susan M. 1973. "People of Wood: Baule Figure Sculpture." *Art Journal* 33 (1): 23–26.

———. 1981. *For Spirits and Kings.* New York: Metropolitan Museum of Art.

———. 1983. "Rapacious Birds and Severed Heads: Early Bronze Rings from Nigeria." In *The Art Institute of Chicago: Centennial Lectures.* Museum Studies, no. 10. Chicago: Contemporary Books.

———. 1986. *African Aesthetics: The Carlo Monzino Collection.* New York: The Center for African Art.

———. 1997. *Baule: African Art/Western Eyes.* New Haven: Yale University Press and Yale University Art Gallery in cooperation with the Museum for African Art.

Volavka, Zdenka. 1981. "Insignia of the Divine Authority." *African Arts* 14 (3): 43–51.

Voogt, Alexander de. 1997. *Mancala Board Games.* London: British Museum Press.

Walker, Roslyn Adele. 1983. "African Art in Color" (exh. booklet). Washington, D.C.: National Museum of African Art, Smithsonian Institution.

———. 1990. "Sculptured Mancala Gameboards of Sub-Saharan Africa." Ph.D. diss., Indiana University, Bloomington.

———. 1991. "Chokwe Snuff Mortars." *Journal of the International Chinese Snuff Bottle Society* 23 (1).

———. 1994. "Anonymous Has a Name: Olowe of Ise." In *The Yoruba Artist: New Theoretical Perspectives on African Arts*, ed. by Rowland Abiodun, Henry John Drewal, and John Pemberton III. Washington, D.C.: Smithsonian Institution Press.

———. 1998. *Olowe of Ise: A Yoruba Sculptor to Kings.* Washington, D.C.: National Museum of African Art, Smithsonian Institution.

Ward, Herbert. 1890. *Five Years with the Congo Cannibals.* London: Chatto and Windus.

Wardwell, Allen. 1984. "A Bambara Master Carver." *African Arts* 18 (1): 83–84.

Webb, Virginia-Lee. 1991. "Art as Information: The African Portfolios of Charles Sheeler and Walker Evans." *African Arts* 24 (1): 57.

Weingarten, Sabine. 1990. *Zur Materiellen Kultur der Bevölkerung des Jos-Plateau.* Stuttgart: Franz Steiner.

White, Charles M. N. 1962. *Tradition and Change in Luvale Marriage.* Rhodes Livingston Papers no. 34. New York: Humanities Press.

Willett, Frank. 1985. *African Art: An Introduction.* New York: Thames and Hudson.

Wingert, Paul S. 1948. *African Negro Sculpture: A Loan Exhibition.* San Francisco: M. H. DeYoung Memorial Museum.

———. 1950. *The Sculpture of Negro Africa.* New York: Columbia University Press.

Wysner, Glora M. 1945. *The Kabyle People.* New York: privately printed.

Zahan, Dominque. 1980. *Antilopes du soleil: Arts et rites agraires d'Afrique noire.* Vienna: A. Schendl.

Zirngibl, Manfred A. 1983. *Seltene Afrikanische Kurzwaffen/Rares armes courtes africaines/Rare African Short Weapons.* Grafenau, Bavaria: Morsak.

Zwernemann, Jürgen, and Wolf Lohse. 1985. *Aus Afrika: Ahnen, Geister-Götter.* Hamburg: Hamburgisches Museum für Völkerkunde und Christians.

DEDICATION

*Sylvia H. Williams (1936–1996) was appointed
Director of the National Museum of African Art
in 1983. From the beginning of her tenure,
she set about building a collection that would
be broad enough to support a wide range of
permanent and temporary exhibitions and at the
same time be of the highest aesthetic quality.
In 1987, Philip L. Ravenhill (1945–1997) joined
the museum as Chief Curator and brought
his own considerable energy, enthusiasm and
critical judgment to this task.*

*In recognition of their love of African art
and their desire to share it with the public
through exhibitions, educational programs
and publications, this book is dedicated to
the memory of Sylvia H. Williams
and Philip L. Ravenhill.*

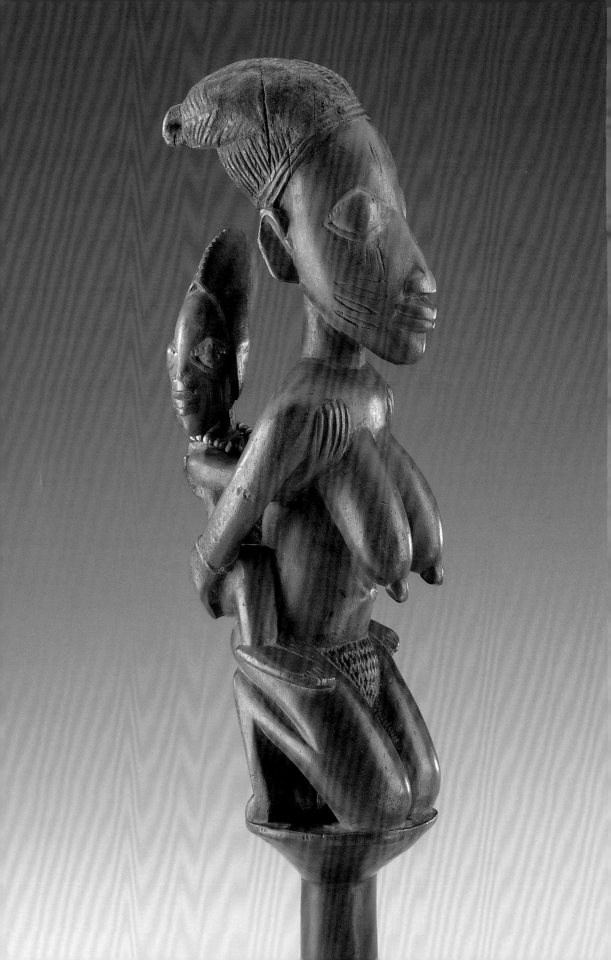